John Maeda MAEDA @ MEDIA

First published in the United States of America in 2000
by Rizzoli International Publications, Inc.
300 Park Avenue South, New York, NY 10010

First published in the United Kingdom in 2000
by Thames & Hudson Ltd,
181A High Holborn, London WC1V 7QX

ISBN 0-8478-2295-8
LC 00-101285

Printed and bound in Hong Kong

To Kris — I love you more than all the 0s and 1s in the world.

Art is primarily a question of form, not of content.
Paul Rand

table of contents

Pinstriped Suits **Nicholas Negroponte**

At the age of sixteen I was determined to be an artist. My determination helped convince my high school to accept art as a substitute for athletics. My father was less easily convinced and suggested that I attend M.I.T. because I had scored the highest possible mark on my college entrance exams for math. The idea was that I should study architecture, because it was a blend of my two childhood skills. I was not convinced.

I shared my dilemma with the headmaster, who told me the following story: "I like grey suits and I like pinstriped suits, but I don't necessarily like grey pinstriped suits." What kind of advice was that? I ignored it and attended architecture school anyway, which was a fine education, one I would not trade back had I to do it all over again. My engineering classmates learned how to solve problems, I learned how to ask questions.

One question was how to change the world. A well designed building here and there was an unlikely means, except in history books. But designing the tools designers would use felt like a lot more leverage. And, M.I.T. being the birthplace of computer graphics, I was brought quickly to the idea of computer-aided design, under the influence of a self-made mathematician named Steve Coons.

Steve had figured out how to mathematically "loft" ships and airplanes (the long

gentle curves which literally required lofts to be laid out and drawn at full scale) on a standard size sheet of paper. Believe me, in the 1960s, bringing computers and design together required pure faith, because the two seemed to bring out the worst in each other. Furthermore, the intellectual space itself seemed to be fully occupied by either failed artists or failed scientists. For the next thirty years, the signature of the machine was invariably stronger than the humans. Witness the near irrelevance to date of computer art— all those unseemly pinstriped suits.

This is changing for many reasons, three of which are germane to this book: visual thinking, graphical expression, and simplicity.

Visual thinking is more a part of our lives than ever before. The personal computer, the internet and modern-day printers bring us into regular contact with drawings, diagrams, and photographs. Increasingly, we make or process them ourselves. Children manipulate lines, shapes, color, as well as still and moving images, like no generation before. We're not only digital, we're visual.

Graphic design is emerging as an every-day tool for communications. After a period of graphical cacophony, which resulted from limitless options (fonts and layout galore), we have entered into a period of far more subtle design, constrained by the continuing need to inform. Making things quick and

easy to understand is a requirement, now
more than ever.

Besides, we're all fed up with complexity.
Software has turned into a compost heap of
useless options, expired releases and non-
sensical interfaces. In fact, computers have
become harder to use in recent years, not
easier. They're also less reliable.

We've all had enough of this. It is time to
rethink our digital world and to listen to new
voices. John Maeda is one of them. He
deconstructs the digital world with the earned
authority of an M.I.T.-trained computer sci-
entist and a card-carrying artist. Being
ambidextrous with Eastern and Western
cultures, he can see things most of us over-
look. The result is a humor and expression
that brings out the best in computers and art,
and in so doing—in my mind—is the grey
pinstriped suit we have all been looking for.

Nicholas Negroponte

Jerome Wiesner Professor of Media Arts and Sciences
Director, M.I.T. Media Laboratory

Foreword

Through my various constructions I struggle to address the conflict between simplicity and complexity.

Simplicity always occurs naturally. You can choose to look for it, or let it find you. A person who creates basic forms knows that the conscious construction of simplicity occurs only when the artistic medium permits. Creating what seems most natural— that is, elemental—can be a most unnatural task.

Complexity results when you attempt to reduce an already simple situation or form. Each action or motion leads incrementally to a set of less simple possibilities. Each step further into the process you take creative decisions or make additions that at the time seem relevant, but which accumulate to the point where the only available choice is to fail.

The computer breeds complexity. The computer industry forces it to be faster, better, and more powerful than its at-that-second incarnation. But consider a computer that is untainted by software, incapable of operating: It would be no more capable of imposing complexity than the grains of sand from which it is made (silicon). How do we allow the machine to exist in its natural uncorrupted state, while unlocking its seemingly endless potential?

I began my quest to answer these questions as the diligent apprentice to my Japanese craftsman father, whose primary wish was that his children be educated so as to not toil as he had. His beliefs, founded in practice, not theory, mandated me to pursue higher education in only one of my favorite studies: mathematics, rather than the arts.

I entered the Massachusetts Institute of Technology in 1984 with the first-generation Macintosh in hand. I tried to secretly switch my major from computer science to architecture but my father caught on to me and I was stopped. The graphical computing boom had just begun and visually sensitive technologists were in high demand. While developing my programming skills, I came across the work of American graphic designer Paul Rand, and I realized what I wanted to do for the rest of my life. When the late Muriel Cooper, who pioneered many of the first designer-centered computer graphics, suggested that I wouldn't find the visual education I was looking for at M.I.T., I left for art school in Japan. It was then that it became clear to me just how much the fields of art and technology are segregated, making it difficult for those who seek to understand both.

My stance has been that neither is more important than the other; the two complement each other in a necessary union of relevant vision united with relevant construction. To assume that the only model for art technology is through collaboration between the artist and technologist, is to gamble the entire future of our culture upon the custom of figuratively grafting artists' eyes and senses directly onto technologists' hands and minds. I am told that the beauty of such a collaboration is a result that neither the artist nor the technologist can expect. I fail to see the merits of an approach based upon mere serendipity.

True digital forms are ephemeral— non-existent in the physical realm. To truly appreciate them we must entertain an eye for the invisible— to see into the expansive electrical conscious of the computer. Our ability to comprehend its multi-dimensional thinking patterns will require intense inquiry into the very nature of computation. The common perception of the computer as an object with screen, keyboard, and mouse, or for that matter any other alternative physical form factor regardless of size, style, or weight, must defer to the computer's rightful identity as pure conceptual mass.

My work over the past decade reflects a single person's attempts to dismantle our understanding of the computer. To give the conclusion up front, I have realized that it is too vast a problem to solve alone. I have chosen the only possible solution I can, to focus on arts, design, and computation education—what I refer to as "post–visual arts education"— with the hope that the upcoming generation, ably equipped, can craft a significantly deeper understanding of the medium.

John Maeda
Lexington, Massachusetts

1 *init* My mother and father were wed in Japan in an arranged marriage. In 1957 they moved to the United States, where they settled in Seattle. As the main cook of a small Japanese restaurant Maneki, my father often made the short walk to the local tofu factory to pick up the order for that day. The owners of the shop had no children and, impressed by my father's hard work, they offered him the business. Thus began a six- and often seven-day-a-week ritual of waking between the hours of one and two in the morning to be the primary automaton at the center of the labor-intensive process of continually lifting, stirring, frying, soaking, and molding all manners of soybean-based substances. If he was lucky, he ended work around five in the afternoon—at least that was what his faithful employees, his wife and children, hoped and prayed. "Dad, we need a break!" He would retort in guttural, *yakuza*-style Japanese, "A break? Aren't you a man? If not, then cut *it* off!" Thus, although I was unquestioningly diligent in service to his work, I had a natural preference for going to school, a paradise where all I had to do was sit in a warm room and pay attention to the teacher.

Tofu begins as soybean seed that usually comes in 60-pound bags from either Kansas or South Dakota. Always a soft yellow-green color and hard like little rocks, the beans are poured into large containers to be soaked in water overnight.

The beans grow larger and softer with soaking, and are then placed into a grinding machine. A tiny trickle of water through the machine aids the flow of beans past the grinding action of two rotating, roughly textured stone plates.

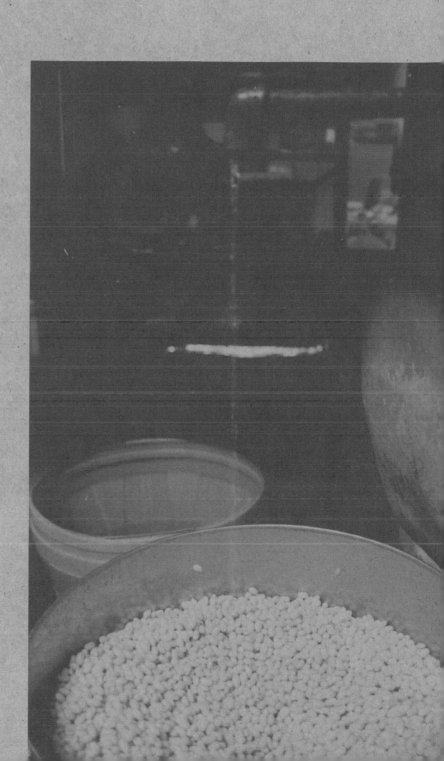

The beans leave the grinding machine as a thick white slurry that gives off a rich, sweet smell.

The mixture is moved into a large copper vat of boiling water by scooping it out a gallon at a time with an aluminum saucepan.

It is heated until the ground beans are thoroughly dissolved.

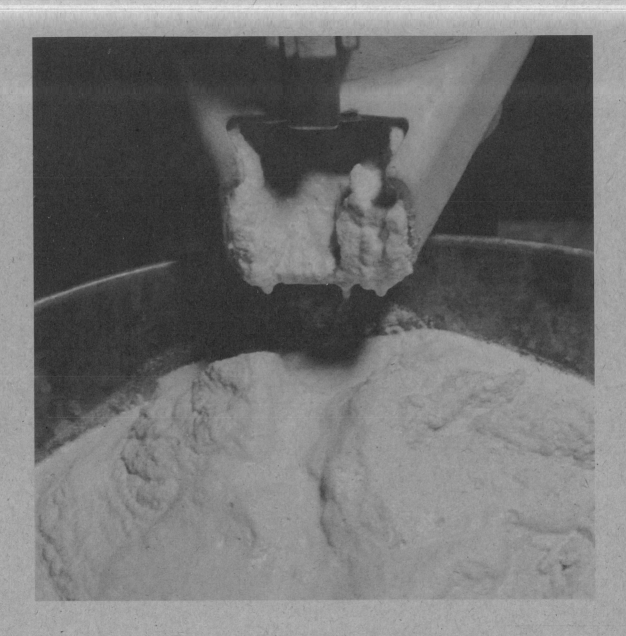

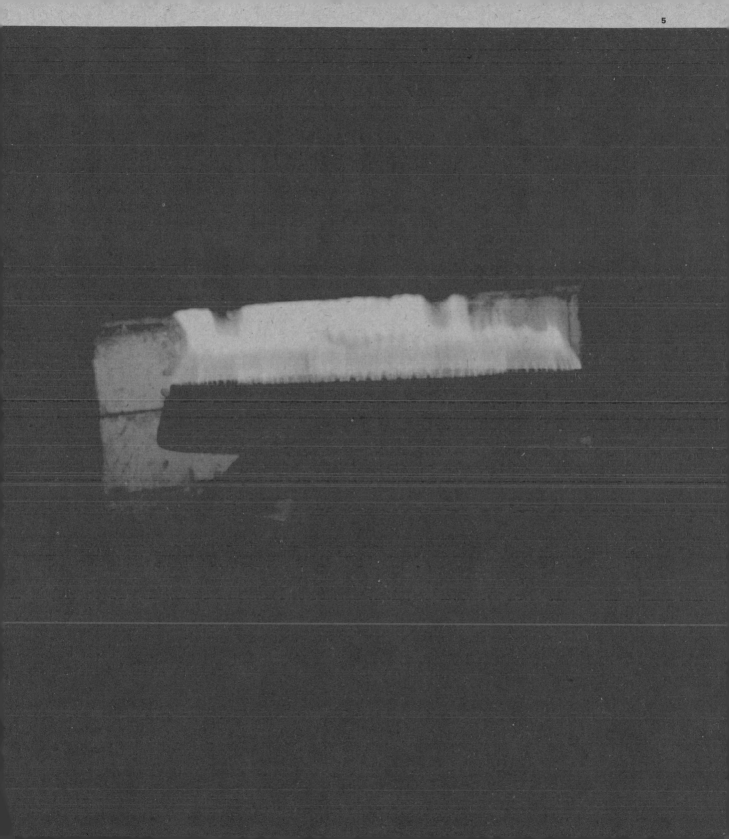

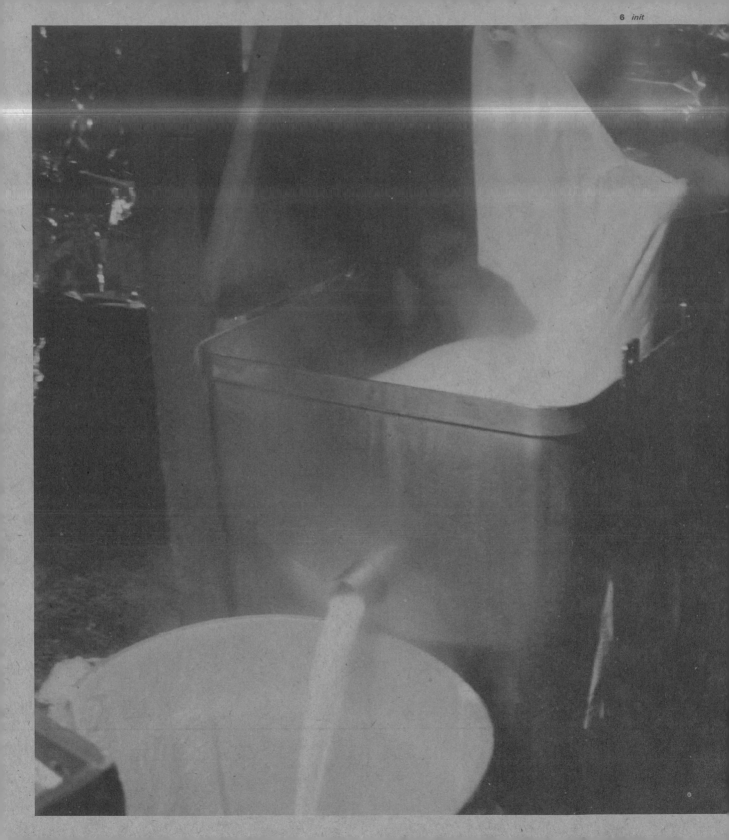

The boiling mixture is scooped out of the vat, again a gallon at a time with the saucepan (ignoring the intense heat), and filtered through a coarsely woven cotton bag. The filtered liquid then flows through another, more finely woven nylon bag. The liquid that results is commonly referred to as soymilk, which is subtly sweet but not nearly as sweet as the sugar-laden commercial product available in supermarkets.

An extract of seawater called nigari
is gently stirred into the soymilk,
and is allowed to slowly permeate
the mixture.

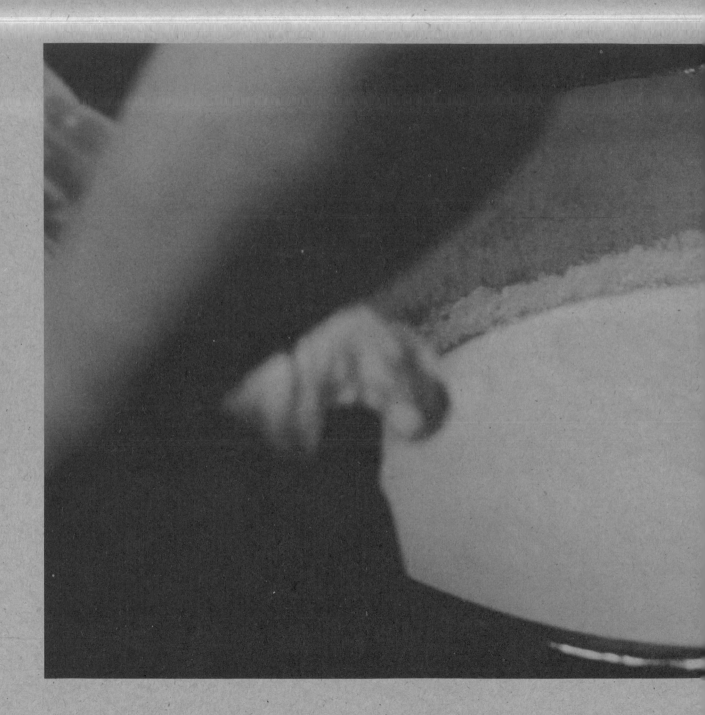

About fifteen minutes after the addition of nigari, small clumps of soybean coagulants form, giving it the consistency of cottage cheese.

It is now ready for molding.

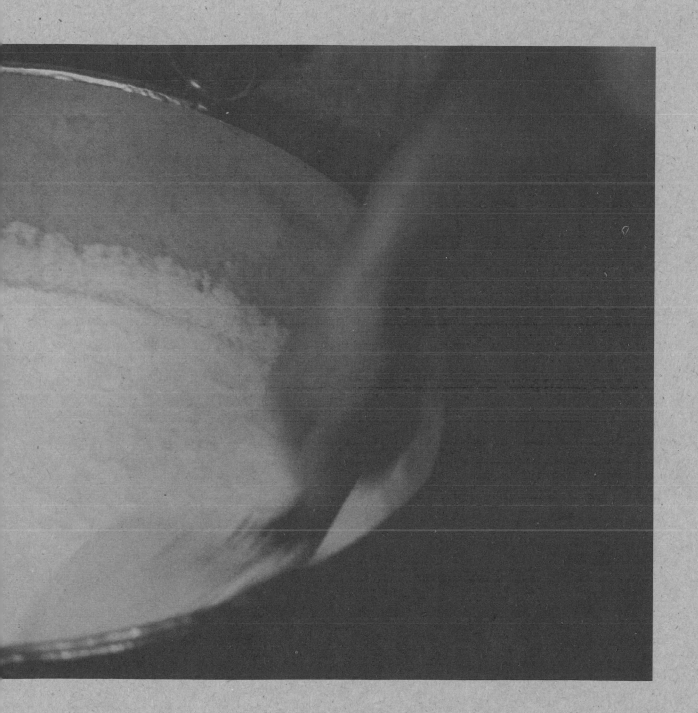

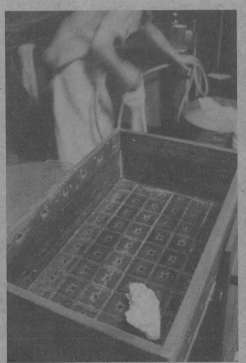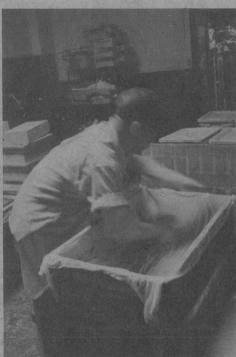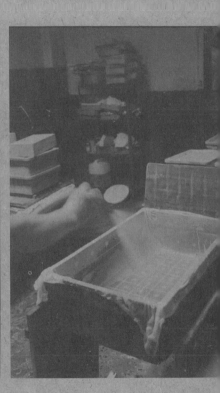

A damp cotton cloth, called a kire, is unfolded to line the inside surface of a cherrywood box dotted with half-inch holes on all sides.

Through the holes most of the liquid from the soybean-curd mixture will escape. On the main interior face of the box are sixty special holes, each of which has five notches around its edge. They are ultimately used to imprint a star logo on the face of the otherwise plain white tofu block.

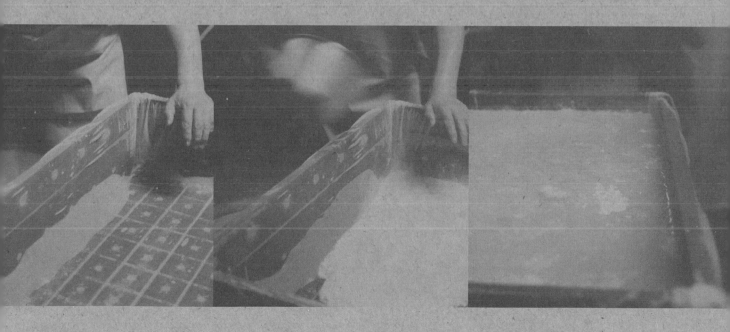

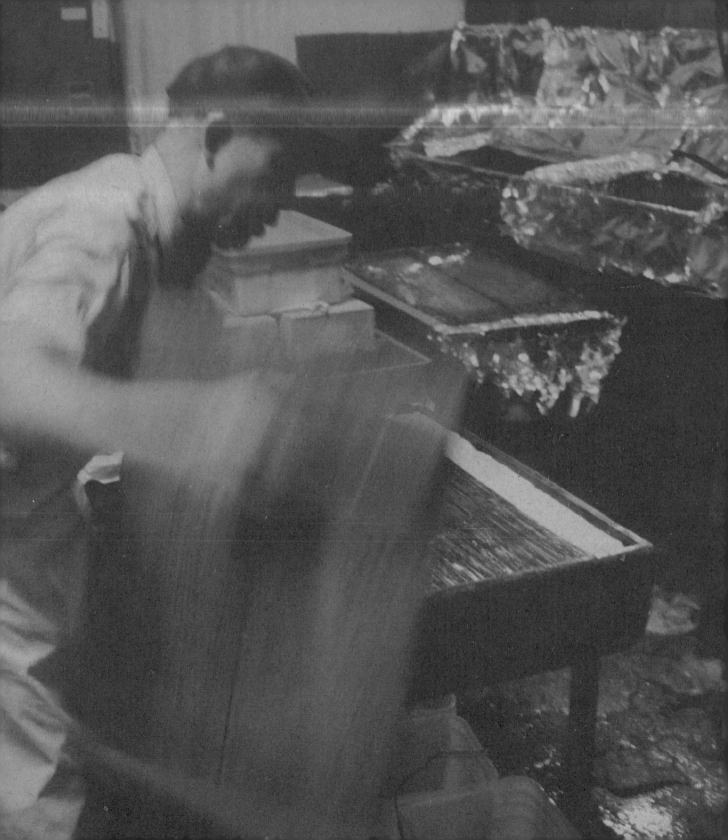

A grid of bamboo floats atop the liquid surface sandwiched by a wooden lid whose weight presses the mixture of the mold. Fifteen minutes later greater pressure is applied with concrete and water weights that add up to between 30 and 50 pounds.

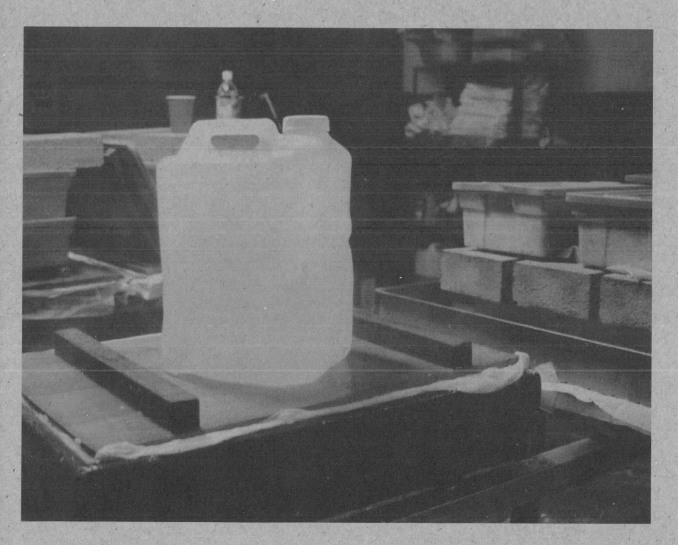

The tofu is now sufficiently firm.
It is carefully carried in its tub across
the room and gently lowered into a
large stainless-steel bin of cold water.

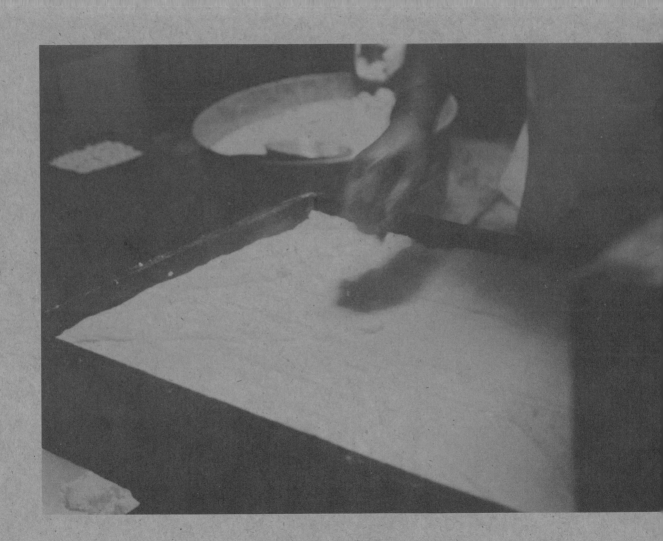

The tofu stays afloat in the buoyant box. A deft flip and it is turned over in the water. The box is removed, revealing sixty irregular stars on a smooth white surface that is perfectly aligned with the face of the water. It is held by the lid that was originally used to begin the pressing process.

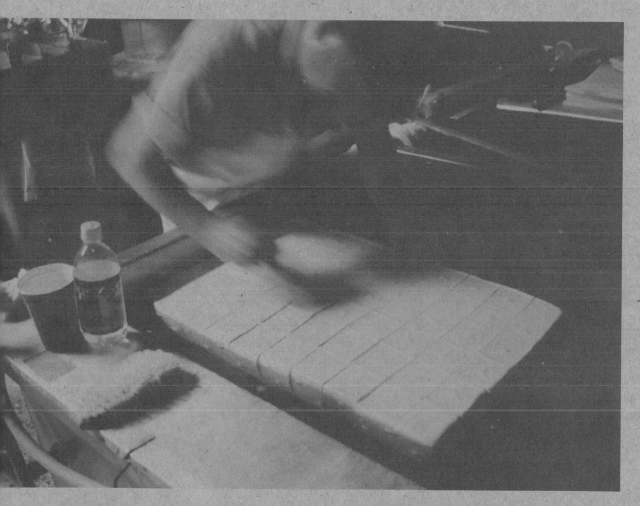

The kire is removed, and the large cake is cut expediently to reveal sixty newborn blocks of tofu that gently fall to the bottom of the bin. The wooden lid is removed from the water, ready to press the next batch.

The coldness of the water cures the tofu, hardening it just enough to be lightly handled and packed before the customers arrive

This entire process is repreated eight to ten times, each cycle taking an hour. Other tofu products are being made concurrently in the same painstaking manner, but let's save those stories for another day...

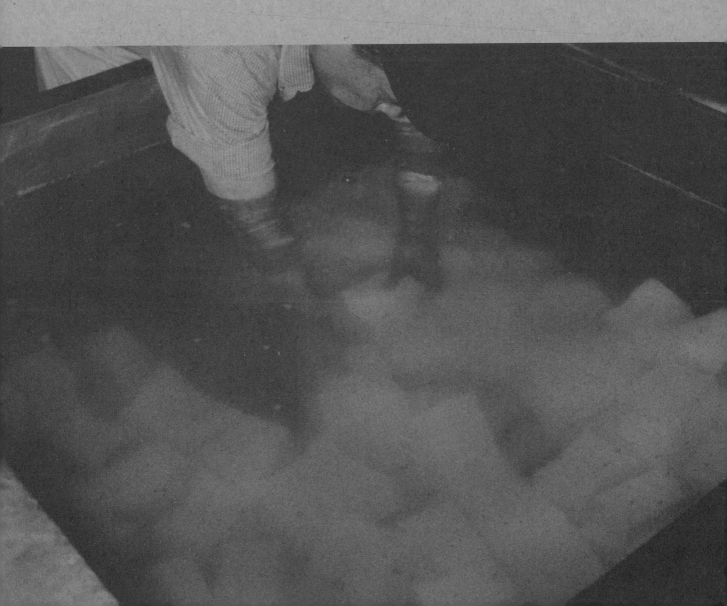

2 *begin* On the cargo ship where my father worked his way up from shining shoes at thirteen years of age to working as a staff cook in his mid-twenties, he had heard of two schools, "Harvard" and "M.I.T." Some time later he would ingrain into his children that they must go to these schools, wherever they might be. Thus from elementary school age my mission was to attend "M.I.T.," which we thought was in California. I remember telling my middle-school teacher that I wanted to go there. One day she pulled me aside and quietly said, "John, I'm sorry that's not possible because you are Oriental." Surprised that I could no longer go to M.I.T., I informed my mother of the bad news. She was upset for a reason that I didn't understand at the time, and told me I still had to go. I managed to make it there, only to find out that M.I.T. wasn't a place where I could explore my artistic leanings, which suited my father quite well, as he often warned that I would never "be able to eat drawing pictures." Computers had just become graphical, and there was much demand for icons. An accidental encounter in the library with a book by Paul Rand put me in my place, and gave me an objective toward which to aspire forever.

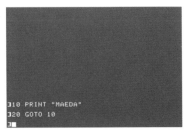

```
]10 PRINT "MAEDA"
]RUN
MAEDA
]█
```

An infinite loop demonstrates a fundamental happening in a computer program. Do something once, then do it again and again until interrupted by either human intervention, systemproblems, or the loss of electrical power.

The first computer program I wrote was a basic accounting system for the tofu store. There were several restaurants and businesses that came to purchase tofu and other tofu-associated products, sometimes on a daily basis. I created a very long program that had twelve sets of about thirty input and output entries that corresponded to each month, which took forever to type. In addition to drawing, typing was my other hobby so it didn't really bother me. The program worked fine.

My math teacher in high school, Mr. Moyer, often suggested that I take his programming class. "Nonsense," I thought to myself, "I have two whole years of practical knowledge behind me." One day I finally went to one of his classes, where he introduced a construct called "FOR … NEXT" that allowed the repetition of a similar task over and over in a very simple way. When I went home and discovered that I could replace ten thousand lines of program statements with about fifty lines, I was dumbfounded. I began to study the computer in earnest.

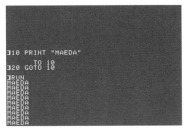

```
]10 PRINT "MAEDA"
]20 GOTO 10
]█
```

```
]10 PRINT "MAEDA"
         TO 10
]20 GOTO 10
]RUN
MAEDA
MAEDA
MAEDA
MAEDA
MAEDA
MAEDA
MAEDA
MAEDA
```

The slightest change in program instructions can result in error or, better yet, significant variation in program output. For instance, the addition of a single punctuation mark, in this case semicolon and comma, respectively reshapes the output pattern.

In the English language we expect punctuation to change the meaning or nuance of what is written, so it is hardly surprising that it has the same effect on a program. The minor addition of an extra letter space offers a bit of unexpected zest.

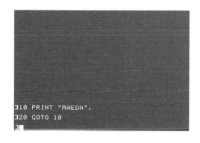

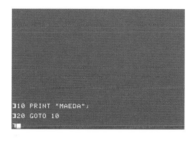

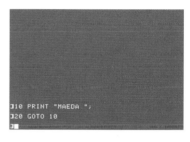

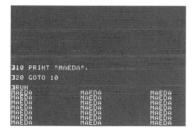

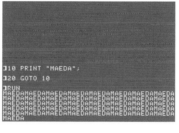

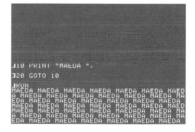

```
/* medialab.c: build fake noland pattern jtm */

#define NumGrays 9
#define NumColors 15
#define TileSize   24
#define InterSize   1
#define BigInterSize (InterSize*3)

static unsigned long grays[NumGrays],colors[NumColors],graybackpix,blackpix,whitepix;
static char *graynames[] = { "gray97","floralwhite","ivory","gray96","floralwhite","ivory","gray95","gray97","floralwhite"};
static char *colornames[] = { "royalblue","slategrey","aquamarine","limegreen","yellow","rosybrown","slategrey","hotpink",
  "orange","pink","tomato","violet","darkorchid","forestgreen","white"};

static void MakeMediaLabColorMap(void)
{
  int i,j=0;

  blackpix = j++; whitepix = j++;
  for(i = 0; i < NumGrays; i++)
    grays[i] = j++;
  for(i = 0; i < NumColors; i++)
    colors[i] = j++;
  graybackpix = j++;
  // allocate pixels a la XWindows ...
}

void DrawMediaLabMural(int w,int h)
{
  int x,y = ystart,yc = 1,goodrand;

  MakeMediaLabColorMap();
  XSetForeground(graybackpix);
  XFillRectangle(xstart,ystart,w,h);

  /* first draw the tiles */
  for(;y<(ystart+h);) {
    for(x = xstart; x < (xstart+w); x+=(TileSize+InterSize)) {
      XSetForeground(grays[GetRandomNumber(NumGrays-1)]);
      XFillRectangle( x,y,TileSize-1,TileSize-1);
      XSetForeground(blackpix);
      XDrawLine(x+1,y+TileSize-1,x+TileSize,y+TileSize-1);
      XDrawLine(x+TileSize-1,y+1,x+TileSize-1,y+TileSize-1);
    }
    y+=(InterSize+TileSize);
    if (!(yc%2)) y+=BigInterSize;
    yc++;
  }
  /* now fill in horizontal interstices */
  y = ystart; yc = 1;
  for(;y<(ystart+h);) {
    for(x = xstart; x < (xstart+w);) {
      XSetForeground(colors[GetRandomNumber(NumColors-1)]);
      x+=GetRandomNumber(TileSize*3);
      goodrand = GetRandomNumber(TileSize*3) + 4;
      if (!(yc%2)) XFillRectangle(x,y+TileSize,goodrand,InterSize+BigInterSize);
      else XFillRectangle( x,y+TileSize,goodrand,InterSize);
      x+=goodrand;
    }
    if (!(yc%2)) y+=BigInterSize;
    y+=(InterSize+TileSize); yc++;
  }
  /* now fill in vertical interstices */
  y = ystart; yc = 1;
  for(x = xstart; x < (xstart+w); x+=(TileSize+InterSize)) {
    y = ystart;
    for(;y<(ystart+h);) {
      y+=GetRandomNumber(TileSize*2);
      goodrand = GetRandomNumber(TileSize*3);
      XSetForeground(colors[GetRandomNumber(NumColors-1)]);
      XFillRectangle(x+TileSize,y,InterSize,goodrand);
      y+= goodrand;
    }
  }
  XSetForeground(blackpix);
}
```

Visitors to M.I.T.'s Media Laboratory are greeted by a four-story-high atrium dominated by a color-tile composition by the premiere American colorist Kenneth Noland. As a graduate student at the Media Lab, I often stared at the wall to attempt to read the pattern, but never could. I thought it would be interesting to create a program to generate a similar result. To my surprise, a reasonable approximation was built with a simple page of program text. Was it the same? No. Was it similar? Yes. Was it right? No. It would take me the entirety of a decade to figure out exactly why.

The process of automatically
generating simulacra of pre-existing
artwork by computer programs began
as early as 1965 with pioneering
computer artist A. Michael Noll's
rendition of a work by the reknowned
painter Piet Mondrian. Such attempts
inevitably focused the public's
perception of computer art towards
its cheap-trickery aspects, making it
impossible for ongoing experiments
in its superspatial qualities to be
properly noticed. The emergence of
digital painting systems quickly made
computer programming irrelevant.

Commanded by the late M.I.T. Professor Muriel Cooper to "go away" (to art school), I had the fortune of starting over as a designer. I followed my love Kris to Japan, where I was fortunate to land at an art school with scarce computer resources. Disconnected from e-mail and other electronic parasites, I rediscovered my mind, paper, and pen.

The most difficult concept to master in design is not the actual execution of a design itself but the more practical aspect of finding a client willing to take a risk on your ideas and in the best of circumstances, leave you alone. Like the rest of my peers, I persevered designing name cards, stickers, and all things printable, and confirmed for myself the maxim that if you persistently do good work, more work will naturally come your way.

A confluence of reactions towards the elegant interactive forms of artist Toshio Iwai, the critical anti-design tirades of cognitive scientist Dr. Donald Norman, and a personal fatigue from the computer display screen sparked my interest in thinking about physical manifestations of digital information. I began to write and illustrate concepts in this area, which I called "dynamic form," specifically three-dimensional form:

Prior to the development of modern technology, artifacts produced by humans obeyed an intuitive relationship between size and complexity. A small object corresponded to a simple function, whereas a larger object was associated with a proportionately more complex function. This simple relationship arose from the macroscopic nature of technology at the time and is significant because it extended two sacred promises, one to the user and one to the industrial designer. The first is that the user would be able to

construct a priori impressions of an object before actually using it, that is, literally *sizing up* the nature of the object at first glance. The second is that industrial designers would have a suitable amount of visual and tactile design space. Both promises had as a prerequisite the luxury of a space for the user to assess functionality, and a space for the designer in which to express that functionality.

Today objects we make rarely extend these promises because the majority of them are not space-oriented on the

outside but space-oriented on the inside, at incredibly tiny scales. This inner-space is a consequence of the successive miniaturization of integrated circuit technology, which can realize topological complexities equivalent to entire cities within raindrop-sized volumes. In a society where personal living space is gradually decreasing and mobility is at a premium, smallness is indeed a desirable property for objects to possess. On the other hand, small implies a cramped design volume, which has eliminates many traditional means of expression for the industrial artist.

The contemporary solution to the reduction in design volume has been to compensate for physical space with virtual space. We decorate the surfaces of objects with elements equipped with mechanisms for change, like indicator lamps or general display screens. These components have powerful consequences because they imply that spatial restrictions can, in theory, be overcome. Each element can freely hide and display a multitude of possible visual surfaces. Hence, although we might consider an object restricted in a spatial sense, its dynamic surfaces allow the object to transcend those restrictions through expression along the never-ending dimension of time.

Dynamic surfaces are prevalent in our world, making our society sensitive to searching for the display screen of a device when trying to determine its use. This fixation with what I term *skin* dynamism, or the ability of an object's surface to change, results in shifting the focus from an object's body (which once defined its function) to its outer skin (which was once simply an artifact). Consequently, computer screens continue to grow larger and more dominant—signalling a decrease in the significance of the bodies on which these dynamic surfaces lie, and gradually rendering them meaningless.

FORM

While designing the cover for a book entitled *Dynamic Form,* I created a small piece of software to densely depict the cover image with ten thousand words. This process interested me more than the book itself and led me to create more visuals in this programmatic style. →

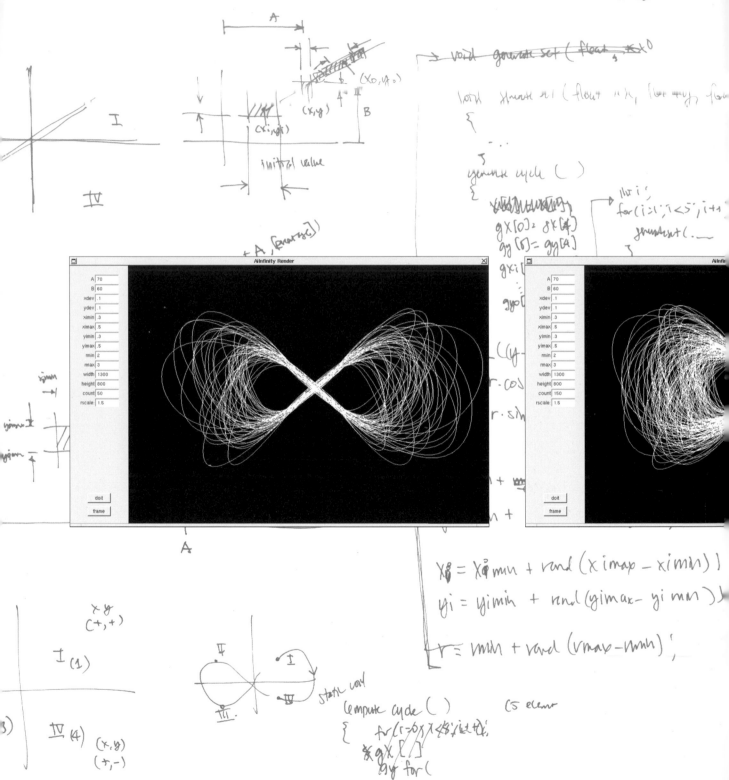

A

I

IV

(x_0, y_0)

(x, y)

(x_i, y_i)

B

initial value

+ A, (generate))

→ void generate set (float , *x0

void generate set (float *x, float *y, fl
{
 ...
}

generate cycle ()
{

gX[0] = gX[#]
gy[0] = gy[#]
gXi[

gyo[

for i;
for(i=1; i<5; i+1
generate set (—

((y-

r·cos

r·sin

+

+

AiInfinity Render

A	70
B	60
xdev	.1
ydev	.1
ximin	.3
ximax	.5
yimin	.3
yimax	.5
rmin	2
rmax	3
width	1300
height	800
count	50
rscale	1.5

doit
frame

AiInfi

A	70
B	60
xdev	.1
ydev	.1
ximin	.3
ximax	.5
yimin	.3
yimax	.5
rmin	2
rmax	3
width	1300
height	800
count	150
rscale	1.5

doit
frame

ximax

ximin

yimax

yimin

A

$x_i = x_{imin} + rand(x_{imax} - x_{imin})$

$y_i = y_{imin} + rand(y_{imax} - y_{imin})$

$r = r_{min} + rand(r_{max} - r_{min})$;

x, y
$(+,+)$

I (1)

II

I

IV

III

static cord

compute cycle ()
{
 for(i=0; i<5; i++){
 gX[]
 gy for(

(5 elem

3) IV (4) (x, y)
$(+, -)$

B cmt (

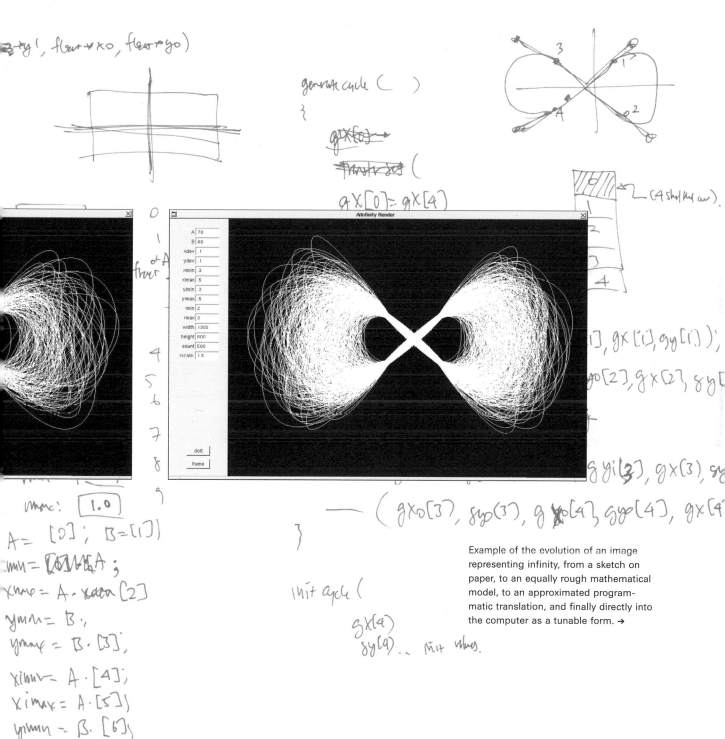

Example of the evolution of an image representing infinity, from a sketch on paper, to an equally rough mathematical model, to an approximated programmatic translation, and finally directly into the computer as a tunable form. →

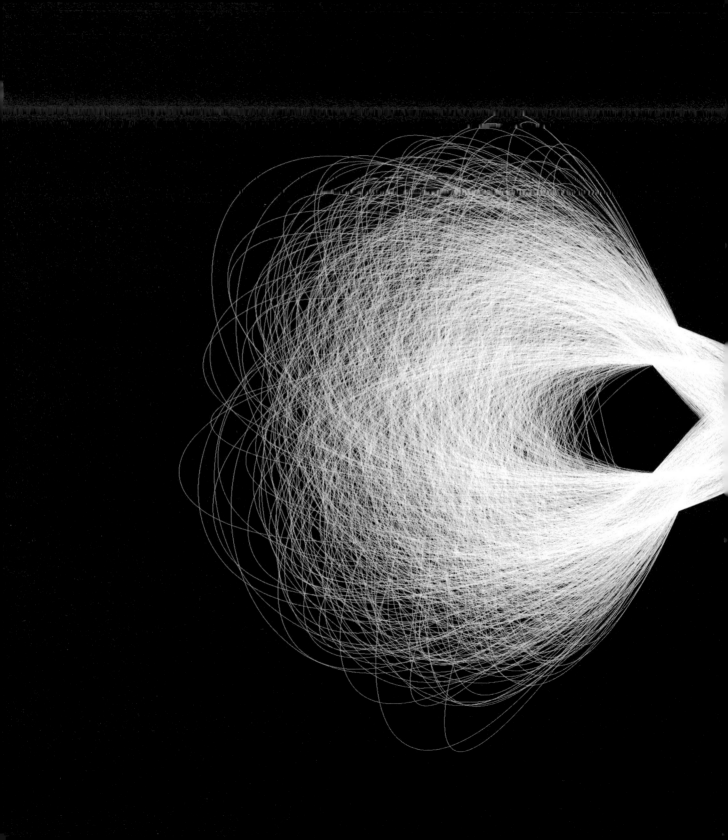

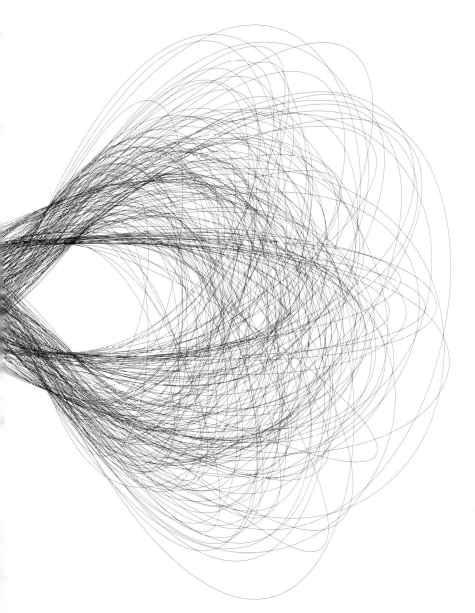

Whether Instructed to stroke ten thousand cycles or even just a few hundred, the computer never complains. It always complies.

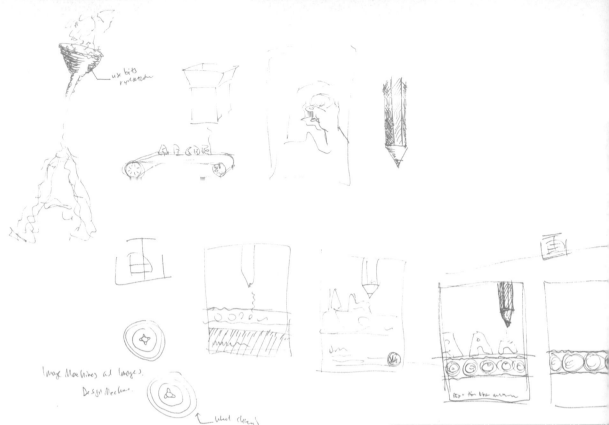

Once encoded as a programmatic form, the computer becomes a literal design machine, capable of rendering endless variations on a basic theme. The foremost challenge in operating such a powerful tool is the same as with the simplest tool: there must always be a clear initial concept that can guide the process to a relevant outcome.

cyberowski

.1pt lines.

256 gray

256 ox

rm 15 wd
0
0

rm 15 wd
0 14 curveto
0 14
fill

1cm element = 28 pt

36.8

gsave
translate
newpath
0 14 moveto

point'

37 + 2 = 39 40

gsave
translate
xtgray
newpath
00 moveto
0 20 lineto
2 28 lineto
28 0 lineto
closepath
fill newpath
0 14 moveto
rm 15 wd

0 arch
rm 15 wd
14

erasore

bar rectangle.

xline 0→15 rand 815

rm 15 wd
rm 15 cwd
14 add
0
14 0 curveto

For the "Design Machines" exhibition I created a B4-size booklet demonstrating ideas in computer-generated complexity. One feature of the show was a NeXT computer that converted whatever stood in front of it into colored type. →

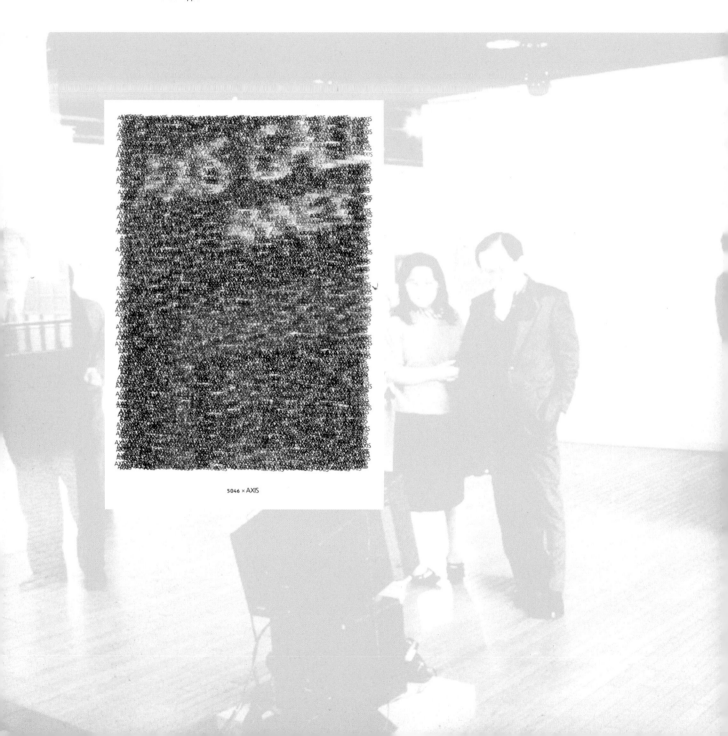

5046 × AXIS

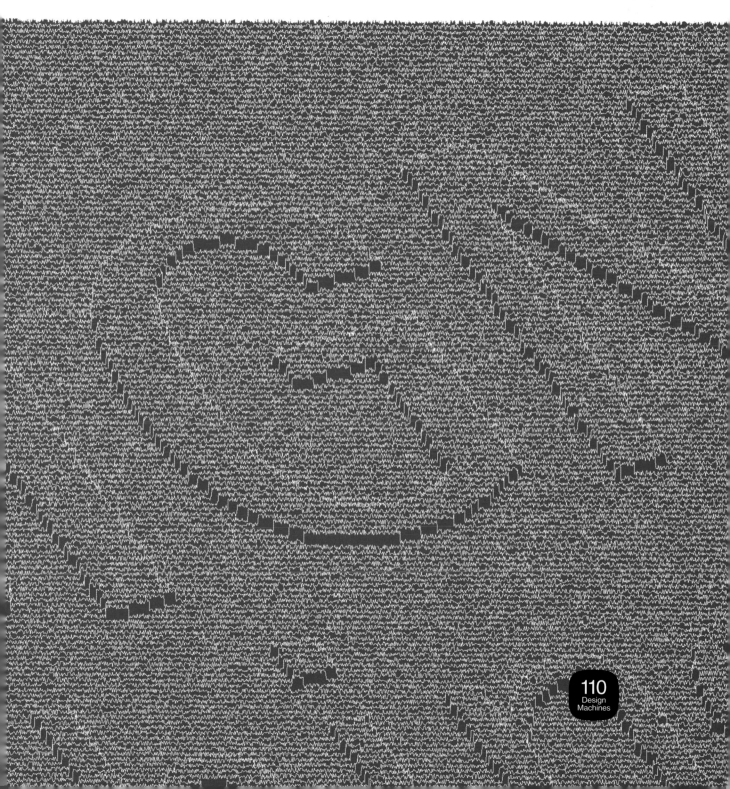

110
Design
Machines

our hands are the primary obstacle to advancement

in the

digital graphic arts

Their physical limitatio

event us from exploring what we cannot construct.

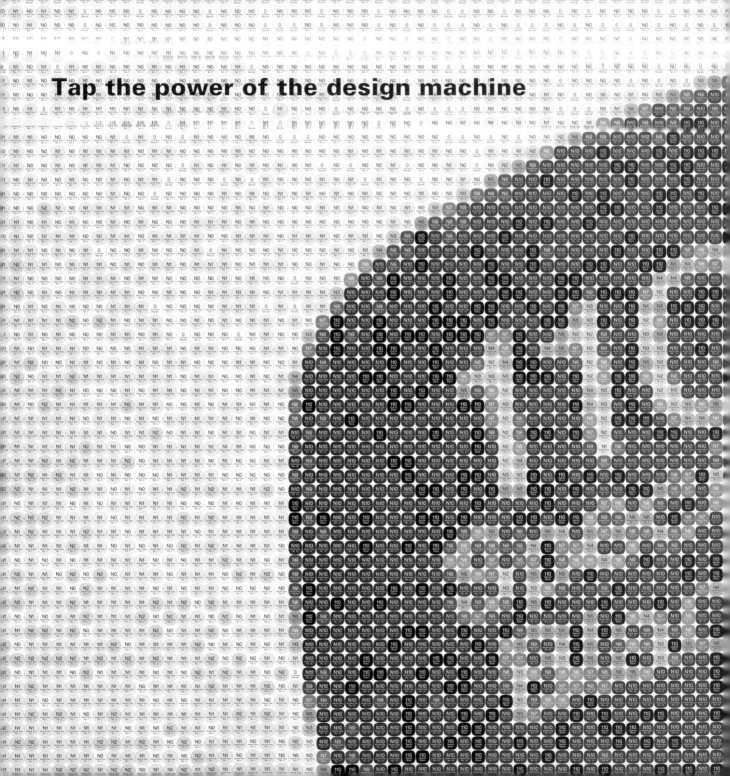

Tap the power of the design machine

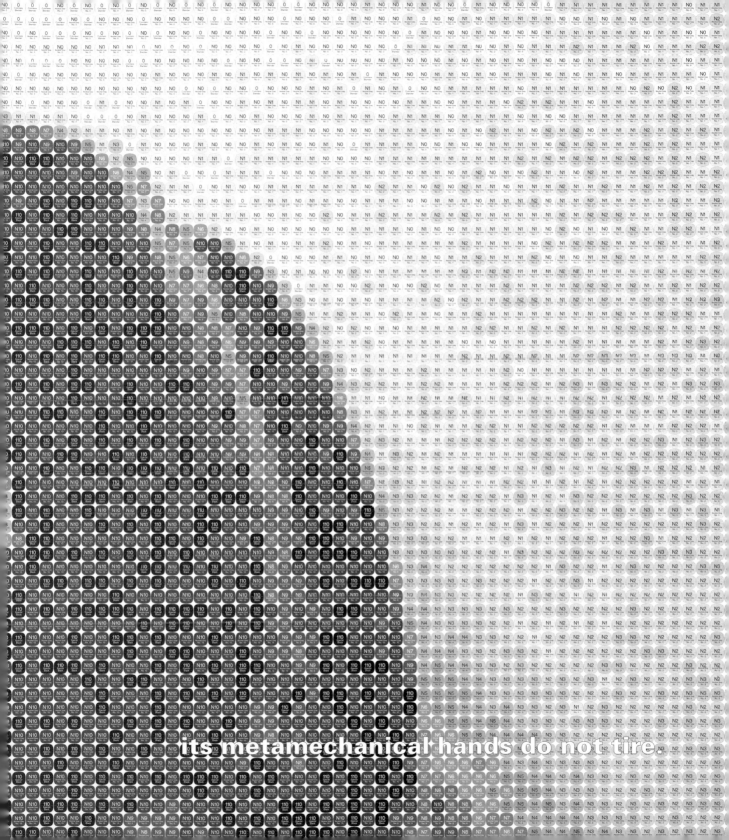

its metamechanical hands do not tire.

design the lens through which it translates
raw information
into your own visible language

escape the monotony of demonstration

engage in a pure discourse of style

Manipulate perfect abstractions of for

unhindered by tactile reality.

with the design machine.

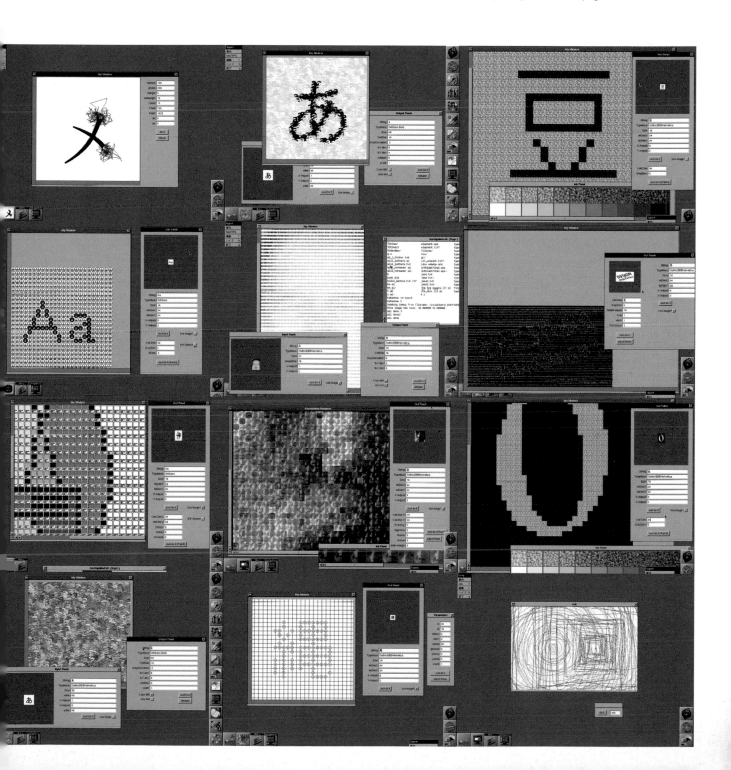

Each page of the booklet directly corresponded to a simple program specifically designed for that page. →

Each circle, triangle, and square was rendered until every pixel on the canvas was painted.

Generating complexity for complexity's sake is similar to shouting complete nonsense at the top of your voice.

Both are embarrassments that are best avoided, but when you are young it is the best way to attract attention.

The Human-Powered Computer Experiment set out to reveal the traditionally invisible spirit of the computer in its true form as a living machine. →

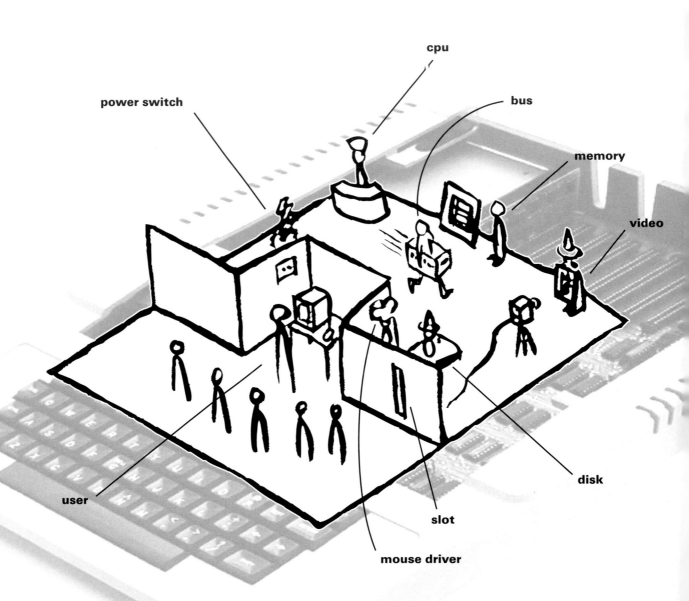

cpu

bus

memory

power switch

video

user

slot

disk

mouse driver

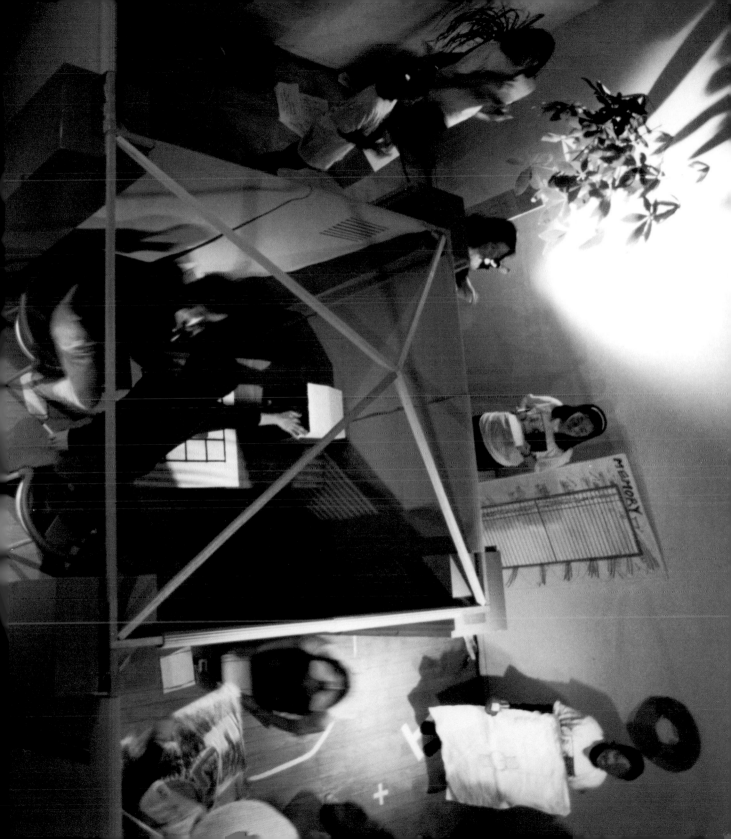

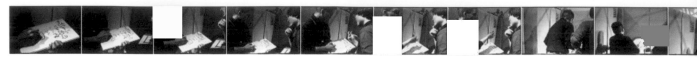

A problem is too difficult to solve so we turn to the computer for help. The computer is turned on.

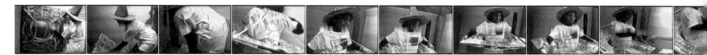

The disk drive receives the disk and immediately wears it. The program enscribed on its cardboard platter spins and is read from the beginning.

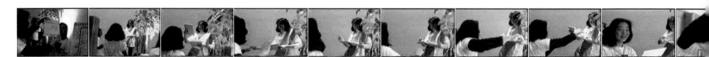

The CPU begins to take a central role by dispatching new instructions.

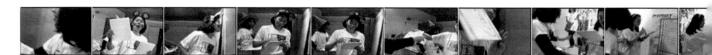

The CPU has requested to find the user's mouse position; the mouse manager takes a quick peek. That position is carried to memory.

The video manager updates itself accordingly.

Lights come on and the assistants come into view. They pick up a giant floppy disk, which is inserted into the computer.

The bus has arrived and data is transferred from the disk to memory. The computer is beginning to start up.

The bus is the sole messenger of all information inside the computer. Back and forth it travels between CPU and memory.

The CPU dispatches the instruction to draw a cursor where the mouse has now moved.

The parts of the computer come out to greet the users. Hello!

The experience of seeing a living computer in action evoked the image of a beehive. Not just one beehive of course, but a million beehives of busy electrons traveling incredible distances at speeds beyond our perceptual capacities.

Imagine if the computer we touch everyday were viewable through special glasses that reveal this alternative reality. We would see something like a shimmering material of pure electric thought, perhaps incomprehensible but at least several universes away from the dreary click, keypress, and drag that we associate with modern computing.

Yet for all of its wondrous metaphysical properties, we force the computer into familiar metaphors. There has to be "paper" and of course a corresponding "pen" or "pencil."

We go so far as to provide the analogue to the "hand," which, oddly, cannot ever be used to hold onto the pencil.

Certainly it could be designed to behave in such a manner without any great effort. But then again you already have a hand, and it is gripping the mouse.

The mouse is a unique device that we cognitively morph into whatever function we please. The more options that can be chosen, the more powerful a tool it appears, but as with all things that grow more powerful, it becomes more uncomfortable.

In the Illustrandom experiment, I built
a system for creating forms with
unstable spatial properties over time
to show just one example of how the
medium of the computer can differ
from that of paper. ↗

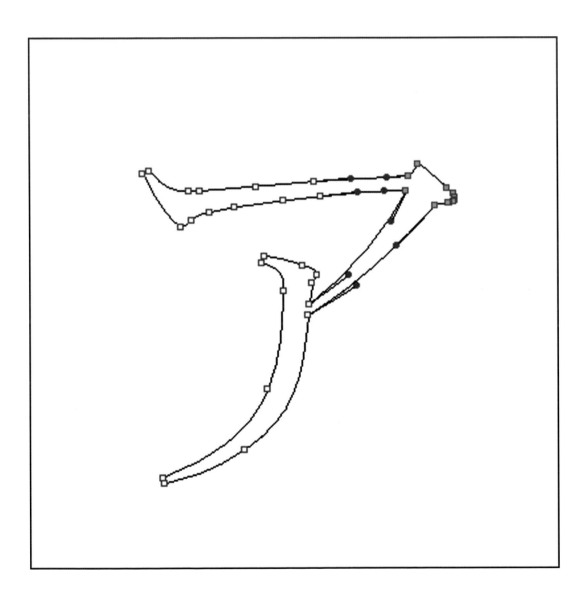

Digital tools have been designed to emulate the behavior and properties of existing tools and materials. So it is no surprise that the fields that have heavily staked their future upon these systems, mainly digital art and design, have had difficulty in moving forward at all. A mark on paper, no matter how ingeniously conceived, is just a mark on paper, nothing more.

Because the traditions of art and design presuppose a material with a single fixed state, our critical instinct is to reduce anything with variability to a single instance. A sole solution is always chosen because a piece of paper, plastic, or stone cannot simultaneously assume multiple forms. A static material enforces a thought process with only one conclusion. Thus it is difficult to appreciate and, more importantly, evaluate an artistic statement of change. A natural reaction is to command the form to be frozen—for it to assume a single instance. But another instinct supports our willingness to let it go—when we realize it is alive.

At the present, to render a dynamic, computerized form static for critical or evaluatory reasons is decidedly less sacrilegious than taking a mobile by Calder and welding all of its joints to make it immobile. As our understanding of and appreciation for programmatic forms grow, we will regard a similar act of digital paralysis as equally offensive.

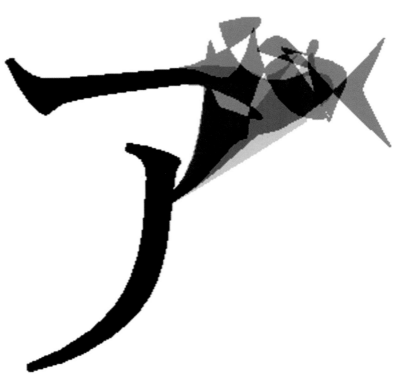

3 *electric dot* During the day, on a completely black surface, a white dot appears like a bright star of hope. As night falls, attempts to resuscitate the star with liberal amounts of white paint inevitably lose to the will of nature. The light of fire enables us to see after the sun has hidden, but its roar and crackle continually warn us of its immediate hunger for fuel. Our uneasiness has been resolved for the present by removing the flame from plain sight, hiding it in power plants where massive forces of fire, heat, and fission translate to electrical power. Transported through a giant maze of mostly hidden cables, it eventually reaches us through an unassuming two- or three-prong jack in the wall. Fed through a mating plug, electricity flows directly into an exposed filament that is safely enclosed in glass that begins to glow—thus the miracle of the light bulb, an electric dot impervious to night and irrespective of white pigment. Elsewhere, another plug mates and a significantly more complicated process forces a beam of electrons onto a plate of glass covered with a chemical that glows when energized, resulting in the mass production of bright electric dots that illuminate the otherwise invisible mind of the computer.

A pixel is a perfectly square dot, or at least that's the way we like to approximate it on paper.

The average "real" pixel you might encounter on a CRT display (cathode ray tube) is never a perfect square, it's more like a fuzzy dot.

If we stepped back twenty years to look at a pixel, we see that a fuzzy dot is clearly preferable to an electric smudge.

Today liquid-crystal displays (LCD) are increasingly prevalent, providing unsurpassed quality in shape and light consistency of the electric dot.

Yet, when viewed in closest proximity, we see that the white pixel is a mere electronic illusion of red, green, and blue glowing elements of oblong shape.

modern pixel

vintage pixel

LCD pixel

When the nature of the glowing mirage is revealed, a fleeting beauty can be perceived not in the actual viewed form but in the marvelously elaborate process of revealing a single number out of the millions of numbers in the computer's mind.

Turn the monitor of your computer off for a moment. Are the pixels you see gone? Certainly their visual presence is, but their electrical presence is not. This is verified by turning the monitor back on—nothing has changed.

By the act of turning the computer off, however, you know that the pixels are now truly gone. Not just the visual trace of the pixel, but the existence of the pixel itself.

A dot of ink on paper is an indelible part of our world. It is a promise always fulfilled. We do not fear for its immediate demise or that it can be lost with the flick of a switch.

It is safely rooted in the fibers of the paper as an impression that is not trivially erased.

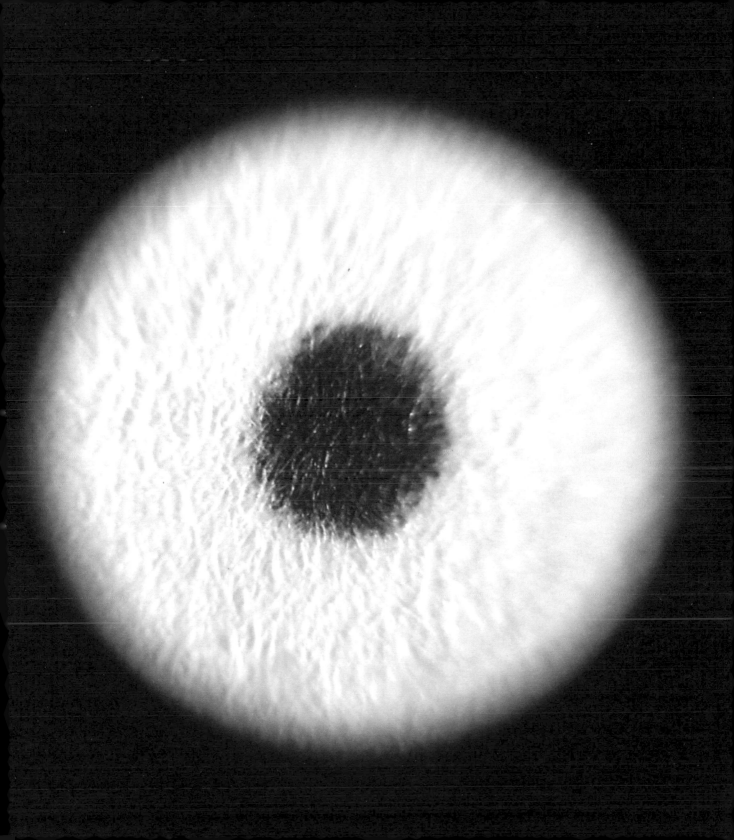

But in many ways it is just as virtual as the electric dot on the screen. Its existence can be compromised at any time.

And if not destroyed by fire, the black hole of human consumptive habits always awaits.

Alone a pixel is powerless. It is a character that only has value when seen as part of a large crowd.

Today we often complain of small screen sizes. A classic 13-inch monitor displaying 640 by 480 pixels is insufficient for most people's visual expectations.

Consider how that represents 640 times 480 pixels—a total of 307,200 individual light-producing elements updated 60 times per second.

If you were to count from 1 to 307,200, estimating it would take an average of one second per pixel, then 307,200 seconds adds up to 5,120 minutes, which is more than 85 hours, or three and a half days, of counting continuously. And that's just for one frame of pixels.

Not to mention the enormous range of colors that any pixel can assume—16 million! To get a sense of that many colors, imagine a set of 64 crayons extending for 262,144 rows, where each crayon is different. In a crayon factory this might be an everyday occurence, but dispel that thought for now and be amazed …

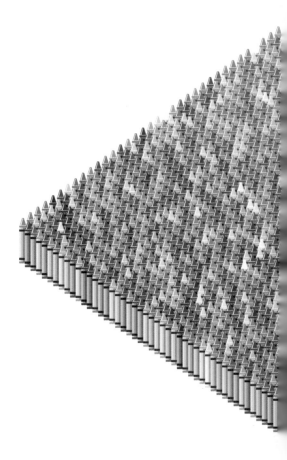

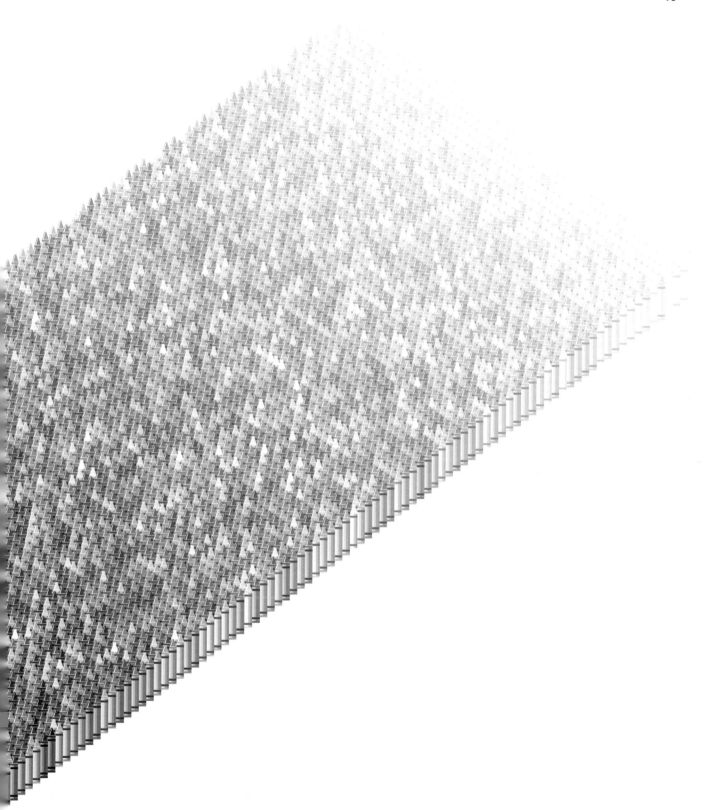

... or not.

4 *reactive* My science teacher made us memorize that "an organism is something that reacts to a stimulus." At an age when big words serve as a façade for intelligence, I filed it away as important. Many years later I was in the midst of a struggle to reconcile my romantic notions of design as represented by designers like Paul Rand, with the considerably less idealistic realization that design was nothing more than another way to make a living. I had recently found two traditionally opposing camps of thought—namely non-designers and designers—in implicit agreement that the methods and manifestos of design were no longer adequate. Researchers maintained that the same sentiments for designing a cup or spoon could not scale to modern information-rich objects; proper designers maintained that "form follows function" was irrelevant when an object's functions could number in the thousands. The interdisciplinary approach to design had emerged and *interaction* design was born. Not only had the object of design become more complex, but the process of design had become more complex as well. Driven to deep depression, I reinterpreted my teacher's words: any living thing *reacts,* even a computer.

My first attempt at creating reactive graphics began with a simple program that translated between cursor motion and color. A graph at right displays the amount of cursor movement at any given instant in any direction, while color tokens to the left define a visual map that correlates specific ranges of motion to specific colors. When the entire screen is filled to correspond to the motion of the cursor, a single reactive pixel is perceived. This concept is simulated on the following five pages. →

The cursor is still.
The page is pink. →

A slight move changes
the page to green. →

A greater motion turns
the page to blue. →

An even greater movement
turns it to yellow. →

Remaining stationary returns
the page to a healthy pink.

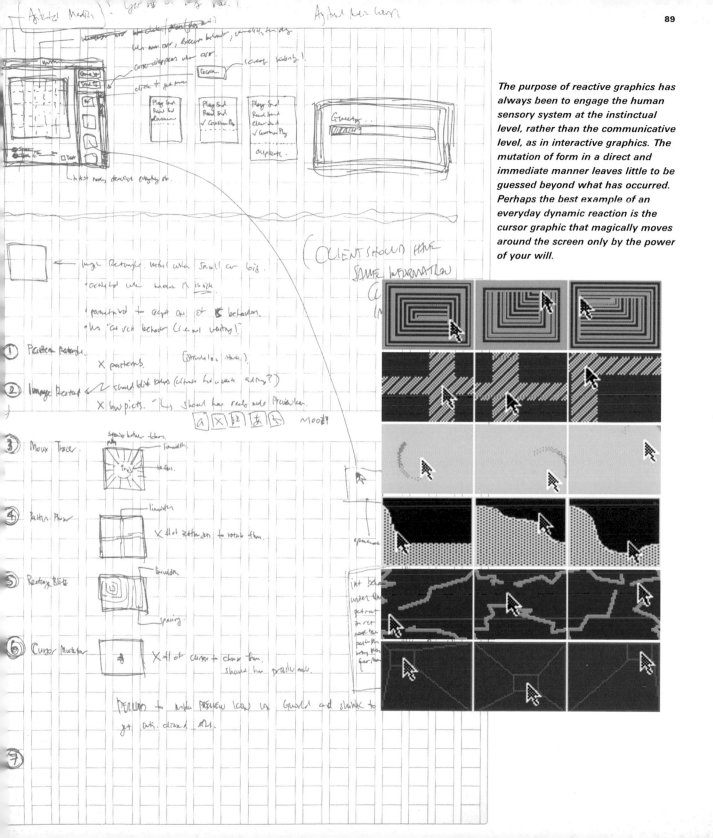

The purpose of reactive graphics has always been to engage the human sensory system at the instinctual level, rather than the communicative level, as in interactive graphics. The mutation of form in a direct and immediate manner leaves little to be guessed beyond what has occurred. Perhaps the best example of an everyday dynamic reaction is the cursor graphic that magically moves around the screen only by the power of your will.

Given the diversity of the reactions I created and observed, it seemed possible to develop a new visual language to describe such systems. The issue of unstable inks was examined as a system

Color is selected and painted.

As the cursor strokes the surface,
the rectangular fibers react and
become unstable in color value for
a brief moment.

The digital medium is unbound in time and in space. A rectangle can be instructed to move every second for eternity. Furthermore, it can be commanded to move off the viewing canvas on to infinity. To draw effectively on such a material requires not only a new set of tools but a new kind of mind.

At the conclusion of developing this system for programming intelligent inks, I realized that unless there is a good idea about what it's for, any sophisticated tool is ultimately hindered.

Rectangles painted with blue ink are programmed to travel continually to the right, shrink vertically when the mouse is near, and otherwise expand vertically.

In recent years the media has crowned certain people as "Photoshop gurus" or "Photoshop masters." I found these appellations to be oxymorons—who is really in control, the tool or the master? To illustrate this point, I created a simple paint system in which the relationship was inverted. It is the tool, not the hand, that clearly appears to be in control.

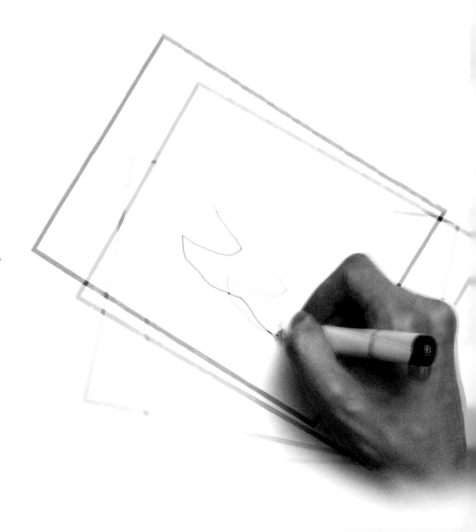

I heard a software evangelist at a design conference say, "The world wide web is like the California goldrush. As you all know, miners couldn't crawl into the mines with their regular clothing, as it would easily get torn. Thus jeans were invented. They also needed specially designed pans for panning for gold. We are the company that makes those tools you need to strike it rich." Stated differently you could also hear it as, "Whether you find gold or not, probably not, we're going to make money from you anyway." The issue of financial gain aside, there is no doubt that digital artists and designers worldwide are indentured in some way to the art director of international renown, identified by the scarlet letter A.

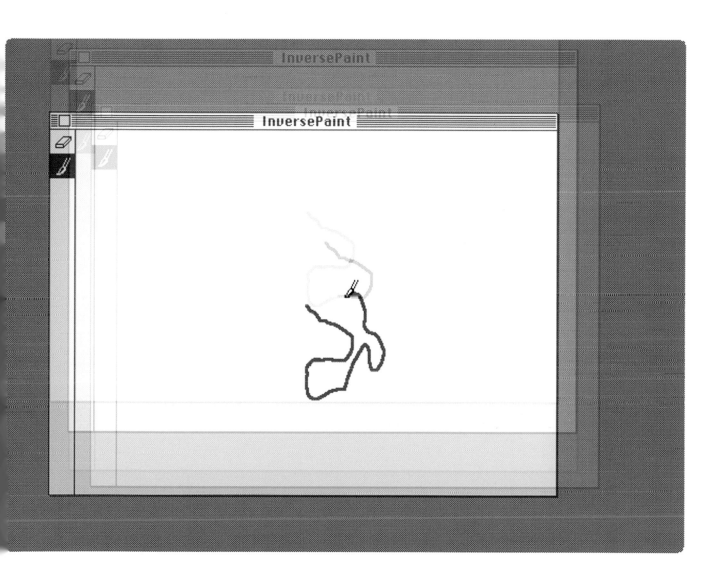

Staring into a bowl one day, I thought it would be useful to experience the phenomenon of painting as restricted to circular movements.

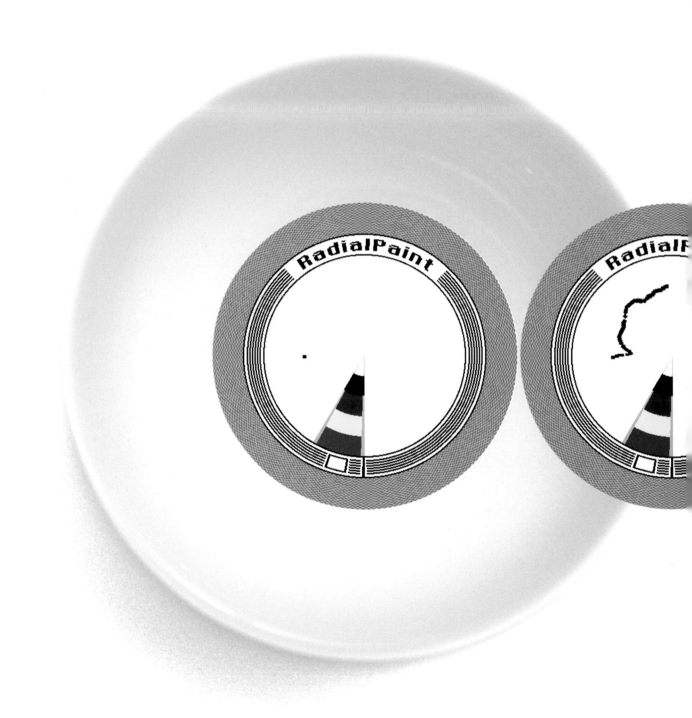

The monitor we use is rectangular, the pixels that fill its space are also rectangular, the windows that tile our interface, its buttons, sliders, and controls are all rectangular. All programs are written with this basic assumption of rectangularity. To break free from any implicit visual restraint requires the maturity to recognize, together with the training to neutralize, predisposition to synthetic conventions.

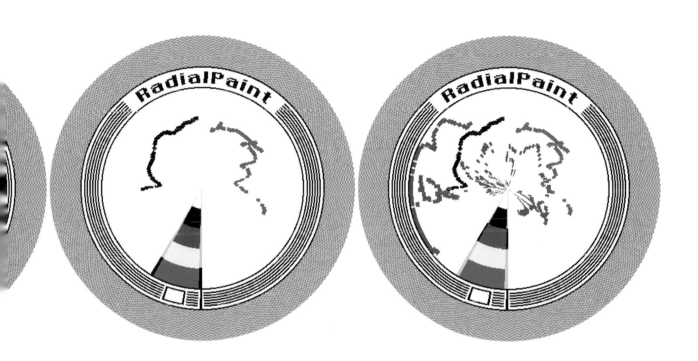

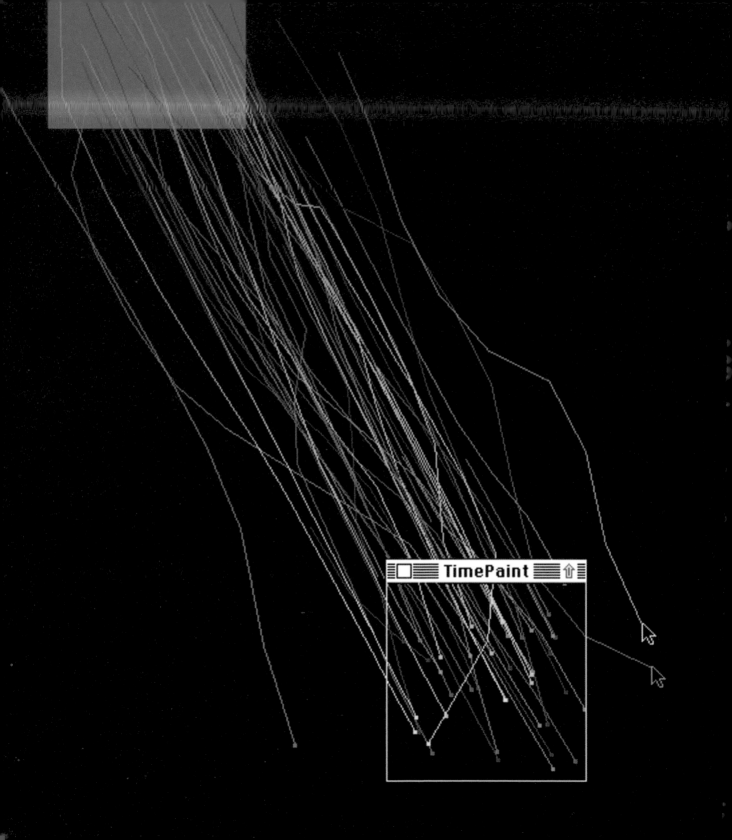

We usually think of a stroke of digital ink as nothing more than a mark left in space. When its true identity is revealed as a path not only through space but also through time, its sculptural, space-time qualities can be revealed, as visualized in this project to paint time.

My children's growing curiosity in the computer was the impetus for a wide variety of basic constructions such as a series of digital pinwheels.

The continually increasing processing power of the average computing machine incites our need to maximize its usage at all times. Sadly, this prevents our common sense from stepping in to allow more passive instincts, like finesse and simplicity, to dominate an expression.

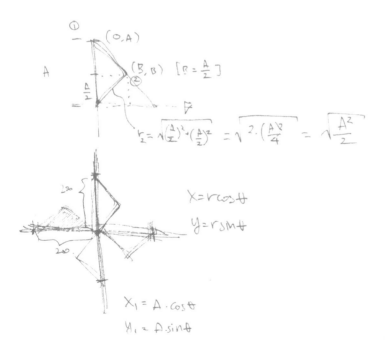

$$r_2 = \sqrt{\left(\frac{A}{2}\right)^2 + \left(\frac{A}{2}\right)^2} = \sqrt{2 \cdot \left(\frac{A^2}{4}\right)} = \sqrt{\frac{A^2}{2}}$$

$$x = r\cos\theta$$

$$y = r\sin\theta$$

$$x_1 = A \cdot \cos\theta$$

$$y_1 = A \cdot \sin\theta$$

$$x_2 = r_2 \cos\theta = \frac{A}{\sqrt{2}} \cos(\theta - 45°)$$

$$y_2 = r_2 \sin\theta = \frac{A}{\sqrt{2}} \sin(\theta - 45°)$$

$$x_3 = 0$$

$$y_3 = 0.$$

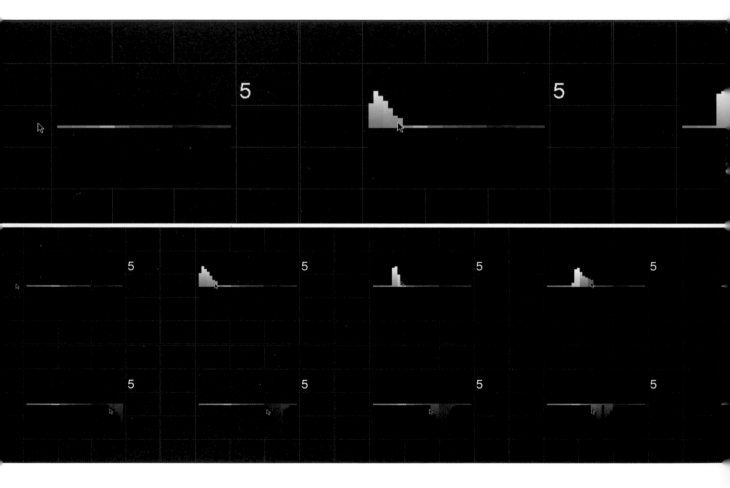

A reaction that incorporates a "tail" of some form, whether it be comet-like or a more abstract propagation of a wave, has the effect of reinforcing a false reality. You become privy to a completely synthetic world and appreciate cues from a realm you already know, even if it is faked.

A reactive color bar reaches upwards to
white or downwards to black as the
cursor strums its top or bottom surfaces.

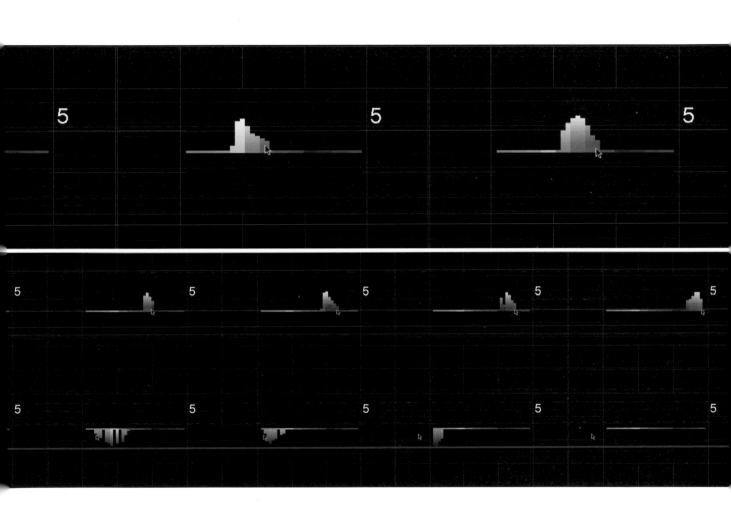

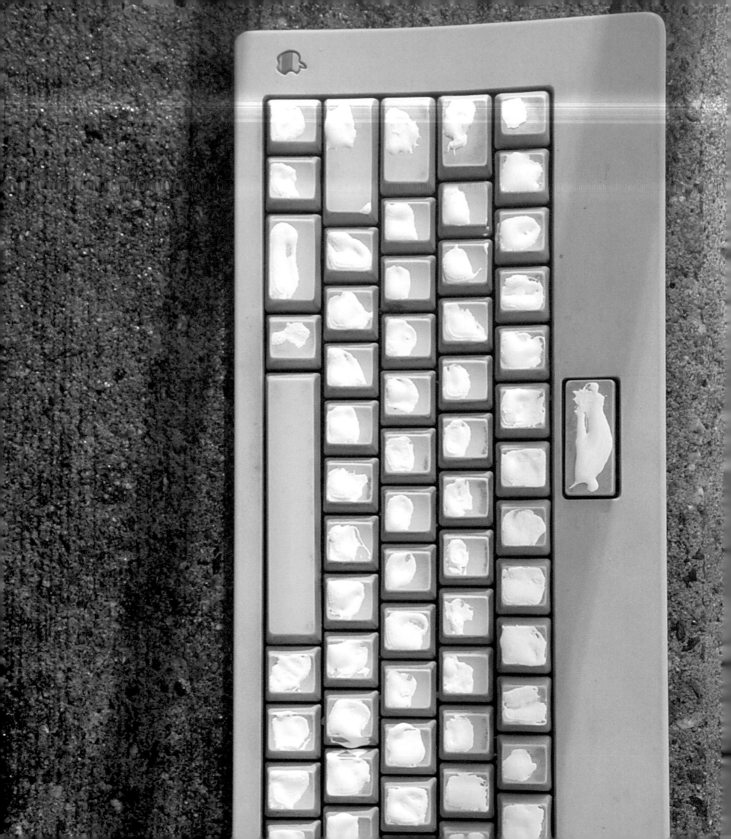

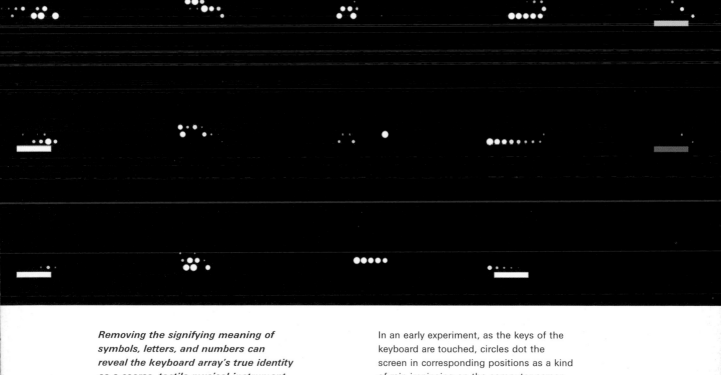

Removing the signifying meaning of symbols, letters, and numbers can reveal the keyboard array's true identity as a coarse, tactile musical instrument.

In an early experiment, as the keys of the keyboard are touched, circles dot the screen in corresponding positions as a kind of rain impinging on the computer screen.

キーボード　マウス　マイク　ビデオモニタ

The average computer has four sensory inputs: keyboard, mouse, mike, and camera. Humans have five: touch, taste, smell, sight, and hearing. In both cases a set of human experiences and motivations guide the interpretation and processing of an output.

Reorganization of input video imagery processed in real time.

Three variations on a cross form and its inter-
action with the progression of time.

The common thread to all reactive
graphic systems is the condition
of time. Time can be perceived in
one of two ways: as a natural
precondition for reality or as a state
measurable with respect to some
specific reference.

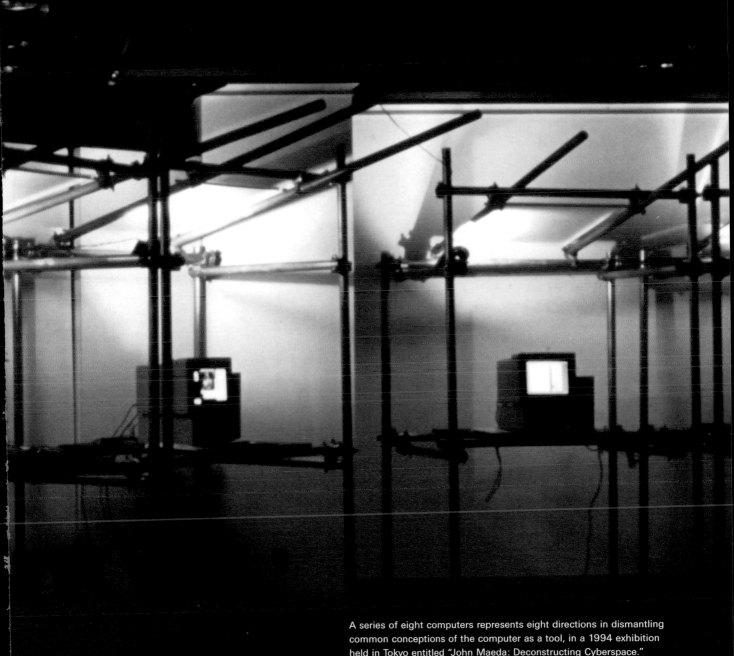

A series of eight computers represents eight directions in dismantling
common conceptions of the computer as a tool, in a 1994 exhibition
held in Tokyo entitled "John Maeda: Deconstructing Cyberspace."

Reactive Books began as an idea to reconcile print media with digital media. The emphasis was to bring together high-quality printing with high-quality digital design, constructed in a single vision by a single person. The first book was *The Reactive Square* (1995). →

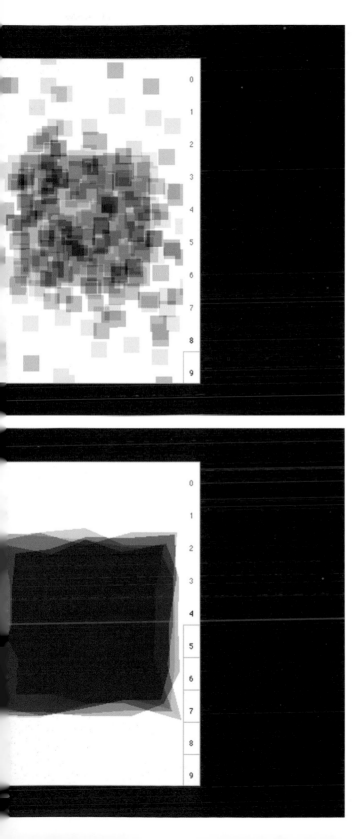

Influenced by the early Russian suprematist Kazimir Malevich, I originally wanted to title this book *Ode to Malevich*. His courage to abandon all decoration in pursuit of the simplest of forms, such as a single square, inspired my thinking about black squares that would exist only on the computer. The medium of the computer could allow tremendous potential as a starting point, but I was not sure in what manner and mode these squares should be interactive.

Not long before the conception of this project, my second child was born. I saw my children growing up in a world filled with computers and their awkward mechanics. I wanted my children to use computers, not by wrestling with the mouse and keyboard, but by simply talking or singing to elicit a reaction from the computer. The input method for *The Reactive Square* thus became the standard, oft-ignored Macintosh microphone, typically buried in a drawer with other useless cables. Viewers could talk to *The Reactive Square*, and it would react accordingly. →

The printed form of *The Reactive Square* was designed as a tactile experience, featuring ten pages with die-cut tabs and using richly textured materials. The accompanying floppy emblazoned with the Digitalogue logomark emphasized two points: the disparity between the sensual experience of paper and the manmade clunkiness of the plastic floppy disk; and that even a small data receptacle, such as a floppy disk compared to a CD-ROM, could hold a wealth of visual information. →

John Maeda

The Reactive Square

DIGITALOGUE

ディスクをケースの後ろからそっと押し出してください。

をコンピュータに装着し、The Reactive Squareを起動してください。

ッピーディスクを装着した状態でないと起動しませんのでご注意ください。

軽起動したら、マイクに向かってなにか喋ってください。

画面の本の見出し数字をクリックすれば他のページを見ることができます。

5. EXITボタンをクリックするかコマンドQを押すと終了します。

6. モニタを256色表示に切り替えるとより速く動きます。

Instructions for using Floppy

1. Remove floppy disk from paper holder.

2. Insert floppy and open "The Reactive Square".
 This application will only run when opened from the floppy disk.

3. If no error has occured, speak freely into the microphone.
 Pages can be browsed by clicking on the graphic page tab, or by
 putting a number from the keyboard or keypad.

 the EXIT button on screen or Command Q from the
 will quit the application.

 to 256 colors for best performance.

A computer program is a utilitarian typographer's dream—a functioning machine composed completely of type.

```
#define NPAGES 10 // number of pages  int gsndtypewritergridval = 32; extern int gErr; int gNRINGS = NRINGS;  void TOde2Malevich::InitOde2Malevich(void) { c_sndavailp = OpenSoundInput(); if (!c_sndavailp) gErr = -2; // means sound
cannot be opened if (rectW(cb)<600) { gNRINGS = 14; gsndtypewritergridval = 20; }  c_birthtime = TickCount(); c_drawcalledp = 0; c_unity = c_rooth(NPAGES+2); c_pageh = c_unity*NPAGES; c_pagew =
(int)((float)c_pageh/1.414); c_pageorgx = (c_rootw-c_pagew)/2 + c_bounds.left; c_pageorgy = (c_rooth-c_pageh)/2 + c_bounds.top; c_indexw = c_unity/2; } int dy = c_pageh-c_pagew; int sqdim = c_pageh-2*dy; int dx = (c_pagew-sqdim)/2;
SetRectWH(&c_sqr,c_pageorgx+dx,c_pageorgy+dy, sqdim,sqdim); c_sqdim = sqdim; g_oderect = c_sqr; InsetRect(&g_oderect,-sqdim/4,-sqdim/4); } SetRectWH(&c_pagearea,c_pageorgx+c_pagew-c_indexw,
c_pageorgy+c_pageh); SetRectWH(&c_pager,c_pageorgx,c_pageorgy,c_pagew-c_indexw,c_pageh); c_pagearea = c_pager; InsetRect(&c_pagearea,1,1); SetRectWH(&c_pageorgx,c_pageorgy,c_pageorgy,c_pagew, c_pageorgy+c_pageh);
c_just_switchedp=1; c_destpage = -1; InitInternalParameters(); } c_exitr = c_bounds; c_exitr.bottom-- ; c_exitr.left = c_exitr.right-64; c_exitr.top = c_exitr.bottom-16; }  void TOde2Malevich::InitInternalParameters(void) { int i; c_lasttick =
gsndtypewritergridval; c_cursgridx = gsndtypewritergridval;

(c_cursdimy*c_cursdimy)/2; SetRectWH(&c_cursbds,c_cursorg.h-1c_cursorg.v )c_cursdimx*c_cursdimy*c_cursdimy*c_cursdimy*c_cursgridx # c_....for......
c_psize,c_sqorg.v-c_psize*3,c_psize*3); c_ringvals(i)=0; for(i = 1; i < gNRINGS; i++) { c_ringr[i] = c_ringr[i-1]; InsetRect(&c_ringr[i],-c_psize,-c_psize); c_ringvals(i)=0. } c_ringr(i).right =-2; c_ringr(i).bottom=-2; for(i=1;i-gNRINGS;i
c_ringr[i].right=c_ringr[i].right; c_ringr[i].right=c_ringr[i].bottom=c_ringr[i].bottom-c_psize; } // for quadrigraph c_topr = c_botr = c_leftr = c_sqr; c_botr.top=c_botr.bottom-c_a; c_topr.bottom=c_topr.top+c_a; c_leftr.right=c__leftr.right+c_a;
c_rightr.left= c_leftr.left+c_a; c_dx = 2; // for pixel wind c_windsubdiv = 8; c_windsize = c_sqdim/c_windsubdiv; c_windorg.h = c_sqr.left+(c_sqdim-c_windsize*c_windsubdiv)/2 c_windorg.v = c_sqr.top+(c_sqdim-c_windsize*c_windsubdiv
for lace doily c_lacedivs = 12;//3; c_lacedim = c_sqdim/c_lacedivs; c_lacemods = c_lacedivs-1; SetRectWH(&c_sqr,left+(c_sqdim-c_lacedivs*c_lacedim)/2, c_sqr.top+(c_sqdim-c_lacedivs*c_lacedim)/2, c_lacedivs*c_lacedim,
c_lacedivs*c_lacedim); c_laceinr = c_laceoutr; InsetRect(&c_laceinr,c_lacedim,c_lacedim); //c_laceoutr.bottom++; //c_laceout.top--; //c_laceinr.bottom++; //c_laceinr.right++; c_lacedeg = 0; // for vortex #ifdef powerc c_vortexdivs = 9;//7;
c_vortexloops = 4;//3; #endif #ifndef powerc c_vortexdivs =7; c_vortexloops = 3; #endif c_vortexdim = c_sqdim/c_vortexdivs; c_vortexdivs*c_vortexdim; SetRectWH(&c_vortexr, c_sqdim-c_vortexdim*c_vortexdivs/2, c_sqr.top+(c_sqdim-
c_vortexdim*c_vortexdivs/2, c_vortexdim*c_vortexdivs,c_vortexdim*c_vortexdivs); }  void TOde2Malevich::Switch2Page(int pagenum) { int i; int j; long t; if (gErr) return; if(c_curpagenum == pagenum) { // do nothing if (pagenum != 5)
Idle();//AnimatedDraw(); else DrawPage(8); } return; } else { c_curpagenum = pagenum; c_just_switchedp = 1 ; InitInternalParameters(); Draw(); //AnimatedDraw(); } #include "Controller.h"  void
TOde2Malevich::MouseDown(Point pt) { int pagenum; if (PtInRect(pt,&c_sqr)&&commandKeyP()) { RecalcMinsoundval(); return; } if (PtInRect(pt,&c_indexr)) { pagenum = (pt.v-c_indexr.top)/c_unity; if (pagenum < 0) pagenum = 0; if (pago
>= NPAGES) pagenum = NPAGES-1; Switch2Page(pagenum); } else if (PtInRect(pt,&c_exitr)) { for(;;){ ......ForeColor(whiteColor)  FrameRect(&r);   if (!insidep) {.... if(Button()) { GetMouse(&pt); if
(PtInRect(pt,&c_exitr) && !insidep) insidep = 1; ForeColor(whiteColor); FrameRect(&r); } else if (!PtInRect(pt,c_exitr && insidep) { insidep = 0; ForeColor(blackColor); FrameRect(&r); } } if (!insidep) { .....   ExitToShell(); } } } } void
SysBeep(0);'; } void TOde2Malevich::DrawPageCollar(void) { int indexy; ForeColor(blackColor); PaintRect(&c_bounds); ForeColor(whiteColor); PaintRect(&c_pagebounds); indexy = c_indexr.top+(c_curpagenum
!=NPAGES-1) { int j, y = indexy+c_unity; RGBForeColor(&gray50); MoveTo(c_indexr.right-1,y-c_unity); LineTo(c_indexr.left,y-c_unity); LineTo(c_indexr.left, c_indexr.bottom-1); PenPat(&qd.gray); RGBForeColor(&gray50); MoveTo(c_indexr.
1,y-c_unity+1); LineTo(c_indexr.left+1,y-c_unity+1); LineTo(c_indexr.left+1,c_indexr.bottom-1); PenPat(&qd.black); for(j = c_curpagenum+1; j < NPAGES-1, j++) { RGBForeColor(&gray75); MoveTo(c_indexr.left,y); LineTo(c_indexr.right-1,y);
PenPat(&qd.gray); RGBForeColor(&gray50); MoveTo(c_indexr.left+1,y+1); LineTo(c_indexr.right-1,y+1); y+=c_unity; PenPat(&qd.black); } y = indexy+c_unity; RGBForeColor(&gray75); MoveTo(c_indexr.right-1,y-c_unity); LineTo(c_indexr.right-1,c
c_unity); LineTo(c_indexr.left, c_indexr.bottom-1); PenPat(&qd.gray); RGBForeColor(&gray75); MoveTo(c_indexr.right-1,y-c_unity+1); LineTo(c_indexr.right-1,y-c_unity+1); LineTo(c_indexr.left,1,c_indexr.bottom-1); PenPat(&qd.black); } else
indexy = c_indexr.bottom-1; } // pseudo page numbers "| int j, Rect r; Str255 mystr; Rect r2; int indexh = c_indexw*2; //TextSize(9); TextSize(10); TextFont(21); // helvetica RGBForeColor(&gray75); SetRectWH(&r,c_indexr.left+3,
StringWidth("\p1"))/2,c_indexw*3/8, c_pager.top+(c_unity/2+8),//c_unity-c_indexw)/2-2, c_indexw/4,c_indexw/4); for(j = 0; j < c_curpagenum; j++) { MoveTo(r.left,r.top); NumToString(j,mystr); DrawString(mystr); OffsetRect(&r,0,c_unity); }
ForeColor(blackColor); MoveTo(r.left,r.top); NumToString(j,mystr); "if (j == c_destpage) { c_destinvr = r2; ForeColor(blackColor); } else { ForeColor(whiteColor);} else { PenMode(blend); OpColor(&gray75); PenMode(patCopy); c_lastp = p;
ForeColor(whiteColor); PenPat(&qd.black); "} DrawString(mystr); OffsetRect(&r,0,c_unity); }RGBForeColor(&gray75); for(j = c_curpagenum+1; j < NPAGES; j++) { MoveTo'r.left,r.top); NumToString(j,mystr);   DrawString(mystr);
OffsetRect(&r,0,c_unity); }}  #define SPIREBEGIN poly = OpenPoly(); MoveTo(0,0) #define SPIREEND ClosePoly(); PaintPoly(poly); KillPoly(poly); #define L(x,y) LineTo(x,y) //#define MYR(mymax) ((long)(Random))/32767
//#define MYPR(mymax) (((long)(Random))+32755)*(long)(mymax)/65535L) #define PMOVETO(x,y,p) MoveTo(x + MYR(p), y + MYR(p)) #define PLINETO(x,y,p) LineTo(x + MYR(p), y + MYR(p)) #define PMOVETO2(x,y,p) MoveTo(x + MYP
y + MYPR(p)) #define PLINETO2(x,y,p) LineTo(x + MYPR(p), y + MYPR(p)) extern RgnHandle rootScrRgn1;  void TOde2Malevich::DrawPage0(long val) { long maxperturb = c_sqdim/4; PolyHandle poly;  ForeColor(whiteColor);
PaintRect(&c_pagearea); poly = OpenPoly(); ForeColor(blackColor); maxperturb = maxperturb * (long/val/SNDRANGE. PMOVETO(c_sqr.left,c_sqr.top,maxperturb); PLINETO(c_sqr.right,c_sqr.top,maxperturb); PLINETO(c_sqr.right-
1,c_sqr.bottom-1,maxperturb); PLINETO(c_sqr.left,c_sqr.bottom-1,maxperturb); ClosePoly(); PaintPoly(poly); KillPoly(poly); } void TOde2Malevich::DrawPage2(long val) // concentric rects  long maxperturb=255; int i; RGBColor col; if
(c_just_switchedp) { ForeColor(whiteColor); PaintRect(&c_pagearea); } maxperturb = maxperturb*(long/val/SNDRANGE; BlockMove(&c_ringvals[0],&c_ringvals[1],sizeof(int)*(gNRINGS-1)); c_ringvals[0] = maxperturb; ForeColor(blackColo
PenSize(c_psize,c_psize); if (rootDepth == 1) { for(i=0;i<gNRINGS,i++) { if (c_ringvals[i] > 204) PenPat(&qd.white); else if (c_ringvals[i] < 102) PenPat(&qd.black); else if (c_ringvals[i] < 153)
PenPat(&qd.gray); else PenPat(&qd.ltGray); if (i) FrameRect(&c_ringr[i]); else PaintRect(&c_ringr[i]); } PenPat(&qd.black); } else { for(i=0;i<gNRINGS,i++) { col.red=col.green=col.blue=c_ringvals[i]<<8; RGBForeColor(&col); if (i)
FrameRect(&c_ringr[i]); else PaintRect(&c_ringr[i]); } } PenSize(1,1); } void TOde2Malevich::DrawPage2(long val) { // square interchanged with 50% blend red long maxperturb = c_sqdim*1.414/2; Rect r; Rect r2; long newp; long p;
ForeColor(whiteColor); PaintRect(&c_pagearea); newp = maxperturb*(long/val/SNDRANGE. #ifdef powerc if (c_lastp < newp) p = c_lastp + 2; else p = c_lastp - 2; if (p < 0) p = 0; if (p > maxperturb) p = maxperturb. #else if (c_lastp < newp
c_lastp + 2; else p = c_lastp - 2; if (p < 0) p = 0; if (p > maxperturb) p = maxperturb; #endif r = r2 = c_sqr; InsetRect(&c_sqdim/2,c_sqdim/2); InsetRect(&r,-p,-p); InsetRect(&r2,p,p); ForeColor(whiteColor); PaintRect(&r2); if (rootDepth ==
PenMode(patXor); ForeColor(blackColor); } else { PenMode(blend); OpColor(&gray75); PenMode(redColor); } PaintOval(&r); ForeColor(blackColor); PenMode(patCopy); c_lastp = p; } void TOde2Malevich::DrawPage3(long val) { // foresectioend sq
// NOTES // this has to be animated (i.e. squares depart from original // in an orderly manner) perhaps... dunno yet int i, j; Rect r,r2; long gvalmax,gval; long maxperturb = c_sqdim(2;//subdiv*3; int x, y, rn1, rn2; ForeColor(whiteColor);
PaintRect(&c_pagearea); maxperturb = maxperturb * (long/val/SNDRANGE; PenSize(c_windsize,c_windsize); rn1 = MYR(maxperturb); for(i = 0, y = c_windorg.v; i < c_windsubdiv; i++,y+=c_windsize) { for(i = 0, x
c_windorg.h; i < c_windsubdiv; i++,x+=c_windslzu) { (m2 – MYR(maxperturb); MoveTo(x+rn1,y+rn2);//MYR(maxperturb),v+MYR(maxperturb); rn1 = rn2. Line(0,0); } } PenSize(1,1); }  void TOde2Malevich::DrawPage4(long val) { // VORTE
loops; int k=0, dim=c_vortexdim, n=c_vortexloops*2+1; int ox = c_vortexr.left,oy = c_vortexr.top; long maxperturb=dim;//2; Rect r; RGBColor col; if (c_just_switchedp) { ForeColor(whiteColor); PaintRect(&c_pagearea); ForeColor(blackColo
PaintRect(&c_vortexr); } else { c_vortexr; maxperturb = maxperturb*(long/val/SNDRANGE; for(loops = 0; loops < c_vortexloops; loops++) { if (loops) SetRectWH(&r,ox+(k-1)*dim,oy+k*dim, (n+1)*dim,dim); } else { // first loop
SetRectWH(&r,ox+(k)*dim,oy+k*dim, (n)*dim,dim); } ScrollRect(&r,-dim,0,rootScrRgn1); if (loops != c_vortexloops) SetRectWH(&r,ox+(k+n-1)*dim,oy+(k)*dim, dim,(n)*dim); } ScrollRect(&r,0,-dim,rootScrRgn1);
SetRectWH(&r,ox+k*dim,oy+(k+n-1)*dim, (n)*dim,dim); } ScrollRect(&r,dim,0,rootScrRgn1); if (loops != c_vortexloops) SetRectWH(&r,ox+k*dim,oy+(k+1)*dim, dim,(n-1)*dim); } ScrollRect(&r,0,dim,rootScrRgn1); } n-=2; k++; } ForeColor(blackColor);
col.green=col.blue=col.red=(long)(val)<<8; RGBForeColor(&col); PenSize(maxperturb,maxperturb); ForeColor(whiteColor); MoveTo(r.left,r.top); Line(dim-maxperturb,dim-maxperturb); PenSize(1,1); } void
TOde2Malevich::DrawPage5(long val) { // snd typewriter  | Rect r; long maxperturb = 255L; RGBColor col; if (c_just_switchedp) { ForeColor(whiteColor); PaintRect(&c_pagearea); ForeColor(blackColor); Rect br;
c_bltr = c_cursbds; SetRectWH(&c_cursorg.h+c_curs.h*c_cursdimx, c_cursorg.v+c_curs.v*c_cursdimy, c_cursdimx,1,c_cursdimy-1); maxperturb = maxperturb*(long/val/SNDRANGE; if (rootDepth == 1) { if (maxperturb > 204)
PenPat(&qd.white); else if (maxperturb < 51) PenPat(&qd.black); else if (maxperturb < 102) PenPat(&qd.dkGray); else if (maxperturb < 153) PenPat(&qd.gray); else PenPat(&qd.ltGray); PaintRect(&r); } else { // cursor stuff removed for timing reasons if
(TickCount()-c_curstime>(10L+c_cursphase*0L)) { if (c_cursphase==0) { c_cursphase = 1; ForeColor(whiteColor); } else { c_cursphase = 0; ForeColor(blackColor); } c_curstime = TickCount(); } } else { // c_curstime  } else { PaintRe
(c_curs.h)++; } if (c_curs.h==c_cursgridx) { c_curs.h=0; (c_curs.v)++; if (c_curs.v == c_cursgridy) { c_curs.v=0; } if (rootDepth == 1) { PenMode(patOr); PenPat(&qd.bkGray); PaintRect(&r); } else { PenMode(patCopy); PenPat(&qd.black); }
PenMode(blend); OpColor(&gray75); ForeColor(blackColor); PaintRect(&c_cursbds); PenMode(patCopy); } } if (val) SetRectWH(&c_cursorg.h+c_curs.h*c_cursdimx,c_cursorg.v+c_curs.v*c_cursdimy, c_cursdimx-1,c_cursdimy-1);
ForeColor(whiteColor); //FrameRect(&r); PaintOval(&r); } PenPat(&qd.black); }  void TOde2Malevich::DrawPage6(long val) { // lace doily if (c_just_switchedp) { ForeColor(whiteColor); PaintRect(&c_pagearea); ForeColor(blackColor);
PaintRect(&c_laceoutr); } else { c_bltr = c_laceoutr; Rect r; long maxperturb = c_lacedim/2+2; int i,j; Rect r1,r2; int starta1,starta2,enda1,enda2; int startangle*(long/val/SNDRANGE; } shift the stuff;
rootGw->CopyTo(&c_laceoutr,&c_laceinr,0L); //InsetRect(&r,1,1); rootGw->CopyFrom(&c_laceoutr,&c_laceinr,0L); // //CopyBits((BitMap *)&(qd.thePort)->portBits, ((BitMap *)&(qd.thePort)->portBits, //&c_laceout,&c_laceinr,srcCopy,0L); // }
across top & bottom |*ForeColor(blueColor); PaintRect(&c_pagearea); ForeColor(greenColor); PaintRect(&c_laceinr); return;*/ ForeColor(whiteColor); r = c_laceoutr; r.bottom=r.top+c_lacedim; PaintRect(&r); r.bottom = c_laceout.bottom;
r.top=r.bottom-c_lacedim; PaintRect(&r); r.top = c_laceout.top; r.right=r.left+c_lacedim; PaintRect(&r); r.right=c_laceout.right; r.left=r.right-c_lacedim; PaintRect(&r); SetRectWH(&r1,c_laceout.left,c_laceout.top,c_lacedim,c_lacedim);
SetRectWH(&r2,c_laceout.left,c_laceout.bottom-c_lacedim,c_lacedim,c_lacedim); PaintRect(&r1,maxperturb,0); PaintRect(&r); ForeColor(blackColor); PaintRect(&r1,maxperturb,0); for(i=0;i<c_lacedivs;i++) { PaintRect(&r1); PaintRect(&r2);
OffsetRect(&r1,c_lacedim,0); OffsetRect(&r2,c_lacedim,0); } SetRectWH(&r1,c_laceout.left,c_laceout.top,c_lacedim,c_lacedim); SetRectWH(&r2,c_laceout.right-c_lacedim,c_laceout.top,c_lacedim,c_lacedim); InsetRect(&r1,0,maxperturb);
InsetRect(&r2,0,maxperturb); for(i=0;i<c_lacedivs;i++) { PaintRect(&r1); PaintRect(&r2); OffsetRect(&r1,0,c_lacedim); OffsetRect(&r2,0,c_lacedim); } } }  void TOde2Malevich::DrawPage7(long val) { // flash effect Rect bltr, srcr,r; int i,j; int my
= 8; int dim2 = c_sqdim/mydivs/2; int dim = dim2*2; long maxperturb=dim*5/4; Rect mybds; Rect r2; if (c_just_switchedp) { ForeColor(whiteColor); PaintRect(&c_pagearea); } maxperturb = maxperturb*(long/val/SNDRANGE.
SetRectWH(&mybds,c_sqr.left+(c_sqdim-dim*mydivs)/2,c_sqr.top+(c_sqdim-dim*mydivs)/2, dim*mydivs+1,dim*mydivs+1); PaintRect(&r); PaintRect(&r); ForeColor(blackColor); PaintRect(&mydivs); SetRectWH(&r,dim2-maxperturb/2,dim2-
maxperturb/2,maxperturb,maxperturb); OffsetRect(&r,mybds.left,mybds.top); for(i=0;i<mydivs;i++,OffsetRect(&r,0,dim)) { for(i=0;i<mydivs;i++,OffsetRect(&r,dim,0)) { PaintOval(&r); } } } }  void TOde2Malevich::DrawPage8(long val) { // stuttered spinner if (c_just_switchedp) { ForeColor(whiteColor); PaintRect(&c_pagearea); ForeColor(blackColor); PaintRect(&c_sqr); } else { c_bltr = c_sqr; if (rootDepth == 1) { Rect r; long
maxperturb=c_sqdim/2;//2; int shiftx; RGBColor col;  col.red=col.green=col.blue=(255L*(long)val/SNDRANGE)<<8;  maxperturb = maxperturb*(long/val/SNDRANGE;  shiftx = ((c_sqdim/16)*(long)val/SNDRANGE); if (shiftx == 0) shiftx = 1,
ScrollRect(&c_topr,shiftx,0,rootScrRgn1); r=c_topr; r.right=r.left+shiftx; r.bottom=r.top+maxperturb; ForeColor(whiteColor);PaintRect(&r); r.bottom = c_topr.bottom; ForeColor(blackColor);PaintRect(&r);
ScrollRect(&c_rightr,0,shiftx,rootScrRgn1); r=c_rightr; r.bottom=r.top+shiftx; r.left=r.right-maxperturb; ForeColor(whiteColor); PaintRect(&r); r.right=c_rightr.right; ForeColor(blackColor); PaintRect(&r);  ScrollRect(&c_botr,-
shiftx,0,rootScrRgn1); r=c_botr; r.left=r.right-shiftx; r.top=r.bottom-maxperturb; ForeColor(whiteColor); PaintRect(&r); r.bottom=r.top; r.top=c_botr.top; ForeColor(blackColor); PaintRect(&r); ScrollRect(&c_leftr,0,-shiftx,rootScrRgn1); r=c_lef
r.top=r.bottom-shiftx; r.right=r.left+maxperturb; ForeColor(whiteColor); PaintRect(&r); r.left=c_leftr.left; ForeColor(blackColor); PaintRect(&r); } else { Rect r; long maxperturb=c_sqdim/2;//2; int shiftx; RGBColor col;
col.red=col.green.col.blue=(255L*(long)val/SNDRANGE)<<8;  maxperturb = maxperturb*(long/val/SNDRANGE; shiftx = ((c_sqdim/16)*(long)val/SNDRANGE); if (shiftx == 0) shiftx = 1; ScrollRect(&c_topr,shiftx,0,rootScrRgn1); r=c_topr;
r.right=r.left+shiftx; r.bottom=r.top+maxperturb; ForeColor(blackColor);PaintRect(&r); r.top=r.bottom; r.bottom=c_topr.bottom; RGBForeColor(&col);PaintRect(&r); ScrollRect(&c_rightr,0,shiftx,rootScrRgn1); r=c_rightr; r.bottom=r.top+shift.
r.left=r.right-maxperturb; ForeColor(blackColor);PaintRect(&r); r.right=c_rightr.right; RGBForeColor(&col);PaintRect(&r); ScrollRect(&c_botr,-shiftx,0,rootScrRgn1); r=c_botr; r.left=r.right-shiftx; r.top=r.bottom-maxperturb;
ForeColor(blackColor);PaintRect(&r); r.bottom=r.top; r.top=c_botr.top; RGBForeColor(&col);PaintRect(&r); ScrollRect(&c_leftr,0,-shiftx,rootScrRgn1); r=c_leftr; r.top=r.bottom-shiftx; r.right=r.left+maxperturb; ForeColor(blackColor);PaintRe
r.left=r.right; r.right=c_leftr.right; RGBForeColor(&col);PaintRect(&r); } } }  void TOde2Malevich::DrawPage9(long val) { // jello pyramid long newb; long maxperturb = c_a/4; int i; short b,b2, c, c2; PolyHandle poly; short db = c_a/32; RGBCol
ForeColor(whiteColor); PaintRect(&c_pagearea); ForeColor(blackColor); BlockMove(&c_b[0],&c_b[1],15*sizeof(short)); maxperturb = maxperturb*(long)val/SNDRANGE+c_a; c_b[0] = maxperturb; if (1) { int i = 0; c_b[0] - c_b[15]; c_b[0] =
(d/2); } #ifdef BLAH if (c_b[1] == maxperturb) c_b[0] = c_b[1]; else if (c_b[1] > maxperturb) c_b[0] = c_b[1]-db; else c_b[0] = c_b[1]+db; if (c_b[0] < 3*c_a/2) c_b[0] = 3*c_a/2; // check to see if c_b[15] is not too much out of range if (0) { i
c_b[0] - c_b[15]; c_b[0] -= (d/4); } #endif SetOrigin(-c_sqorg.h,-c_sqorg.v); for(i = 0; i < 16, i++) { b = c_b[i]; if (i == 15) c = c_b[0]; else c = c_b[i+1]; b2 = b>>1; c2 = c>>1; if (rootDepth == 1) { long val = ((b-c_a)*4*255L/maxperturb); if (val
204) PenPat(&qd.white); else if (val < 51) PenPat(&qd.black); else if (val < 102) PenPat(&qd.dkGray); else if (val < 153) PenPat(&qd.gray); else PenPat(&qd.ltGray); ForeColor(blackColor); } else { col.red=col.green=((b-c_a)*4*255L/maxperturb)<<8;
col.green=col.blue=0L; RGBForeColor(&col); } switch(i) { case 0: SPIREBEGIN; L(b,-b); L(c2,-c); SPIREEND; break; case 1: SPIREBEGIN; L(b2,-b); L(c,-c); SPIREEND; break; case 2: SPIREBEGIN; L(b,-b); L(c,-c2); SPIREEND; break; case 3:
SPIREBEGIN; L(b,-b2); L(c,0); SPIREEND; break; case 4: SPIREBEGIN; L(b,0); L(c,c2); SPIREEND; break; case 5: SPIREBEGIN; L(b,b2); L(c,c); SPIREEND; break; case 6: SPIREBEGIN; L(b,b); L(c2,c); SPIREEND; break; case 7: SPIREBEGIN;
L(b2,b); L(0,c); SPIREEND; break; case 8: SPIREBEGIN; L(0,b); L(-c2,c); SPIREEND; break; case 10: SPIREBEGIN; L(-b,b); L(-c,c2); SPIREEND; break; case 11: SPIREBEGIN; L(-b,b2);
SPIREEND; break; case 12: SPIREBEGIN; L(-b,0); L(-c,-c/2); SPIREEND; break; case 13: SPIREBEGIN; L(-b,-b2); L(-c,-c); SPIREEND; break; case 14: SPIREBEGIN; L(-b,-b); L(-c2,-c); SPIREEND; break; case 15: SPIREBEGIN; L(-b2,-b); L(0,-c);
SPIREEND; break; default: break; } } SetOrigin(0,0); }  void TOde2Malevich::DrawPage(int num) { long val = GetSoundInput();  if (val < MINSOUNDVAL) { val = 0; } else { val = (val - MINSOUNDVAL); }  c_bltr = c_pagearea; switch(num) { c
DrawPage0(val); break; case 7: DrawPage2(val); break; case 2: DrawPage3(val); break; case 3: DrawPage3(val); break; case 6: DrawPage6(val); break; case 5: DrawPage5(val); break; case 3: DrawPage
break; case 4: DrawPage4(val); break; case 9: DrawPage9(val); break; default: break; } c_just_switchedp = 0; } // gave everyone a chance }  void TOde2Malevich::AnimatedDraw(void) { rootGw->LockFocus(); if (c_sndavailp) {
DrawPage(c_curpagenum); } rootGw->UnlockFocus(); rootGw->CopyFrom(&c_bltr,&c_bltr,0L); }  void TOde2Malevich::Draw(void) { if (gErr) { c_drawcalledp = 1; rootGw->LockFocus(); DrawPageCollar(); rootGw->UnlockFo
rootGw->CopyFrom(&c_bounds,&c_bounds,0L); } if (rootDepth == 1) { ForeColor(blackColor); PaintRect(&c_exitr); ForeColor(whiteColor); Helvetica(10); //TextMode(srcBic); MoveTo(c_exitr.left+2,c_exitr.bottom-4); DrawString("\pEXIT
TextMode(srcCopy); } else { ForeColor(redColor); PaintRect(&c_exitr); ForeColor(blackColor); Helvetica(10); MoveTo(c_exitr.left+2,c_exitr.bottom-4); DrawString("\pEXIT"); } } #ifdef powerc long mywaits[10] = {0,1,0,1,0,1,0,0,0,2}; //else lon
mywaits[10] = {0,0,0,0,0,0,0,0,0,1}; #endif  void TOde2Malevich::Idle(void) { if (gErr) { StringPtr s; long now = TickCount(); switch(gErr) { case -1 : s = "\pError: Not enough memory. Please restart or increase memory."; break; case -2 : s =
"\pError: Cannot open sound input. Does not support microphone."; break; case -3: s = "\pError: Not opened from floppy."; break; case -4: s = "\pError: Requires System 7.1 or later."; break; default: s = "\pUnknown error"; break; } Helvetic
if (rootDepth == 1) { ForeColor(blackColor); TextMode(srcBic); //TextMode(srcXor); MoveTo((rectW(c_bounds)-StringWidth(s))/2+c_bounds.left, rectH(c_bounds)/2+8+c_bounds.top); DrawString(s); TextMode(srcCopy); now = TickCount();
//while(TickCount()-now < 5L); } else TextMode(srcXor); MoveTo((rectW(c_bounds)-StringWidth(s))/2+c_bounds.left, rectH(c_bounds)/2+8+c_bounds.top); DrawString(s); } *while(TickCount()-now<20L); ForeColor(whiteColor);
MoveTo((rectW(c_bounds)-StringWidth(s))/2+c_bounds.left, rectH(c_bounds)/2+8+c_bounds.top); DrawString(s); now = TickCount(); while(TickCount()-now<10L);"/ return; } if (c_brandnewp&&c_drawcalledp) { int i; long ticks. now =
TickCount(); RGBColor color  AnimatedDraw(); Helvetica(10); TextMode(srcBic); MoveTo(c_exitr.left+2,c_exitr.bottom-4); DrawString("\pCopyright © 1995 John Maeda, DIGITALOGUE Co., Ltd."); while(TickCount()-now < 120L}
AnimatedDraw(); if (1) { //TickCount()-c_birthtime > 2L*60L) { for(i = 255; i >=0; i-=15) { color.red=color.green=color.blue = (unsigned long)(i)<<8; RGBForeColor(&color); MoveTo(c_bounds.left+2,c_exitr.bottom-4); DrawString("\pCopyrigh
1995 John Maeda, DIGITALOGUE Co., Ltd."); } AnimatedDraw(); now = TickCount(); while(TickCount()-now < 1L); } ForeColor(blackColor); MoveTo(c_bounds.left+2,c_exitr.bottom-4); DrawString("\pCopyright © 1995 John Maeda, DIGITA
Co., Ltd."); } c_brandnewp = 0; } } if (c_curpagenum != 5) { if (TickCount()-c_lasttick >= mywaits[c_curpagenum]) { if (c_sndavailp) AnimatedDraw(); c_lasttick = TickCount(); } } else { if (TickCount()-c_lasttick > mywaits[c_curpagenum]) { if
(c_sndavailp) DrawPage(5); c_lasttick = TickCount(); } } }
```

$$= (d2)^2 + (d2)^2 + (d2)^2 + (d2)^2 + (d2)^2$$

$$(5d2^2) = \boxed{\sqrt{5} \cdot d2}$$

2.2361

$$\theta_{start} = atan \cdot \frac{d}{d_2} = \frac{2 \, d2 \cdot d}{d_2}$$

2.

4.2487

−1.1071

#2. 1.1071 Rad

#define NRINGS 12.

1.1071

int vals [12],
int i;
Rect ring rings [12],

...).
ox − psize, oy + ring psize ×2, psize ×2);
(12; i++) {
r[i],

rect (r[i], −psize, psize);
fill (r[i], −psize, psize);

2.0344 Rad

1.1071

blockmove Rurls (0) Rurls [i], sro + Crn) × NRurls −);
vals [5] → curral;
fill (psize, psize);
for (i=0; i < 12; i++) {
col.r = a, i=col. L Rurl [i] × muprul ;

U = cot + col / 5 (float /
system (U)

if (i) {
int }. fromRurls[i]5
the Rurls (~)}
θ = θstart + prul3
X = r · cos θ
y = r · sin t.

$$X = (2.2361 \cdot (float)\, d2) \cdot cos\, \theta$$
$$y = (2.2361 \cdot (float)\, d2) \cdot sin\, \theta$$

I later began an abstract series of
typographic marionettes, where
cursor motion is linked to a chain of
letters, in this case the "Tokyo Type
Director's Club."

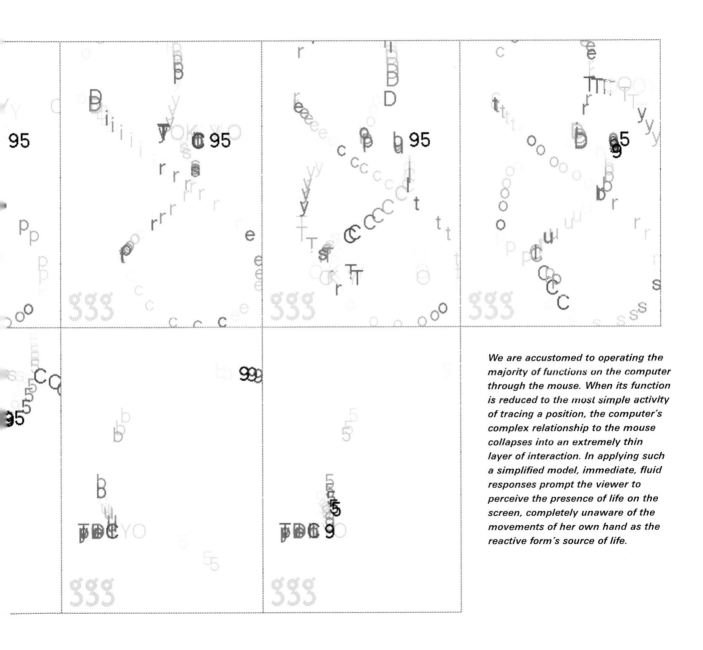

We are accustomed to operating the majority of functions on the computer through the mouse. When its function is reduced to the most simple activity of tracing a position, the computer's complex relationship to the mouse collapses into an extremely thin layer of interaction. In applying such a simplified model, immediate, fluid responses prompt the viewer to perceive the presence of life on the screen, completely unaware of the movements of her own hand as the reactive form's source of life.

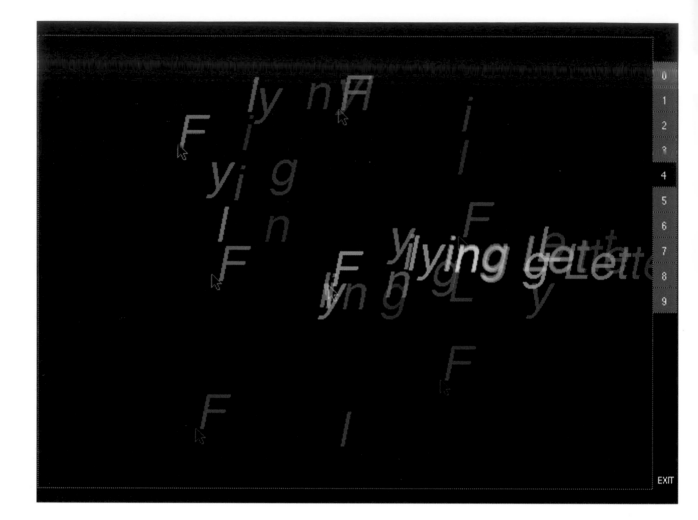

The completely abstract nature of *The Reactive Square* puzzled many viewers. As a break from the stoicism of geometric space, I chose to play with kinetic type. The result is *Flying Letters,* a collection of ten typographically motivated reactive graphics rendered in monochrome with an accompanying short story about my childhood experience with letters that fly. →

close to you.

0
1
2
3
4
5
6
7
8
9

EXIT

Typographic themes are always immediately endearing because, when draped over even the most abstract of ideas, they appear to make sense from nothing. We are trained from a young age to read and write letterforms and thus feel a deep intellectual attachment to text. The composition of a work involving kinetic typography is best measured by mentally replacing all traces of text with similarly sized moving blobs. Usually the resulting animation, devoid of all of its semantic camouflage, can be of the most offensive quality.

same as , insert here ≠

0x0141
0x1000

// LINKURZKEYS.
CLRTOP(y) { (y) = (y)&0x7F; }
SETTOP(y) { (y) = (y)|0x80; }
RIGHTSHIFT 0X3C // check FIRST
CLRTOP(y) {(y)&0x7F}
LEFTSHIFT 0X38 // covers both shift keys.

u <ctype.h>
MW:: Do SHIFTKEY (void)

nsigned char km [16];

unsigned short k;
Boolean leftp = 0, rightp = 0;
tKeys ((long *)km);
int level, i;
if ((KM [RIGHTSHIFT >>3] >> (RIGHTSHIFT &7)) &1)
 rightp = 1;
else if ((km [LEFTSHIFT >>3] >> (LEFTSHIFT &7)) &1)
 leftp = 1;

// draw left side
index = 1, i=0
 → Move to (C_pkoleftpt [i].h, C_pkoleft[i].v);
if (leftp)
 Draw Char(*'p'), C_pko [index]
else Draw Char('p') → index++;
while (C_pko [index] != ' ') {

vel=-1; i=1; → BlockMove(C_pkoleftbits, C_pkoleftbits+1 sizeof(int)*
 8*c_pkoleftnum
nile (C_pkoleftstr [i] != ' ') { C_pkoleftbits[0]= leftp;
 if (C_pkoleftstr [i] == 'p'){ level++; Moveto (c_pkoleftpt [level].h,
 if (C_pkoleftbits[i-1]) C_pkoleftpt[level][v];}
 Draw Char (tr.....(c_....r [i]));

concatString(C_pkolettstr, \p.),
for(i=0; i< C_pkolettrightnum-1; i++)
 concatString(C_pkorightstr, "\p pach...
concatString (C_pkorightstr, "\p.");
for(i=0; i< 8* PKOMAXLEVELS; i++) {C_pko
 C.

The shift key is
► useful for ...

current text.

c_pkolettunity = C_pagearea.h/c_pkol...
c_pkorightunity = c_pagearea/c_pkoris...
SetPageFont (SHIFTKEY); //perhaps c
c_pkow = StringWidth ("\p pach...
c_pkofheight = 32; //update if nee
y = c_pkolettunity;
for (i=0; i< C_pkolettnum; i++)
 C_pkoleftpt [i].h= MYPR (C_P
 C_pkoleftpt [i].v= y; y+= M

y = c_pkorightunity;
for(i=0; i< C_pkorightnum; i++){
 C_pkorightpt [i].h = MYPR(C_po
 + C_pagearea
 y += MYPR (C_pkorightunity
 + C_pkofheight;

I designed *Flying Letters* as a long fold-out book that doubled as a container for the accompanying disk. →

When letters are handwritten they are directly in contact with the pen and person that renders them. When letters are read we rarely reach out to touch them unless they are printed in a manner that invites touch, such as letter-press or spot lamination. The responsive "ink" of the computer screen is uniquely qualified to realize endless variations of relationships to touch, but it is seldom exploited beyond the token roll-over or highlight. As a result, interactive texts are usually no better than the average pop-up book for children.

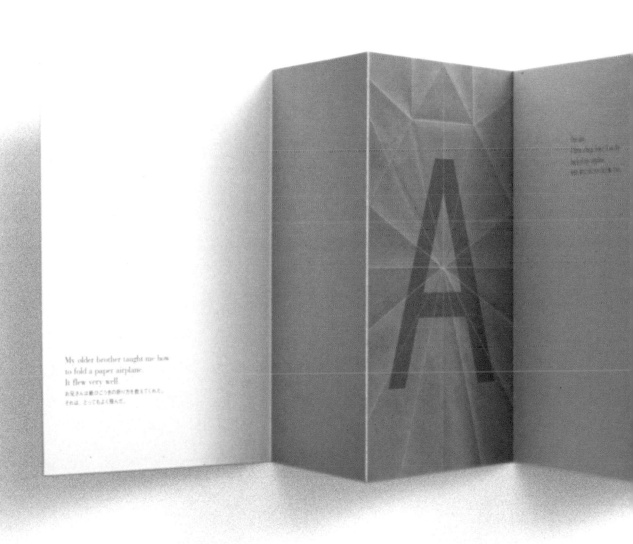

My older brother taught me how to fold a paper airplane. It flew very well.
お兄さんは紙のこうきの折り方を教えてくれた。それは、とってもよく飛んだ。

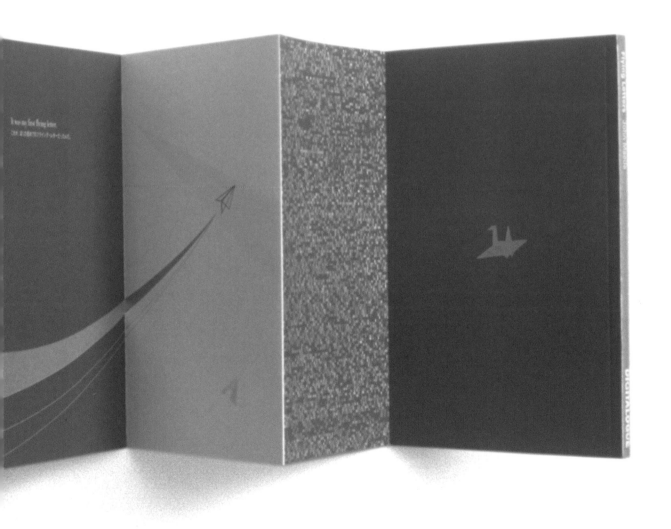

And to fold paper ~~origami~~ ... another day holly

~~My mother taught me to write.~~
~~When I was small~~ My ~~father taught~~
~~me to fold paper.~~

~~He gave ...~~ taught me to fold airplanes.

~~In 2nd grade I learned to~~
~~write also the hair~~
~~later write the~~
~~alphabet. My mother~~

~~I learned how to write~~
~~from my mother.~~

- Around the same time
 I learned how to write,
 my father taught me how
 to fold a crane,

- And to fold airplanes.

Mom taught me how to write the
~~... alphabet~~
letters of the alphabet, a to z.

Dad taught me to fold a ~~paper crane~~.
~~The crane~~ the crane did
~~it would not fly~~ not fly.

~~... taught me how to fold an~~
airplane. ~~The wings carried air~~
~~and~~ It flew quite well.

~~... because~~ I drew the letter 'A' on
~~... the back one day.~~ That was the first
time I ~~made~~ my own flying letter.
~~So that I would make airplanes~~
~~out of my~~
to avoid practicing my letters,
~~I would fold them into~~
~~airplanes~~ I would fly them
away as airplanes. But
they never flew away too far.

Letters were boring, so I would
make them fly away.

I became tired of cries for more *anti-aliased* type to correct the jaggedness of digital type. While one side of me cried to see Garamond butchered on the pixel grid, another side thought, "Who cares?" I decided to create a series of twelve clocks based upon the decidedly untrendy (at the time) original typeface of the computer—a simple face set on a basic 5 by 7 grid. →

Issues of screen resolution will be irrelevant in the future because computer screens will be as sharp as printed paper. In fact, experts believe that they will eventually be one and the same. The most important areas of visual exploration are therefore not in the mimicry of screen space and the printed page, but in the deconstruction of our spatial senses to stimulate the higher dimensions of expression made possible by the computer.

5x2

Color.

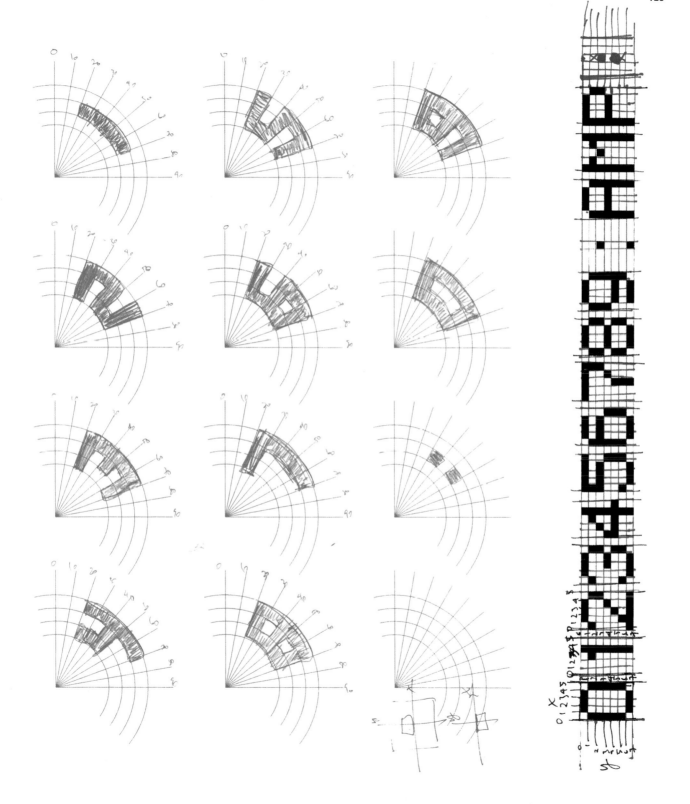

The program for *12 o'clocks* took no more than a week to write, but the preparatory sketches had been worked on for well over a year. →

As I transcribed the pencil sketches to
algorithms, I felt the vast difference
between the expressive contexts. Often,
switching from pencil sketching to
computation lifted impediments to inno-
vation. For instance, I had difficulty
developing the concept for one of the
clocks, a tricolor clock composed of
concentric circles (the second image in
the first row), but it became perfectly
clear when I sketched it as computation
on the screen. Then again, some of the
unresolved pencil sketches refused to
improve in the computational phase.
Eventually, I'd give up and rework them
again on paper.

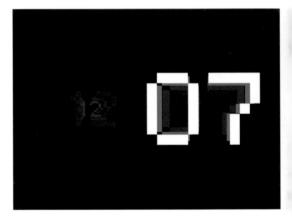

The pages of the printed book were
created by the same software that runs
the clocks themselves. I rewrote the
codes to output in the PostScript
language and rearranged some of the
themes to maximize the effect of output
to print media. In fact, all of the images
were created computationally, except
for the book's opening illustration,
which was rendered not by a computer
but by my children. →

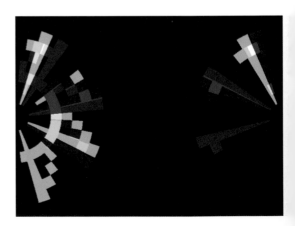

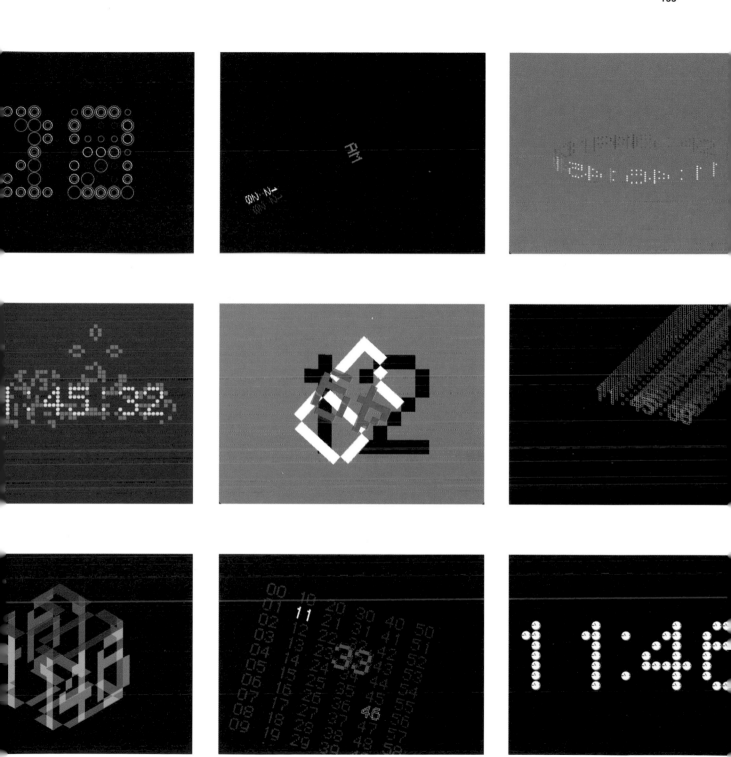

For a series of print pieces using the colored marker caps for the arts-supply manufacturer .Too Corporation, I wanted to demonstrate the real-time conversion of any video imagery into .Too marker caps. This concept was used for .Too's Graphic Arts Message '96 event.

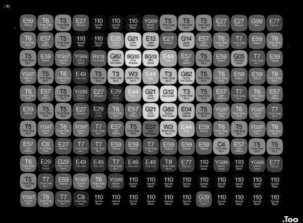

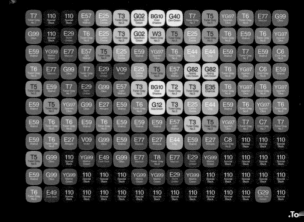

This project was conceived for Sony Tokyo
Design Center as realized with Yumie
Sonoda. Each physical object used Sony's
product semantics to communicate a
non-standard usage of the object.

A microphone attached to headphones—
speak into the microphone, and your
voice is converted into music.

A videophone in which speaking creates
graphics that mutate according to your
vocal prowess.

A video-camera that can be picked up
and strapped onto the hand, with a
viewfinder that can be spoken into to
generate a set of gentle pulses on your
palm depending to your voice.

A color typewriter in which color tokens,
instead of letters, are created by typing
into the keyboard.

Stick all arrays into one class in easier.

 12
 11
 10
 9
 [8] ← standard.

if pressed.

put The boundaries into tstamp;

if (tickcount — tstamp) > TLAGMAX)
 A) store → frac count (col) paint (col);
 } else {
 // put
 render cols;
 a translated zero col blue = ((Tcount — tstamp · 255) / TLAGMAX) << 8;
 } paint (back)

A ── SPECTRUM ── Z

D ── black ── 9

CHAR ── it loses magnet color

SHIFT → VIVID.
PLAIN → DULL.

the start word
the state word

operator.

SPC → TALK.

default. 252 gray.

will count by in class

we full screen and lists.

→ ADD MOUSE JERICLE ROUTINES.

a → z top: LCA
 bot: O

i,t top: LCi gipqy top: LCA
 bot: O bot: LCg

j top: LCi
 bot: LC8

bdlhf A→z top: UC
 bot: O

← (Get perspex/paint is,
 GND KEY

→ PENDING [A] [2] [V] [C] FOR FULL SCREEN

ab|cd|ef|gh|i|jK|l|mn|o|p|q|r|s|t|u|v|w|x|y|z
A B C D E F G H I J K L M N O P Q R S T U V W X Y Z

Lab Fontram

CW
CH

ijt →
bdfb
bdfl →

a → z lower.

ijt

bdlhf
gjpqy

Successive variations on a grid of spinning forms illustrate the absence of a single default scale on the computer.

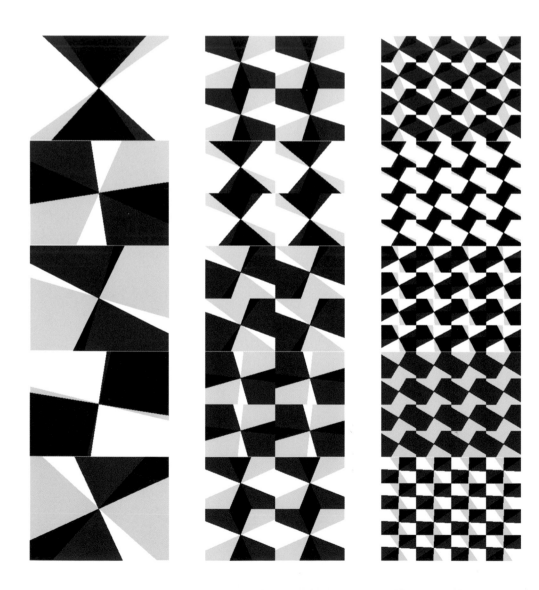

There are few creative luxuries in life greater than non-commercial projects. The freedom to experiment responsibly within a completely irresponsible envelope of expression is by no means easy. The intellectual challenges of solving a client's problems are indeed formidable and should not be belittled. But when the world's greatest problem-solver runs out of other people's problems to solve, she realizes that her own problems are not only the most diffi- cult to solve, but the most difficult to articulate.

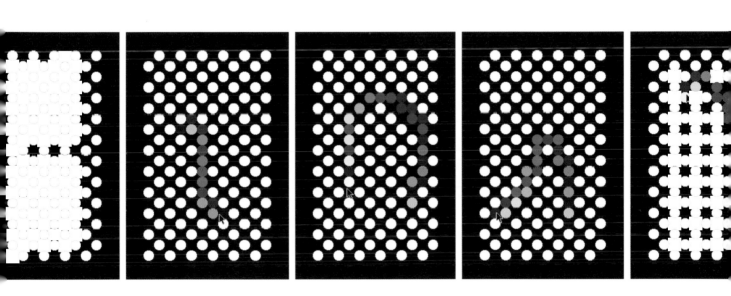

Black and white poles are upset with a brush of the cursor to reveal a hidden color that appears momentarily. The spatially discrete train of dots contrasts lightly with the smooth shifts of color.

Experiment in creating sticky pixels.

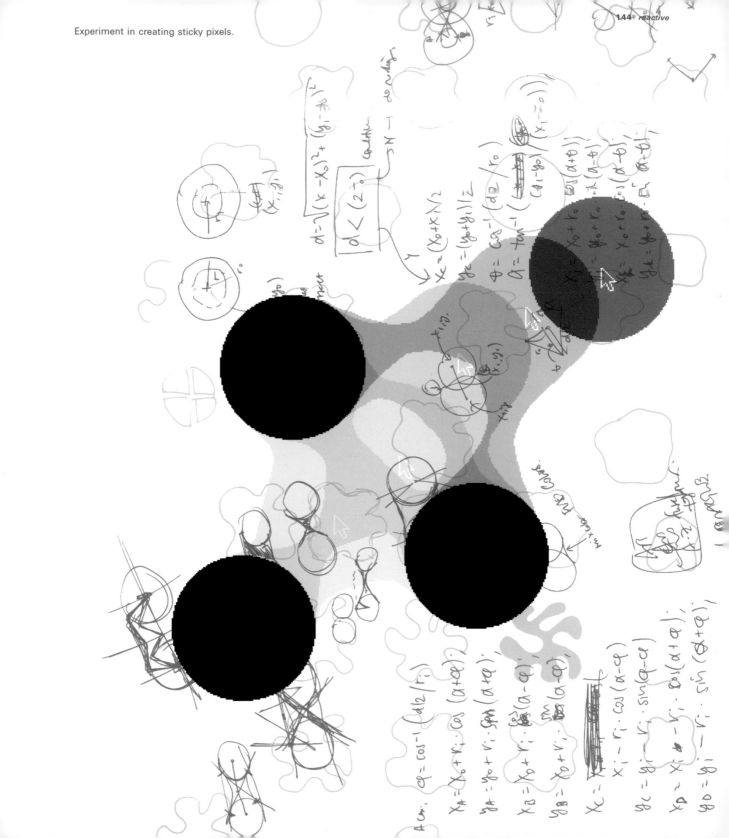

5 *paper* I would like to say that I never leave the house in the morning without a pen, but sometimes I do make this disastrous mistake. Once I realize my error, the feeling I get is not unlike what a drug addiction must be like. "Must have pen!" is all that runs through my mind as I check my pockets over and over, hoping it might appear by sheer will. The second I satisfy my fix with pen in hand, another fundamental need wells up with equal force, "Must have paper!" However, I find that the paper addiction is much easier to satisfy than the pen addiction because in the worst case I can write on a scrap piece of paper from my wallet or the interior of my car, on a napkin or placemat, or, as a last resort, my hands (although recently I have discovered that, depending upon the season, the abdomen can be a flatter surface). To most of us, paper is more a state of mind than an object—it is a place outside our minds to think and reflect. It is unfortunate that the display technology of the computer we use has been designed around the flat, rectangular metaphor of machine-cut paper, instead of the unflat, unrectangular, and infinitely multidimensional space of pure computation.

A sheet of paper stimulates a visual dialogue between your hand and mind. The subject can be absolutely anything, which can make a lifeless sheet of paper the most intimidating of companions. Eventually the two of you hit it off and conversation flows freely. From childhood memories to management theory to shopping habits, there is no end to what thoughts you might share. And just when a mutual understanding starts to form, you find that there is no more room to carry it even further.

The miracle of adhesives provides a reliable method of escape from any physical confine.
Out of room? Simply tack on another to
keep on going. Need more room?
Tack on another, and so on.

The make-up of a book relies heavily upon liberal amounts of adhesive. There is the glue that holds the crevice in the middle together, and the conceptual glue that connects each page to the next.

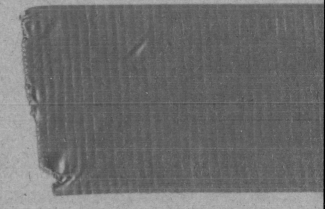

When we become dissatisfied with the amount of space our computer screen provides, the natural reaction is simply to extend the size of the screen with more screens.

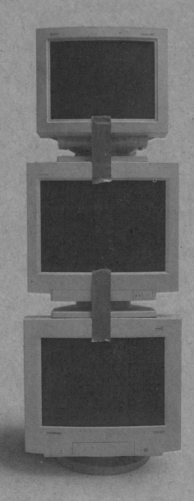

In general, the sophisticated interface ... sophisticated interface of the compute ... the problem of ever having to go out a ... ever having to go out and purchase m ... It turns out that you have access to cl ...

... of the computer circumvents ... and purchase more screen space. ... ose to infinite space to write upon.

In Japanese the words paper and god
(more accurately, "spirit") are phonet-
ically equivalent. It is an unsurprising
coincidence that origami, the art of
folding paper, bonds an animate
spirit, such as a crane, to the physical
form of paper without any extraneous
synthetic additions or interruptions.

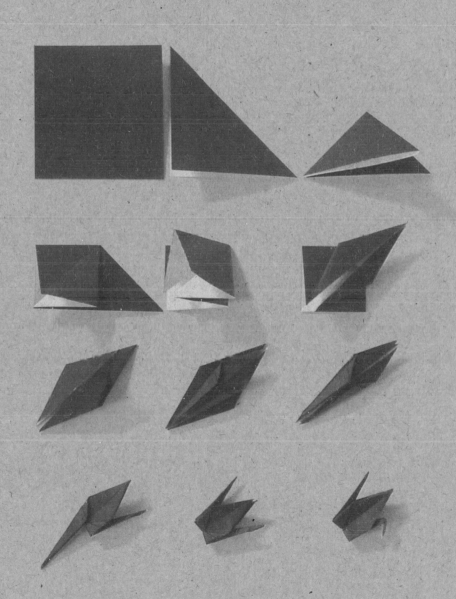

We can respond to this one-upmanship of paper by trying to similarly fold a computer screen with old-fashioned brute force.

This would be an unfortunate mistake, preventing us from sensing the real material inside the computer—the program—that is continually folding, collapsing, growing, and evolving at unimaginable speeds.

Today the computer is used for little more than as a digitally powered brush for painting numbers instead of real pigment.

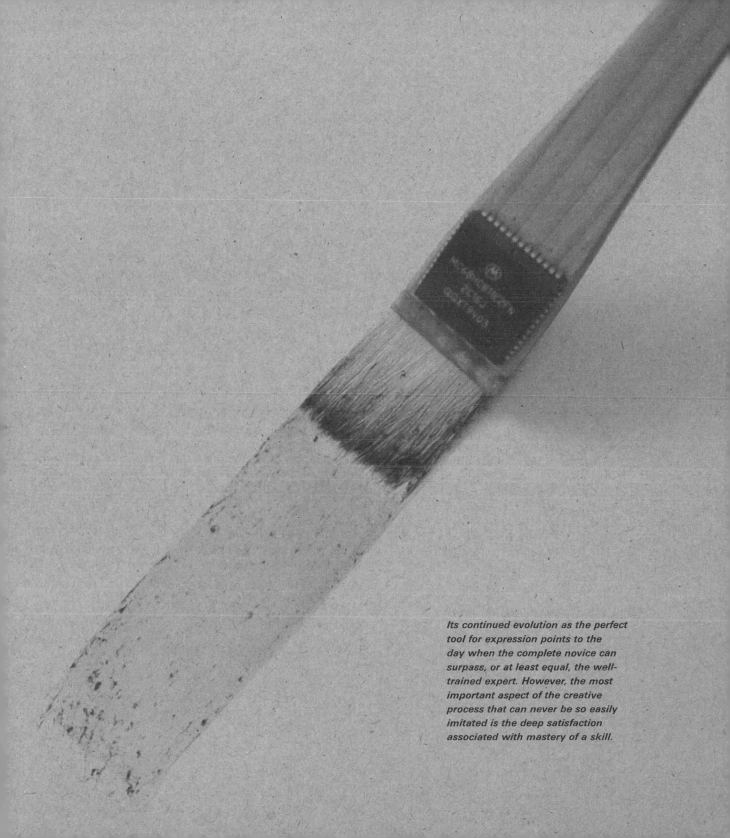

Its continued evolution as the perfect tool for expression points to the day when the complete novice can surpass, or at least equal, the well-trained expert. However, the most important aspect of the creative process that can never be so easily imitated is the deep satisfaction associated with mastery of a skill.

No matter how many technologies might be developed to augment the operation of our bodies and mind, it is hard to imagine a better starting point for thought than a blank sheet of paper. Its honesty and reliability naturally provoke excitement for the next encounter.

6 *static* At the moment printed images do not have the privilege of changing at rapid speeds. On the other hand, on-screen digital imagery cannot currently be realized at very high resolutions. In the future we can imagine that digital will be sharp and print will be in motion. While we await the day when paper will literally run away from us, we can examine the unique properties of each material in their natural form. Printed images look most natural on paper; digitally motivated images look best on the computer. It seems odd when people describe a printed piece as being a "digital print." By nature of their construction, digitally originated images cannot be so trivially realized in print; an analogy would be to call a photograph or illustration of a building an "architectural print." Naturally the print has representational and some-times artistic value, but we usually assign superior value to the building being depicted, unless there is something to hide, such as a poor facade or perspective. In print such inadequacies can conveniently be placed or cropped out of view. A digital print by comparison should be thought of as illusory—a mere sliver or minor facet of what really exists in the digital realm.

I was given my first print commission by Michio Iwaki to celebrate thirty years of Shiseido advertising films. I chose an abstract method of visualization in which the image would represent those thirty years of commercials in the visual domain in a non-intuitive way. Three data sources were used: Visuals, audio, and the film titles were to be mixed into the image. So began my experiments in print.

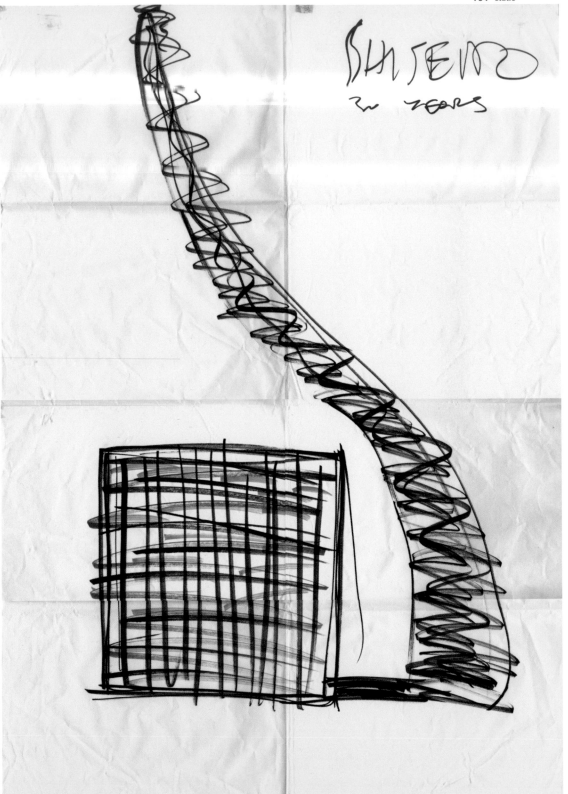

Full-scale rough draft.

Shiseido 30 (sketch)

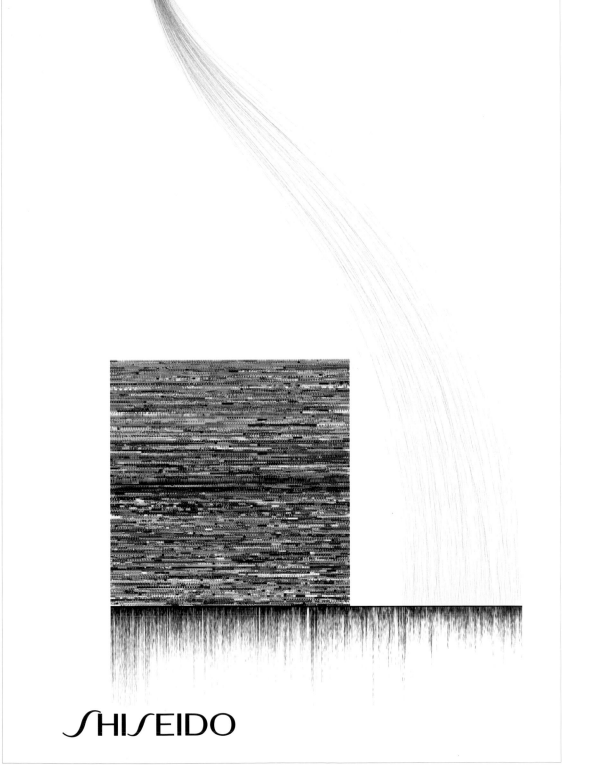

Aud o, visual, and text information are cislayed as pure abstractions.

Shiseido 30

SHISEIDO

The morning glory is known in Japan as a flower of summer.

Seibu Summer

SEIBU

Fireworks are another symbol of summer in Japan.

Seibu Summer

SUMMER

The pattern of seeds in a sunflower follows a simple mathematical logic.

Seibu Summer

A four-color chart demonstrates a new paper grade's printing capabilities.

Mr. B Paper Promotion

Arrangement of flags based upon a simple flag grammar.

20.5

Flags, 1 Color

When filled with color, the image takes on a distinctly different character.

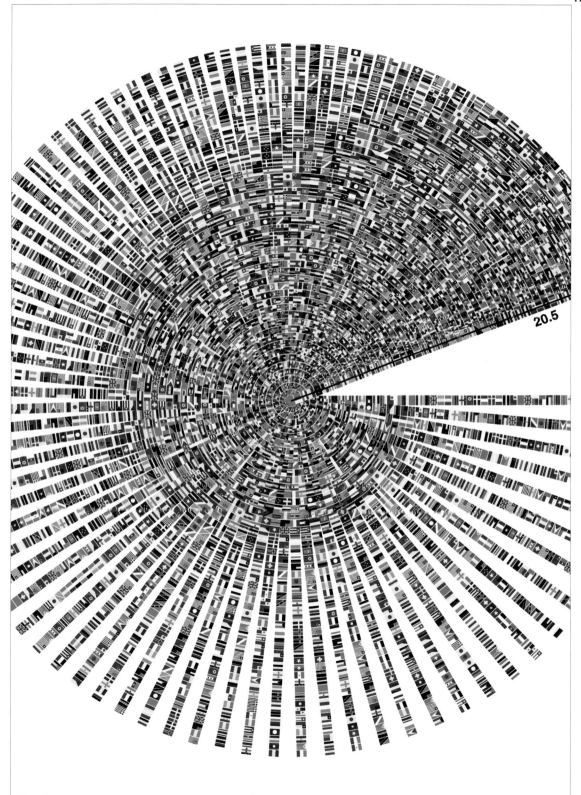

20.5

Flags, 4 Colors

Taiji Watanabe of Grapac printing company became a patron of my experiments.

Grapac Swirl

GRAPAC JAPAN CO., INC.

Revealing the aspect of multiplicity inherent to the reactive dimension.

The Reactive Square Unfolded

Promotion for Grapac's color-proofing technology.

Syncolor Left

syncolor
THE COLOR MATCHING TOOLS

With the companion image of Syncolor Left, an endless continuum can be created.

Syncolor Right

syncolor
THE COLOR MATCHING TOOLS

A pattern of lines derived from the structure of the Sony symbol for Sony Live.

Sony Xmas

Arrangement of Sony products in a fan structure for SonyDrive.

Sony Fan

SONY

Sony Mountain

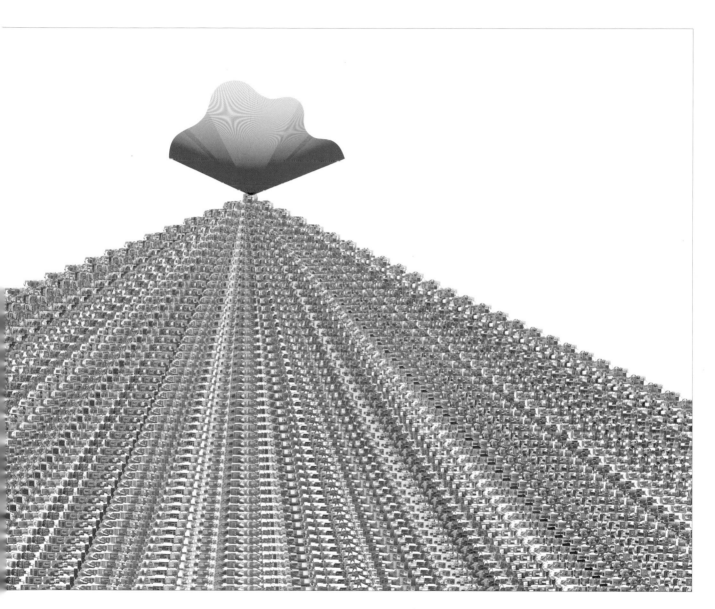

Six hundred Sony products arranged in a landscape for SIGGRAPH 95 in Los Angeles.

First experiments in connected-line illustrations; silhouett d figure is Chiyo_ Misawa.

Misawa Homes

Illustration for *Tategumi Yokogumi* magazine.

Morisawa Mo

グラフィックアーツメッセージ '96 大阪

5月23日（木）10:00～19:00（受付終了18:00）　24日（金）10:00～17:00（受付終了16:00）

会場／マイドームおおさか3F

完全招待制　招待券は最寄りの「Too」へお申し付けください。

Too 総合展示会　Graphic Arts Message '96

DTPを中心とした各分野のソリューションを提供するTooの総合展示会。グラフィックアーツからマルチメディアまで、様々なクリエイティブツールが集結！Mac関連他、各種機器・ツールの展示やデモや、最新トピックスのワークショップを開催！ビジネスに活用できる役立つ有益なデジタル環境を提案。

.Too

Using the 214 different Copic-series markers to form a patern.

.Too Graphic Arts Message

Ode to the most famous woman in the world.

.Too Giaconda

An activity with my children that grew into a challenge. →

DIC Kokeshi

Japanese color chips arranged as a group photo.

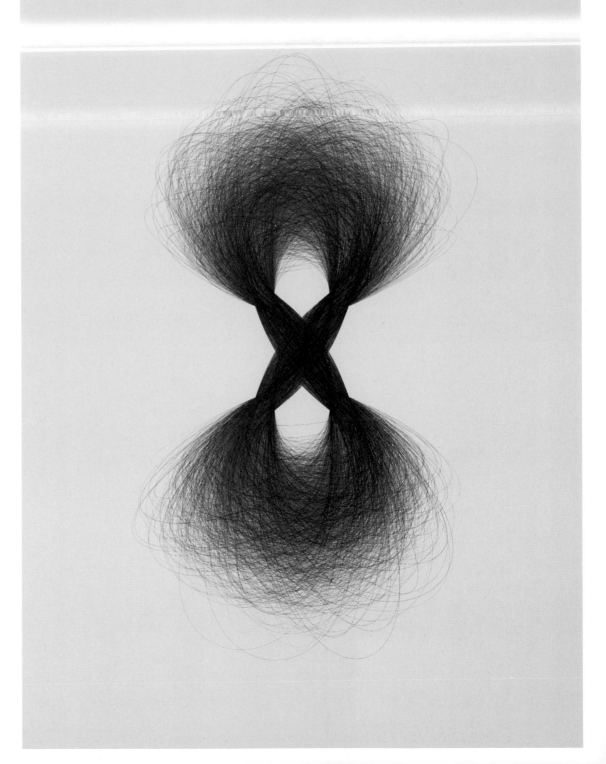

Infinity

An eternal symbol revisited.

Space density collage.

Red Yellow Blue

Density diagram of a cross.

Shape Study 1

Density diagram of a diamond.

Shape Study 2

Density diagram of a rectangle.

Shape Study 3

Density diagram of a vertical cross.

Shape Study 4

Density diagram of a parallelogram.

Shape Study 5

Density diagram of an ellipse.

Shape Study 6

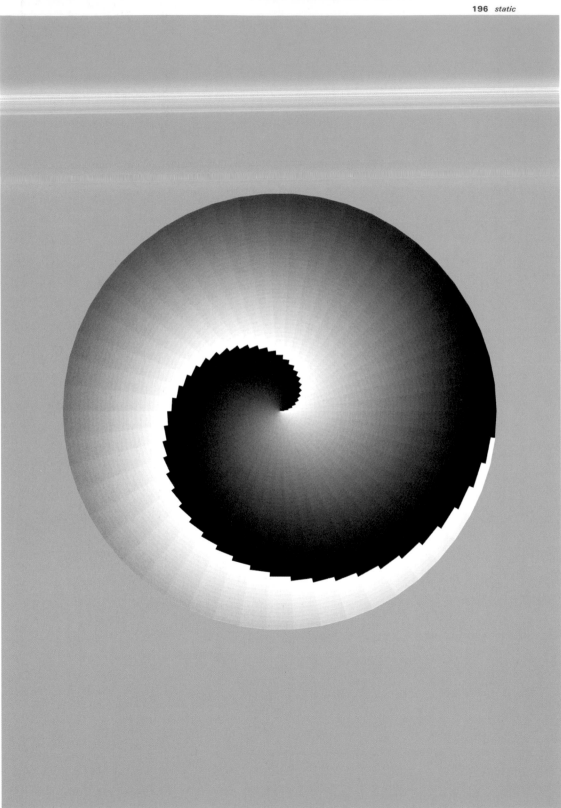

Relationship in shape and color as one node.

Tomoe 1

Relationship in shape and color as three nodes.

Tomoe 2

Relationship in shape and color as five nodes.

Tomoe 3

Relationship in shape and color as seven nodes.

Tomoe 4

Criss-cross of dots.

Dots 1

Enhancement of the diagonal.

Dots 2

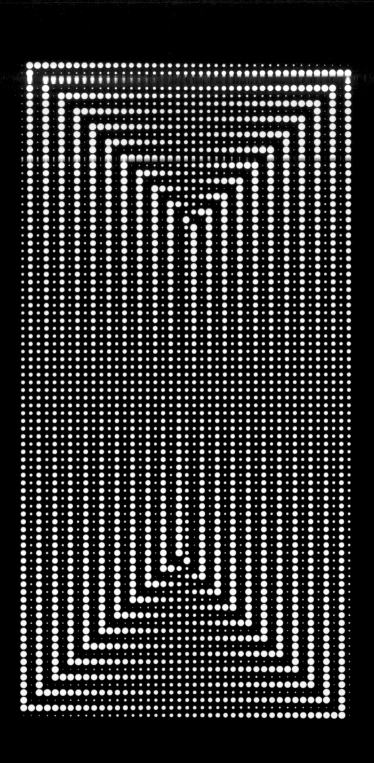

Chase toward center.

Dots 3

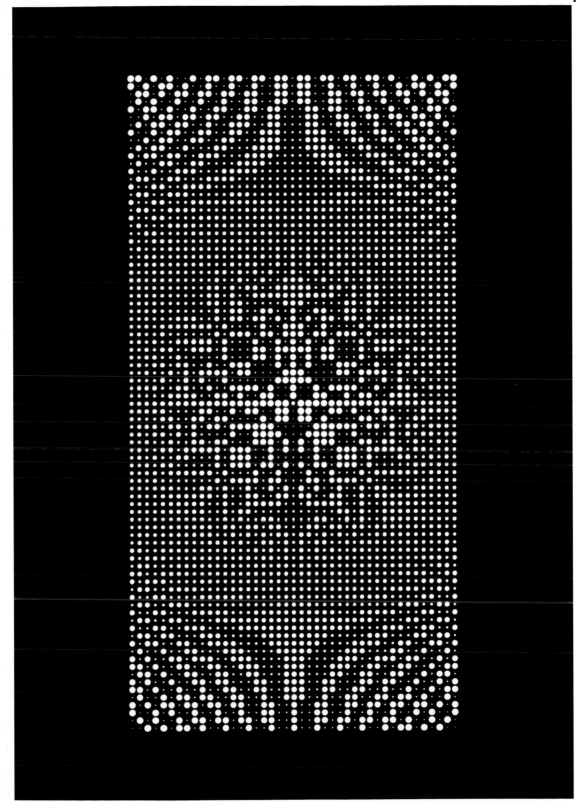

Measurements of a set of concentric circles.

Dots 4

All the seconds in a day displayed as comets of minutes.

One Day

Running the marathon in alternating black and white steps of one centimeter.

Marathon

Table of CMYK values articulated as words.

4 Colors

designed by john maeda, 1996.

2000 Year Calendar

Excerpt from a calendar that starts 1 January 0 and extends to 31 December 2000.

```
#include "ailib.h" #include "Mountain.h"  void invjustmori(void) ; void justmori(void) ; void justmoriS(void) ; void moriE(void) ; void moric(int n,int s) ; double mc[5] = { 245.15, 13.04, 216.65, 293.73, 231.32}; extern F
2 3 Th\n0 Tq\n3 Tg\n0 0 Tf\n0 Tc\n0 Tw\n(Designed by John Maeda). Printed 1996, GRAP) Tx 0 60 Tk \n(AC JAP) Tx 0 60 Tk\n (AN Co., Inc. ) Tx \n(\r) TX \nTO\n";  static void morisign(void) { fprintf(aifp,sign); | stat
nsc,cubedim,gg,gg2,sc2; int iiw = 176/4, iih = 211/4; double iw = iiw, ih = iih,dy; double nsc2;  gg=.95; gg2=.9; mt[0]=0; mt[1]=mc[0]+mc[1]; mt[2]=mt[1]+mc[2]; mt[3]=mt[2]+mc[3]; aiopen("mori5.ai"); aigsave(); a
mw,0); justmori(); aigrestore(); } aigsave(); aitranslate(0,h-mh2); aisetgrayF(0); aiscale(sc,sc); justmori(); aigrestore(); aigrestore(); aisetgrayS(0); aitombo(0,0,728,1030); aisetgrayF(0); morisign(); aiclose(); } static vo
nsc,cubedim,gg,gg2,sc2; int iiw = 176, iih = 211; double iw = iiw, ih = iih,dy; double dd=0; gg=.95; gg2=.9; mt[0]=0; mt[1]=mc[0]+mc[1]; mt[2]=mt[1]+mc[2]; mt[3]=mt[2]+mc[3]; aiopen("mori9.ai"); aigsave(); aitra
j++) { aigsave(); aitranslate(0,-nsc*mw*(double)(j+1)/4.); aiscale(nsc,nsc); for(i=0;i<iw;i++) { double tx,ty; int kk = i%4; aigsave(); aitranslate(mw*(i/4),0); aitranslate(tx=mt[kk]+mc[(kk]>=1?(kk)]+1:(kk)]/2,ty=mh/2);
aiclose(); } #include <stdlib.h> static void main7() { double bdr = 10; double w = 728.bdr*2,h=1030-bdr*2; double mw=1000, mh=222.645; double sc=w/mw; double mw2=sc*mw,mh2=sc*mh; double segs[1000],p
```

Morisawa 10 (program source)

Reaching the limits of a typography affliction, I created ten variants on the logotype of Japanese type foundry Morisawa Company. →

```
"0 To\n1 0 0 1 1164.9689 -1042.5546 0 Tp\n0 Tv\nTP\n0 Tr\n|_Helvetica 5 4.6997 -1.0998 Tf\n0 Ts\n100 100 Tz\n0 Tt\n0 TA\n%%_0 XL\n0 TY\n1 TV\n0 0 5 TC\n100 100 200 TW\n25 TG\n0 0 0 Ti\n0 0 2
ble bdr = 10; double w = 728-bdr*2,h=1030-bdr*2; double mw=1000, mh=222.645; double sc=w/mw; double mw2=sc*mw,mh2=sc*mh, double segs[1000],poss[1000]; int npts=250,i,j; double mt[4]; double
<90;i++) { aigsave(); aitranslate(mw2,h-mh2); aisetgrayF(1-(double)i/90.); aiscale(sc,sc); airotate(90.-i); nsc2 = (double)i/90.; nsc2 = dsin(i); nsc2=1+((1-(double)i/90.)*(h-w)/mw2); aiscale(nsc2,nsc2); aitranslate(-
double bdr = 10; double w = 728-bdr*2,h=1030-bdr*2; double mw=1000, mh=222.645; double sc=w/mw; double mw2=sc*mw,mh2=sc*mh; double segs[1000],poss[1000]; int npts=250,i,j; double mt[4]; double
late(-tx,-ty); moric(kk,0); aigrestore(); } aigrestore(); } aigrestore(); aitranslate(0,h-mh2); aisetgrayF(0); aiscale(sc,sc); justmori(); aigrestore(); aisetgrayS(0); aitombof(0,0,728,1030); aisetgrayF(0); morisign();
/iw; printf("max rows displayable %d\n",(int)((h-mh2)/cubedim)); nsc=cubedim*4./mw; aigsave(); //aitranslate(0,h-mh2+cubedim-nsc*mh); aitranslate(0,h-mh2+cubedim-nsc*mh); dy = nsc*mw/4.; for(j=0;j<ih;
h-mh2)/cubedim)); nsc=cubedim*4./mw; aigsave(); aitranslate(0,h-mh2+cubedim-nsc*mh); dy = nsc*mw/4.; for(j=0;j<ih; j++) { aigsave(); aitranslate(0,-nsc*mw*(double)(j+1)/4.); aiscale(nsc,nsc); for(i=0;i<iw;i++)
morisign(); aiclose(); } static void mainunused() { double bdr = 10; double w = 728-bdr*2,h=1030-bdr*2; double mw=1000, mh=222.645; double sc=w/mw; double mw2=sc*mw,mh2=sc*mh; double
ri(=360;i>=0;i--) { double nsc = i+1; int ff = 0; double mxsc = 6; aisetgrayF(i/360.); aisetgrayS(1); if (i==360) aisetgrayF(0); aigsave(); aitranslate(0,h-mh2); aiscale(sc,sc); aitranslate(mt[0]+mc[0]/2,mh/2);
grayF(1); //moric(0,0); aisetgrayF(0); aigrestore(); aitombo(0,0,728,1030); morisign(); aiclose(); } static void main8() { //void main() { double bdr = 10; double w = 728-bdr*2,h=1030-
+mc[1]; mt[2]=mt[1]+mc[2]; mt[3]=mt[2]+mc[3]; aiopen("mori8.ai"); aisetlinewidth(.5); aigsave(); aitranslate(bdr,bdr); nseg = 360*3; x1=0;y1=h-mh2; x2 = 0; y2=0-(mh2-mh2*minsc)/2; for(i=nseg-1;i>0;i--) {
ate(mt[0]+mc[0]/2,mh/2); aiscale(dcos(i)*ssc,ssc); aitranslate(-mt[0]-mc[0]/2),(-mh/2)); /// moric(0,ff); aigrestore(); } x1=mt[1]*sc;y1=h-mh2; x2 = 0-(mh2-mh2*minsc)/2; for(i=nseg-1,i>0;i--) {
g-1))*(1-minsc)+minsc); //aitranslate(tx=(mt[1]+(mc[2])/2),ty=mh/2); tx=mt[1]+mc[2]/2.; aitranslate(tx,ty=mh/2); //aitranslate(mt[1]+(mc[2]+mc[1])/2,mh/2); aiscale(dcos(i)*ssc,ssc); aitranslate(-tx,-ty); ///
2+i*(y2-y1)/(nseg-1); aitranslate(x,y); aiscale(sc,sc); aitranslate(-mt[2],0); //// ssc=((1-(double)i/(nseg-1))*(1.-minsc)+minsc); aitranslate(tx=mt[2]+mc[3]/2,ty=mh/2); aiscale(dcos(i)*ssc,ssc); aitranslate(-tx,-ty); ///
*y2-y1)/(nseg-1); aitranslate(x,y); aiscale(sc,sc); aitranslate(-mt[3],0); //// ssc=((1-(double)i/(nseg-1))*(1.-minsc)+minsc); aitranslate(mt[3]+mc[4]/2,mh/2); aiscale(dcos(i)*ssc,ssc); aitranslate((-mt[3]-mc[4]/2),(-
{ double bdr = 10; double w = 728-bdr*2,h=1030-bdr*2; double mw=1000, mh=222.645; double sc=w/mw,newsc; double mw2=sc*mw,mh2=sc*mh; int npts=100; double i,j; double nseg,x1,y1,x2,y2; int ff = 1,
l*sc; y2=0; for(i=nseg-1,i>0;i-=.2) { double x,y; aigsave(); aisetgrayF((double)i/(nseg-1)); aisetgrayS((double)i/(nseg-1)*gg2+(1-gg)); x=i*(x2-x1)/(nseg-1)+x1; y=h-mh2+i*(y2-y1)/(nseg-1); aitranslate(x,y);
 le)i/(nseg-1)); aisetgrayS((double)i/(nseg-1)*gg2+(1-gg)); x=i*(x2-x1)/(nseg-1)+x1; y=h-mh2+i*(y2 y1)/(nseg-1); aitranslate(x,y); aiscale(sc,sc); aitranslate(-mt[1],0); //// aitranslate(mt[1]+(mc[2]+mc[1])/2,mh/2);
gg2+(1-gg)); //aisetgrayS(0); //aisetlinewidth((double)i/(nseg-1)*.6 x=i*(x2-x1)/(nseg-1)(x1) x1; y=h-mh2+i*(y2 y1)/(nseg 1); aitranslate(x,y); aiscale(sc,sc); aitranslate(-mt[2],0); //// aitranslate(mt[2]+mc[3]/2,mh/2);
2-x1)/(nseg-1)+x1; y=h-mh2+i*(y2-y1)/(nseg-1); aitranslate(x,y); aiscale(sc,sc); aitranslate(-mt[3],0); //// aitranslate(mt[3]+mc[4]/2,mh/2); airotate(i); aitranslate((-mt[3]-mc[4]/2),(-mh/2)); /// moric(3,ff);
le w = 728-bdr*2,h=1030-bdr*2; double mw=1000, mh=222.645; double sc=w/mw,newsc; double mw2=sc*mw,mh2=sc*mh; double segs[1000],poss[1000],off,sp; int npts=100,i,j; double mt[4]; mt[0]=0;
aisetgrayS(i/360.); aisetgrayF(i/360.); aigsave(); aitranslate(mt[3]+mc[4]/2,mh/2); aiscale(sc,sc); airotate(i); nsc = (1-(i)/360.+1./mxsc)*mxsc; aiscale(nsc,nsc); aitranslate((-mt[1]-mc[2]/2),(-mh/2)); moric(1,ff);
grestore(); aigsave(); aitranslate(0,h-mh2); aiscale(mt[1]+mc[2]/2,mh/2); airotate(i); nsc = (1-(i)/360.+1./mxsc)*mxsc; aiscale(nsc,nsc); aitranslate(-mt[1]-mc[2]/2),(-mh/2)); moric(1,ff);
j; aitranslate(bdr,bdr); for(i=0;i<90;i+=1) { double dist = h/2-mh2; double y = dcos(i); aigsave(); aitranslate(0,h-y*dist-mh2); aiscale(sc,sc*(1-y)); aitranslate(mw/2,0); aiscale((double)i/90*.05+.95,1); aitranslate(-
= dcos(i); aigsave(); aitranslate(0,y*dist); aiscale(sc,sc*(1-y)); moriE(); aigrestore(); }*/ aisetgrayS(0); aitombof(0,0,728,1030); aisetgrayF(0); morisign(); aiclose(); } static void main2() { double bdr = 10;
; aitranslate(0,h-mh2); aiscale(sc,sc); aisetgrayF(0); justmori(); aigrestore(); off=mh2; i=0; while(1) { aigsave(); newsc=sc*(double)1/(double)(i+2); aitranslate(0,h-off-mh*newsc); aiscale(newsc,newsc);
rayF(0); morisign(); aiclose(); } //static void main3() { void main() { double bdr = 10; double w = 728-bdr*2,h=1030-bdr*2; double mw=1000; double mh=222.6;//45; double sc=w/mw; double mw2=sc*mw,mh2=sc*mh;
segs,poss,sizeof(double)*npts); CollapseSegments2(npts,poss); i=npts-1; printf("last: %lg\n",h-mh2-poss[i]-segs[i]); aigsave(); aitranslate(0,h-mh2); aiscale(sc,sc); aisetgrayF(0); justmori(); aigrestore();
igrestore(); } aisetgrayF(0); aisetgrayS(0); aigrestore(); aitombo(0,0,728,1030); aisetgrayF(0); morisign(); aiclose(); } static void mori1() { double bdr = 10; double w = 728-bdr*2,h=1030-bdr*2; double mw=1000,
+1); } BlockMove(segs+1,segs,sizeof(double)*(npts-1)); BlockMove(segs,poss,sizeof(double)*npts); CollapseSegments2(npts,poss); i=npts-1; printf("last: %lg\n",h-mh2-poss[i]-segs[i]); aigsave(); aitranslate(0,h-
aitombo(0,728,1030); aisetgrayF(0); morisign(); aiclose(); } void invjustmori(void) { /* w=1000, h=222.645 */ aimoveto(145.1,164.9); aicurveto(138.8,164.9,133.7,159.9,133.7,153.6); ailineto(133.7,132.6);
132.6); ailineto(61.57,158.5); aicurveto(61.57,193.9,90.28,222.6,125.7,222.6); ailineto(245.2,222.6); ailineto(245.2,57.7); ailineto(145.1,57.7); aifill(); aimoveto(258.2,0.02551); ailineto(258.2,132.6);
6,935.8,222.6); ailineto(852.4,222.6); ailineto(852.4,164.9); ailineto(916.5,164.9); aicurveto(922.7,164.9,927.8,159.9,927.8,153.6); ailineto(927.8,52.53); ailineto(834.5,52); ailineto(834.5,132.6);
; ailineto(651.9,93.47); ailineto(585.2,93.47); ailineto(585.2,132.6); ailineto(519.4,132.6); ailineto(519.4,93.47); ailineto(474.8,93.47); ailineto(474.8,158.5); aicurveto(474.8,193.9,446,222.6,410.6,222.6);
551); ailineto(585.2,40.99); ailineto(651.9,40.99); aisetgrayF(0); ailineto(651.9,0.02551); aifill(); } void justmori(void) { /* w=1000, h=222.645 */ aimoveto(145.1,57.7);
170.2); ailineto(61.54,142.5); ailineto(0,142.5); ailineto(0,90.07); ailineto(61.54,90.07); ailineto(61.57,64.14); aicurveto(61.57,28.72,90.28,0,125.7,0); ailineto(245.2,0.02857); ailineto(245.2,57.7); ailineto(145.1,57.7);
651); ailineto(61.54,142.5); aicurveto(1000,28.72,971.2,0,935.8,0); ailineto(852.4,0.02857); ailineto(852.4,57.7); ailineto(916.5,57.7); aicurveto(922.7,57.7,927.8,62.79,927.8,69.07); ailineto(927.8,170.1); ailineto(834.5,170.1);
,652,69.07); ailineto(651.9,129.2); ailineto(585.2,129.2); ailineto(585.2,90.04); ailineto(519.4,90.04); ailineto(519.4,129.2); ailineto(474.8,129.2); ailineto(474.8,64.14); aicurveto(474.8,28.72,446,0,410.6,0);
+585.2,181.7); ailineto(651.9,181.7); ailineto(651.9,222.6); ailineto(724.1,222.6); aifill(); } void justmoriS(void) { /* w=1000, h=222.645 */ aimoveto(145.1,57.7); aicurveto(145.1,89.9,157.7,133.7,62.79,133.7,69.07);
; ailineto(0,90.07); ailineto(61.54,90.07); ailineto(61.57,64.14); aicurveto(61.57,28.72,90.28,0,125.7,0); ailineto(245.2,0.02857); ailineto(245.2,57.7); ailineto(145.1,57.7); aistroke(); aimoveto(258.2,222.6);
72,971.2,0,935.8,0); ailineto(852.4,0.02857); ailineto(852.4,57.7); ailineto(916.5,57.7); aicurveto(922.7,57.7,927.8,62.79,927.8,69.07); ailineto(927.8,170.1); ailineto(834.5,170.1); ailineto(834.5,90.04);
;61.9,129.2); ailineto(585.2,129.2); ailineto(585.2,90.04); ailineto(519.4,129.2); ailineto(474.8,129.2); ailineto(474.8,64.14); aicurveto(474.8,28.72,446,0,410.6,0); ailineto(324.0.02857);
;51.9,181.7); ailineto(651.9,222.6); ailineto(724.1,222.6); aistroke(); } void moriE(void) { /* w=1000, h=150.016 */ aisetgrayF(0); aisetgrayF(0); aimoveto(862,146.3); ailineto(889.8,146.3); ailineto(889.8,33.25);
,906,3.913); ailineto(862.3,3.913); ailineto(862,146.3); aifill(); aimoveto(779,0.1447); aicurveto(760.2,0.1447710.28.272,710.28.277,710,7.141,9.760,2.150.779.150);
2,817.7,35.23,817.7,75.08); aicurveto(817.7,114.9,795.1,124.8,779,124.8); aifill(); aisetgrayF(0); aimoveto(696.9,3.766); ailineto(634.7,3.766); aicurveto(596.8,3.766,589.9,31.72,589.9,44.01);
3,624.7,90.4,646.7,90.4); aicurveto(667.8,90.4); ailineto(667.8,146.1); ailineto(696.9,146.1); aisetgrayF(1); aimoveto(642.6,66.47,619.6,61.619.6,61.06,619.6,46.98);
ifill(); aimoveto(492.4,102.3); aicurveto(492.2,110.2,488.2,125.3,462.2,125.3); aicurveto(448.2,125.3,432.5,121.9,432.5,106.9); aicurveto(432.5,95.75,443.2,92.78,458.3,89.21); ailineto(473.5,85.64);
urveto(491,52.73,481.9,55.11,475.9,56.5); ailineto(441.2,65.03); aicurveto(421.8,69.78,403.9,77.71,403.9,103.3); aicurveto(403.9,146.1,447.6,149.9,460.1,149.9); aicurveto(512,149.9,520.9,119.9,520.9,102.3);
,64.7,107.8); ailineto(164.3,107.8); aicurveto(151.9,94.36,159.4,82.07,140.4,3.766); ailineto(109.4,3.766); aicurveto(195.2,76.33,197.8,62.45,202.8,35.09); ailineto(203.2,35.09);
; ailineto(363.6,116.8); ailineto(371.7,146.1); aifill(); aisetgrayF(1); aimoveto(357.2,92.19); ailineto(326.2,92.19); ailineto(342,35.88); ailineto(342.4,35.88); aisetgrayF(0);
,6,92.19); ailineto(61.54,142.5); ailineto(61.54,90.07); ailineto(78.06,92.19); aifill(); } void moric(int n,int s) { /* w=1000, h=222.645 */ switch(n) { case 0: aimoveto(145.1,57.7);
170.2); ailineto(61.54,142.5); ailineto(0,142.5); ailineto(0,90.07); ailineto(61.54,90.07); ailineto(61.57,64.14); aicurveto(61.57,28.72,90.28,0,125.7,0); ailineto(245.2,0.02857); ailineto(245.2,57.7); ailineto(145.1,57.7); if
,446,0,410.6,0); ailineto(324,0.02857); ailineto(324,57.7); ailineto(391.3,57.7); aicurveto(397.6,57.7,402.7,62.79,402.7,69.07); ailineto(402.7,222.6); ailineto(474.8,222.6); if (s) aistroke(); else aifill(); break; case 2:
585.2,129.2); ailineto(585.2,90.04); ailineto(519.4,90.04); ailineto(519.4,129.2); ailineto(474.8,129.2); ailineto(474.8,181.7); ailineto(519.4,181.7); ailineto(519.4,222.6); ailineto(585.2,222.6); ailineto(585.2,181.7);
o(1000,28.72,971.2,0,935.8,0); ailineto(852.4,0.02857); ailineto(852.4,57.7); ailineto(916.5,57.7);
```

aicurveto(922.7,57.7,927.8,62.79,927.8,69.07); ailineto(927.8,170.1); ailineto(834.5,170.1);

ailineto(834.5,90.04); ailineto(768.6,90.04); ailineto(768.6,22.6); if

(s) aistroke(); else aifill(); break; default:break; } }

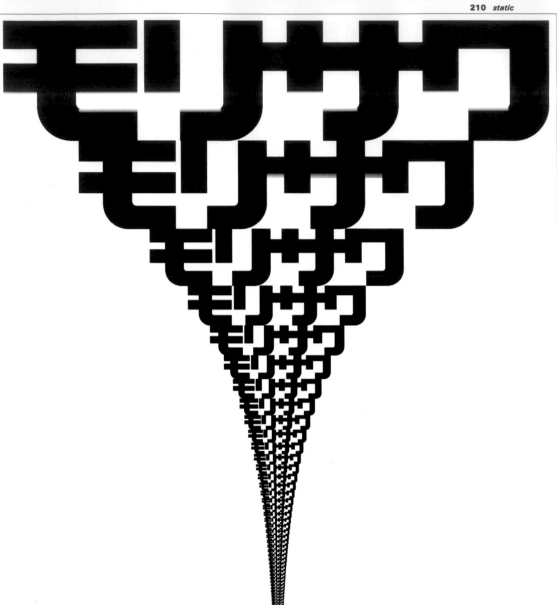

Morisawa 1

モリサワ

モリサワ

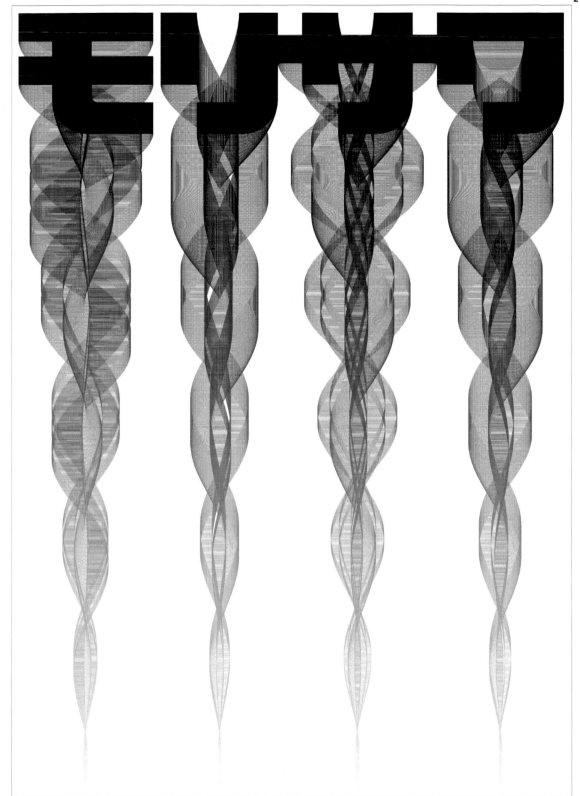

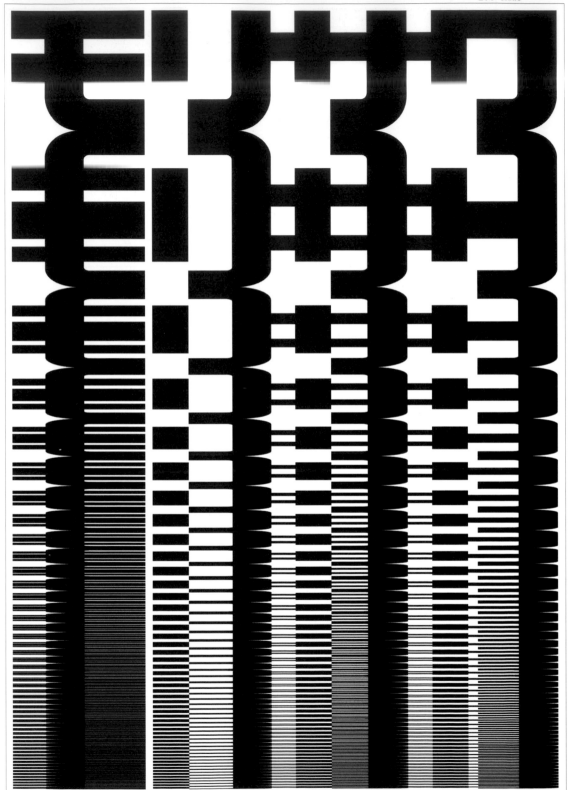

Morisawa 5

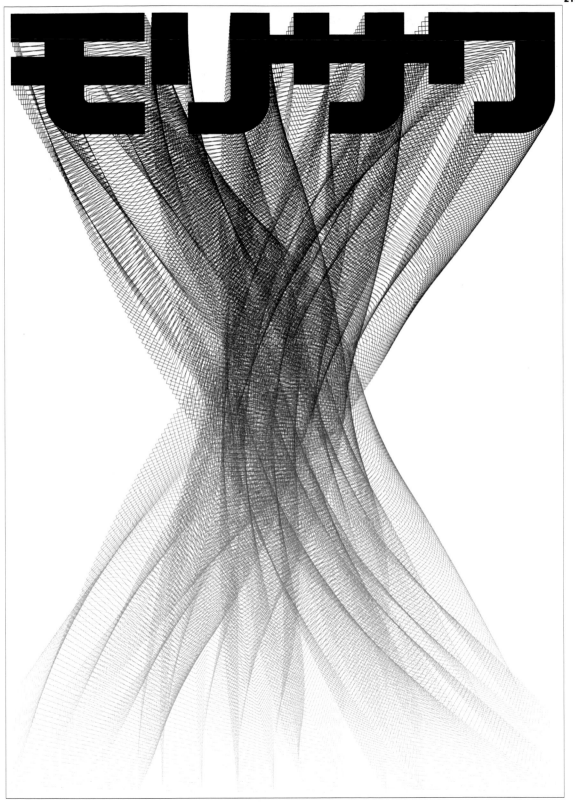

モリサワ

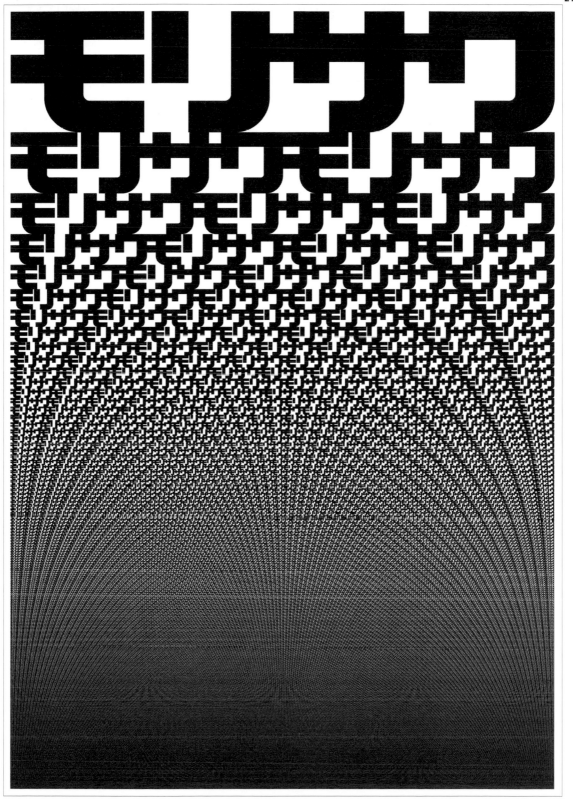

Morisawa 8

モリサワ

Morisawa 9

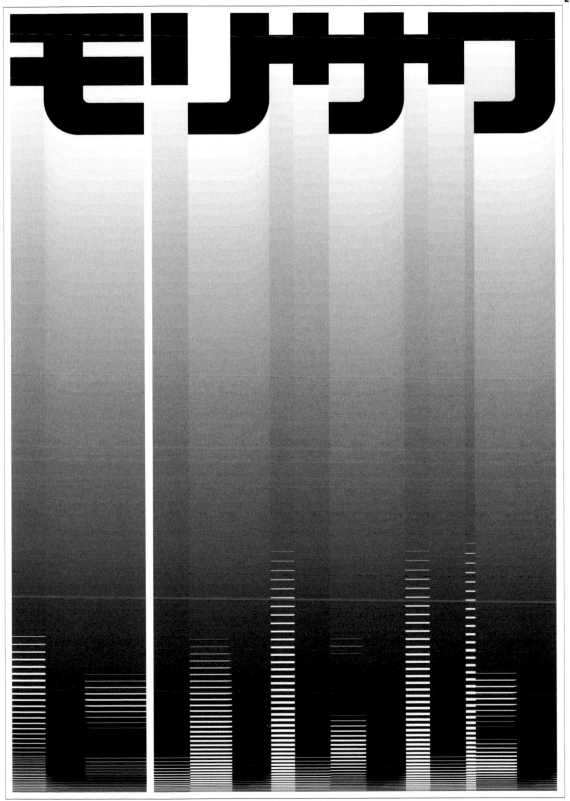

Morisawa 10

123rd Ginza Graphic Gallery (GGG) Exhibition, "John Maeda: Paper and Computer" (1996), in Tokyo.

Fifty lithographs and twenty powerbooks on display. →

Counting to 123 and beyond.

The 123rd GGG Exhibition, poster

前田ジョン「かみとコンピュータ」展

ギンザ・グラフィック・ギャラリー第123回企画展　1996年8月2日(金)—8月27日(火)

ggg
GINZA GRAPHIC GALLERY

The 123rd GGG Exhibition, poster nvitation Similar idea of counting, this time in Japanese.

Dai-Nippon Duo Dojima Gallery (DDD), poster Exhibit traveling from Tokyo to Osaka, shown as each kilometer explicitly spelled out.

7 *four colors* Bradbury Thompson's landmark work in reformulating the printing press as a custom illustration tool captured a spirit that has evaded contemporary digital design. Most of today's digital composition tools are fundamentally incapable of being reduced to smaller parts that might be reconstituted in new ways. Considering that software is generally designed in a modular, layered fashion and is mutable to more than one single interface, this seems strange. Software must become truly *soft,* capable of being molded and recast into new tools by the will of the artist. We see aspects of this attitude in the scriptability of most of the new releases of applications, mainly to enable increased automation and greater productivity. But the truly creative mind will prefer to wander rather than repeat her greatest hits over and over again—and we also know that greater productivity often translates into poorer quality. There needs to be a concrete set of core advancements in the tools we use, not just incremental updates. To realize such a future, more artists must be unafraid to peer deep inside the machine and directly affect a deconstruction of the software systems that imprison all digital expressions.

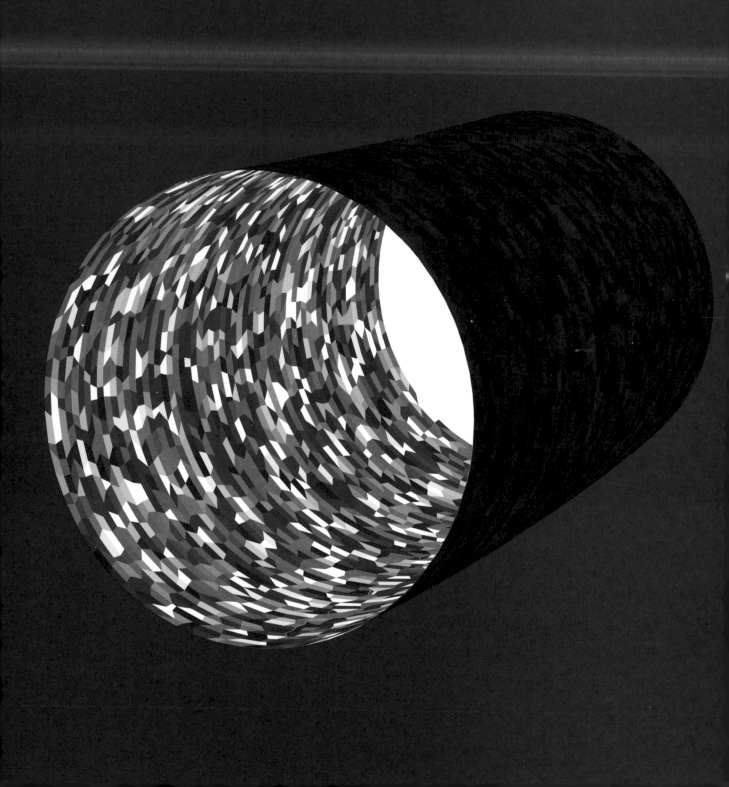

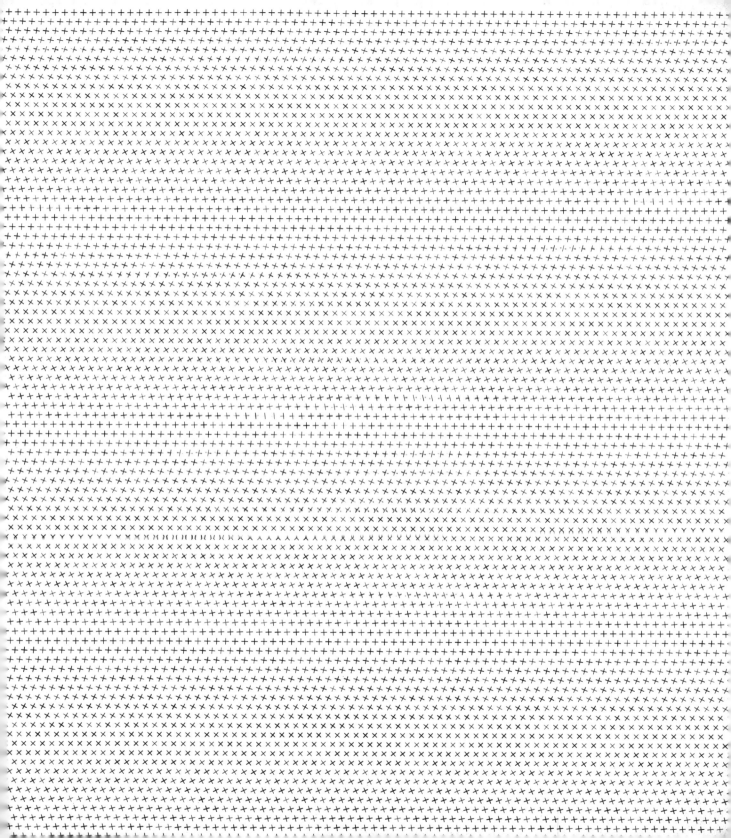

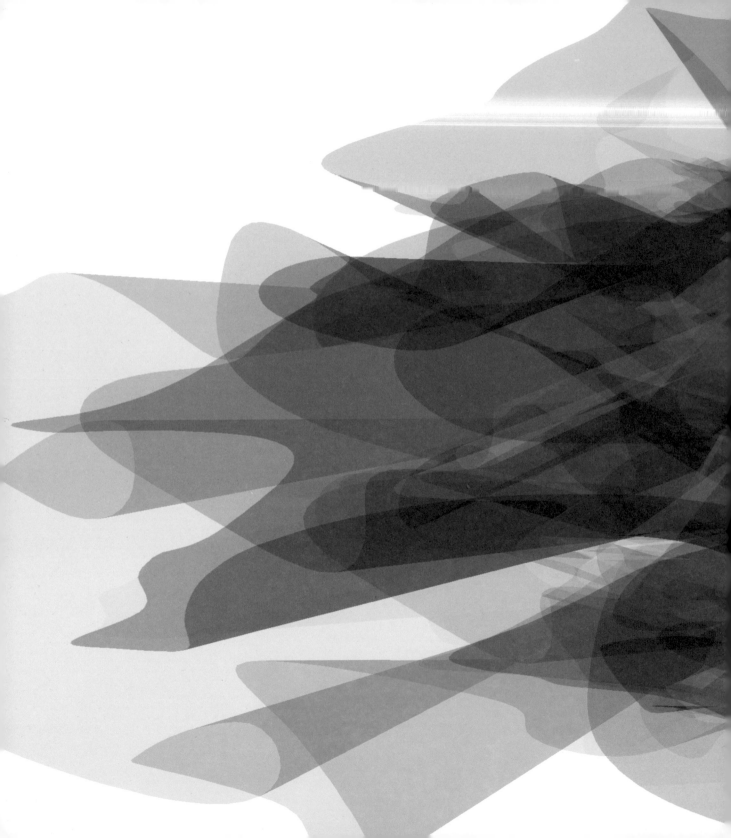

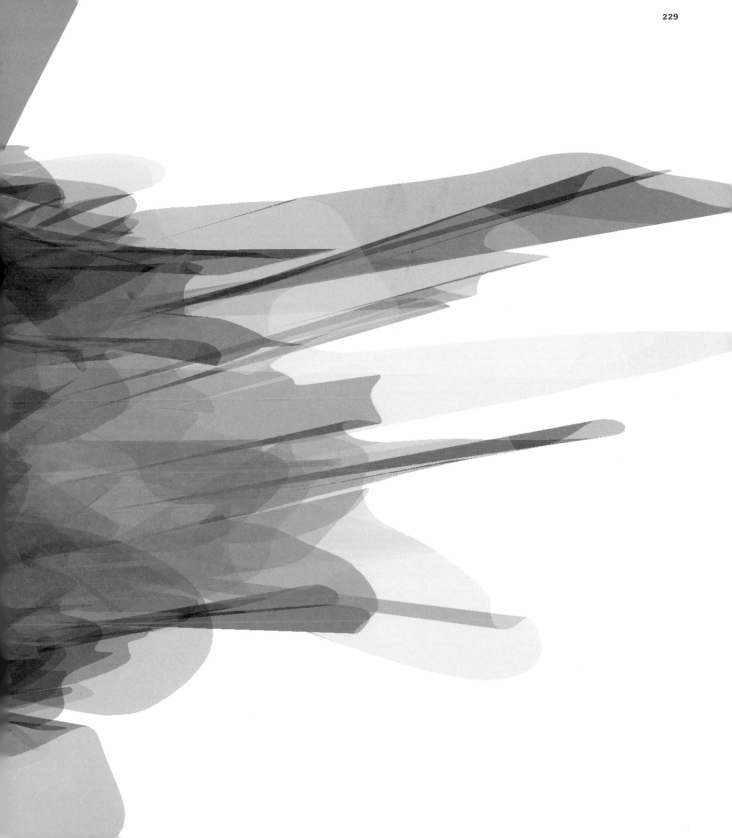

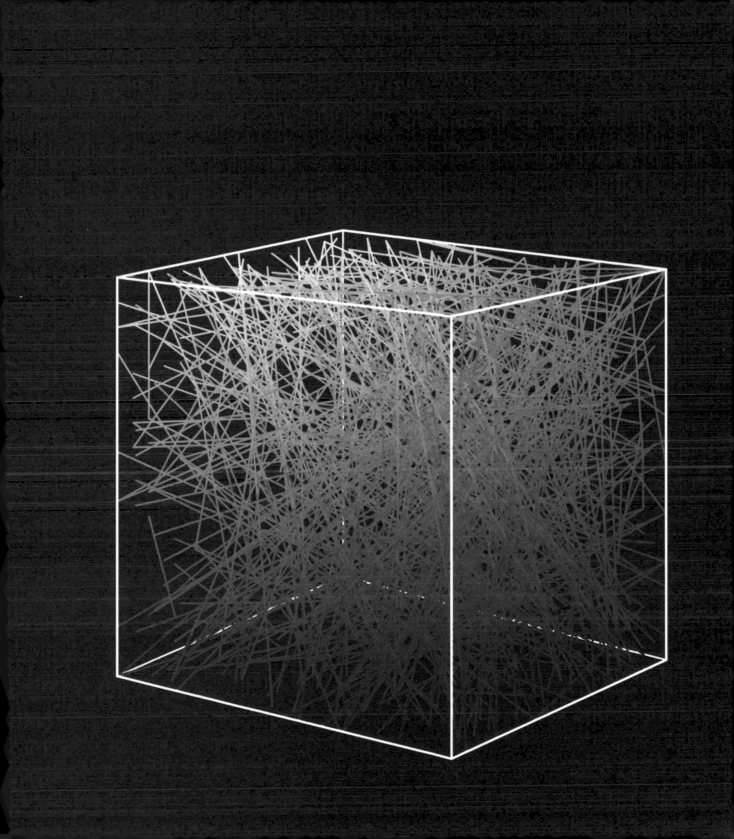

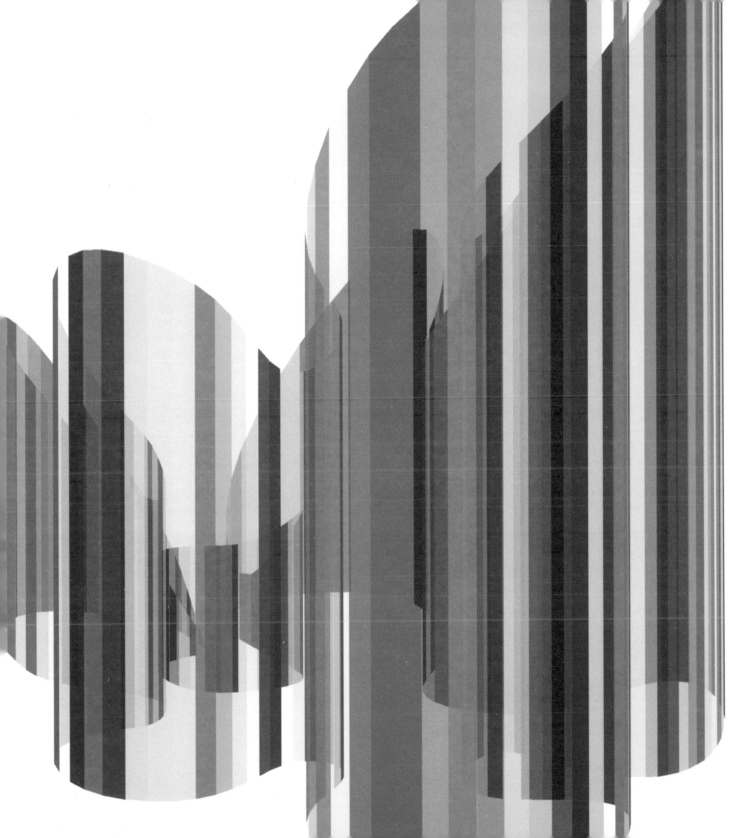

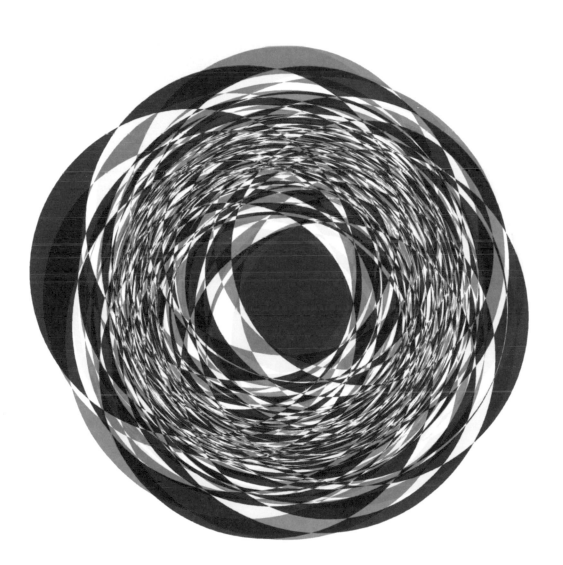

8 *online* For a long period, work on the computer was limited to transmission by slides, video, or in printed form. When it first appeared, cd-rom was hailed as the only medium capable of delivering large quantities of digital content to the masses. Although inexpensive to physically produce in large quantities, cd-rom technology unfortunately had difficulty in finding a proper distribution channel. The emergence of the world wide web finally made it possible to broadcast digitally originated content en masse, and overnight made digital creative activities as legitimate as those in print. Initially, most work centered around the basic hypertext metaphor intrinsic to the web's html format; my favorite capability of html was to make text blink, which was everyone's least favorite feature. Unfortunately, it has since been removed, which is quite a pity considering that, as a kinetically motivated typeface styling, it was a big step beyond bold and italic. Around this time Paul Rand asked me a surprising question, "So, this work you do on the computer is interesting, but how are you going to make any money doing it?" The java programming language made it possible to create distinguishing content, at least for a while.

When the web first took hold, Kaoru Matsuzaki of Sony had the vision to commission designers to create unique front pages for the now-extinct SonyDrive. All pages had to be static in nature and within a specific size. →

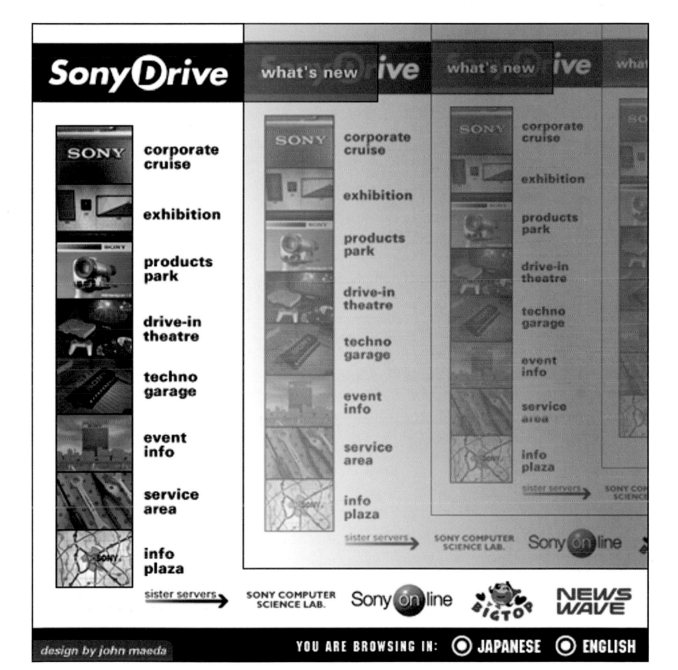

Ms. Matsuzaki was called off to a remote
area in Japan and was unable to
manage the project. A replacement was
assigned, and I quickly became
reminded of Paul Rand's insistence that
a good design requires a good client →

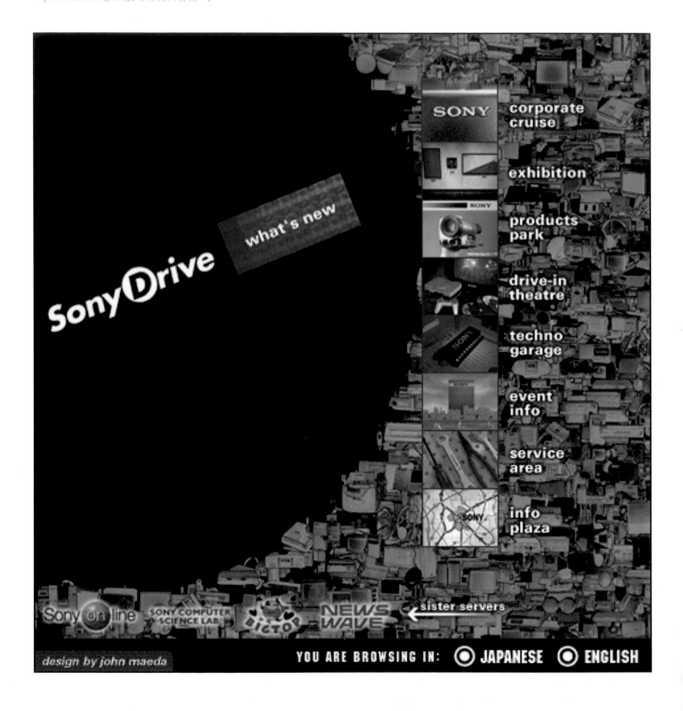

For the remaining term of the commission, I reluctantly received changing demands of smaller, less, smaller, less, and so on. A printing analogy would be to demand less color, less ink, and, most critically, less paper area.

As the web has evolved from conventional static expressions to realtime dynamic expressions through a variety of advanced technologies, it is clear that the greatest challenge is not just to realize the content but to ensure that it will run for at least a week after it is launched. The term "standard" when discussed in relationship to the web takes on a new meaning when version numbers seem to append and increase faster than anyone can keep up, jeopardizing the integrity of content created for older versions of the web.

A series of online works from Shiseido commissioned by creative director Michio Iwaki resulted in the bulk of my experiments for the web. With projects ranging from e-cards to games to calendars, I experimented in the java language with complete freedom.

In conjunction with the launch of Shiseido's online orchid-ordering system, Mr. Iwaki asked me to design an orchid-theme card-making system for Shiseido's website. To echo the great variety of orchids, the card system would be equally varied and built in the then-emerging java standard. →

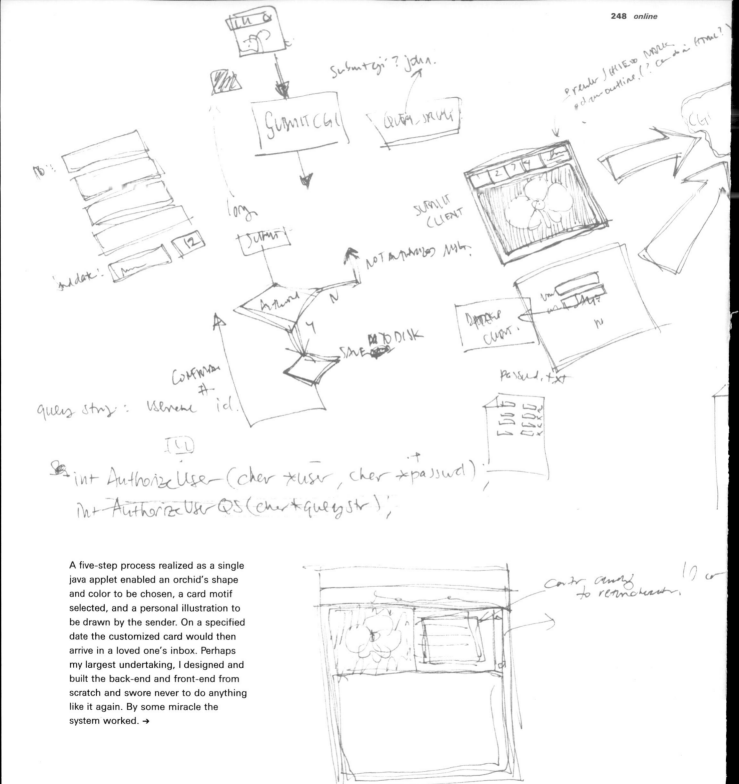

A five-step process realized as a single java applet enabled an orchid's shape and color to be chosen, a card motif selected, and a personal illustration to be drawn by the sender. On a specified date the customized card would then arrive in a loved one's inbox. Perhaps my largest undertaking, I designed and built the back-end and front-end from scratch and swore never to do anything like it again. By some miracle the system worked. →

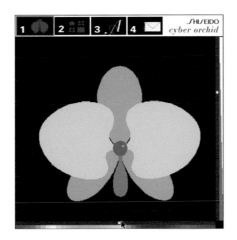

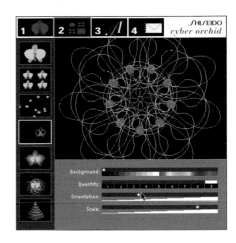

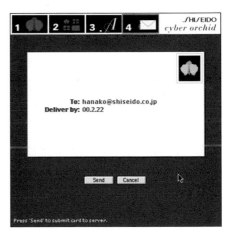

Designing a temporal form versus a static form can appear to be more difficult because there are proportionately more images to imagine and create. It turns out that the effort required to execute either situation is essentially equivalent when constructed from the programmatic standpoint. A properly constructed programmatic form is by definition of a variable nature, but if the core visual idea is without any real worth, its variations will prove no better.

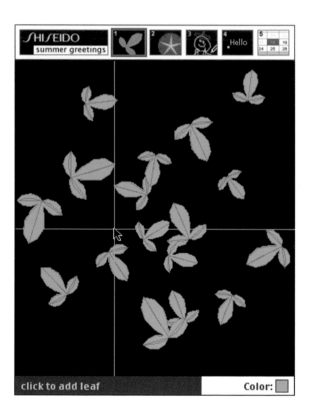

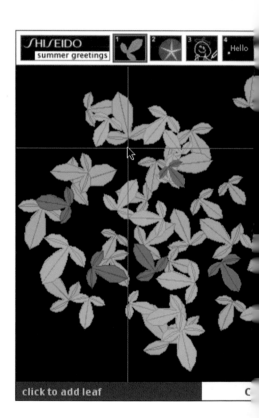

With an increase in java's reliability and the continual acceleration of consumer personal computers, I redesigned the basic card system around a more ambitious, time-enhanced simulation of morning glories that open gracefully. →

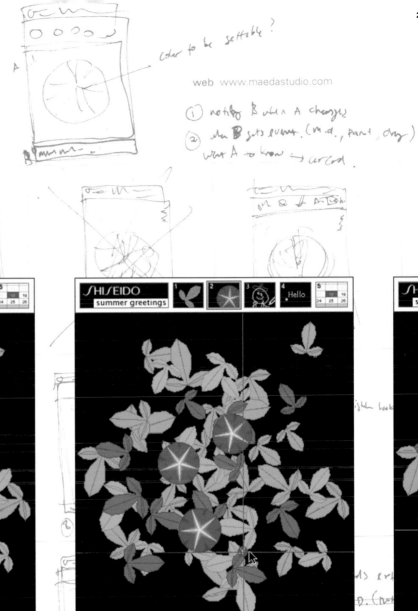

web www.maedastudio.com

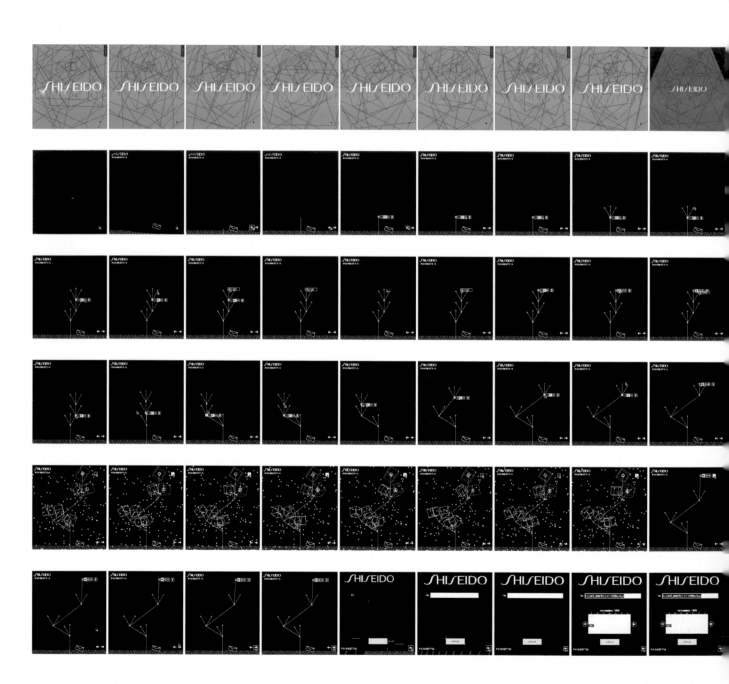

Experiment in a seamless experience of animation and interaction with a Cubist-inspired poinsettia-theme card service. →

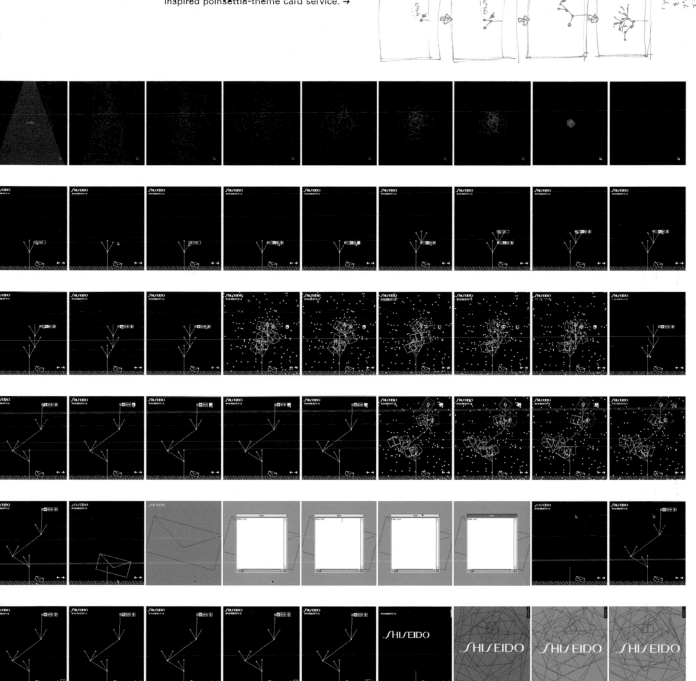

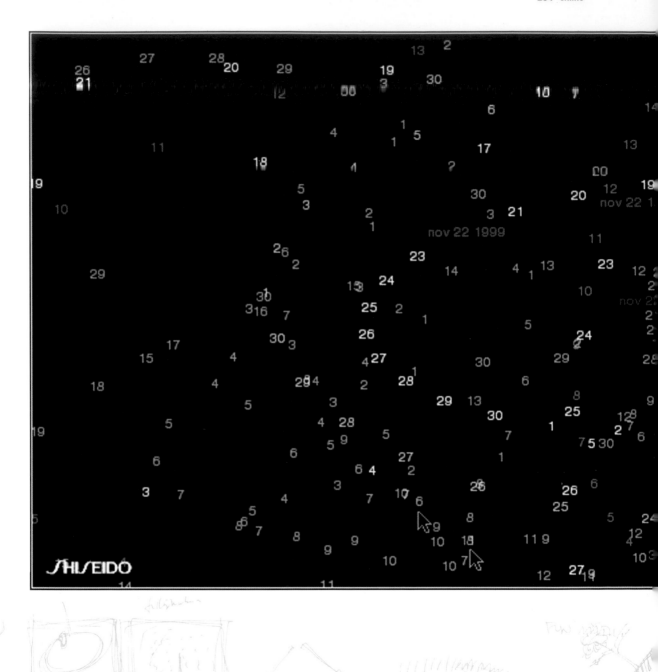

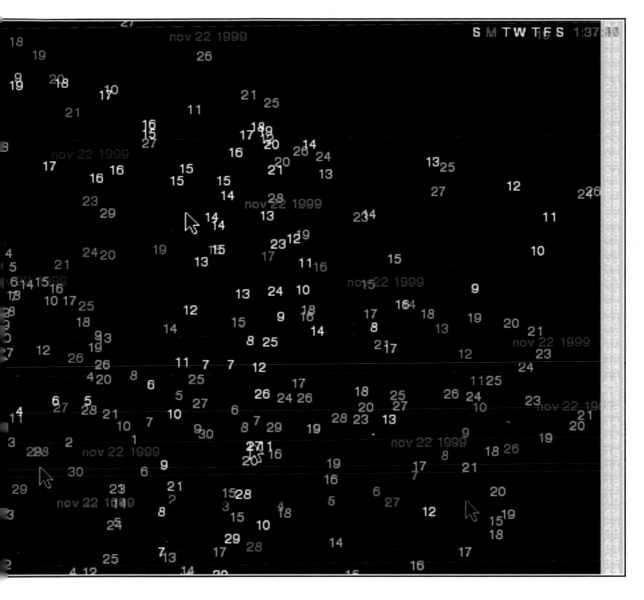

A calendar to celebrate the beginning of 1997 as a series of dynamic orbital rings. As the mouse is dragged, a new orbit is revealed and left as a trace. →

The design of a calendar is a useful exercise for developing skills in the perception of time. With each new season comes a significant change in the environmental surroundings that affects your lifestyle, dress, and body condition. To consciously map a numerical form to the natural rhythm of the earth requires a careful synthesis of math and spirit.

Twelve months viewed as 365 days viewed
as 8,760 hours viewed as 525,600 minutes
viewed as 31,536,000 seconds. →

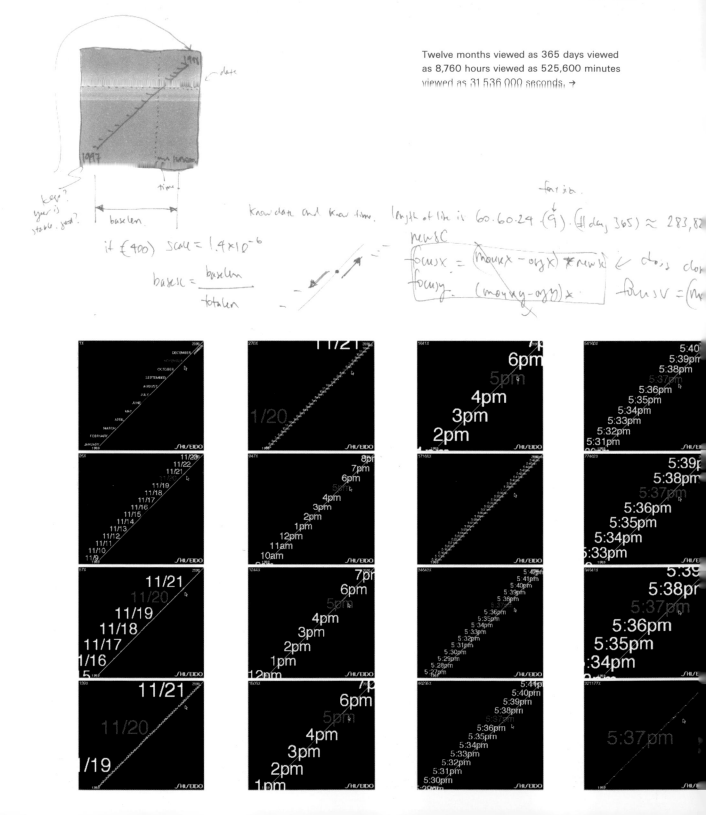

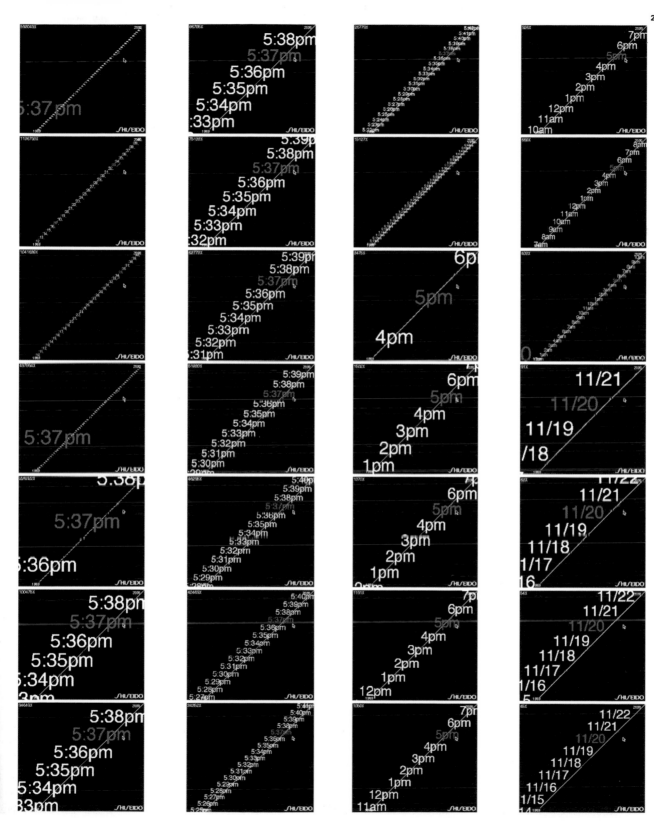

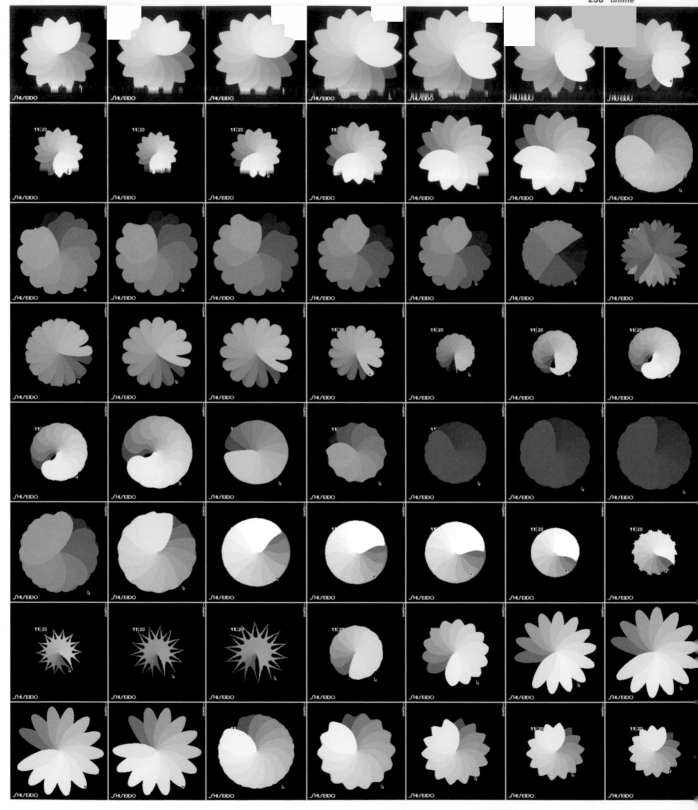

Calendar designed to celebrate spring
1997 as a series of floral petal trans-
formations. A click reveals a new petal;
a drag amplifies or reduces the visual
area of the spinning flower. →

In Japanese the word for fireworks is
hanabi, which literally means "fire flowers." →

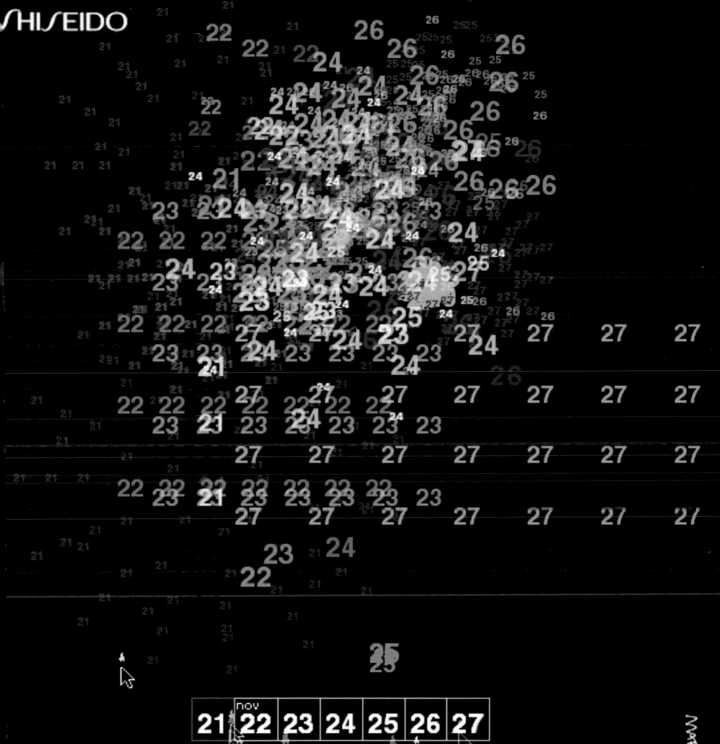

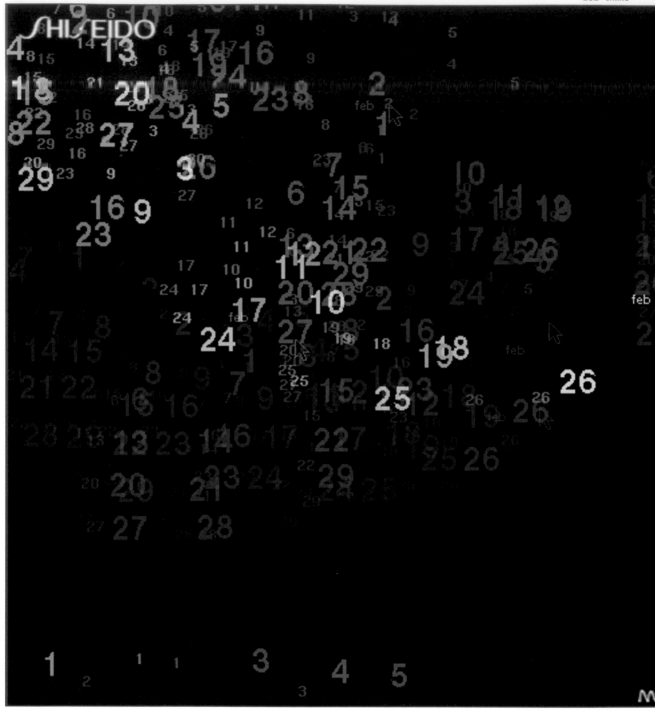

The fall of New England as a bough of numbers. →

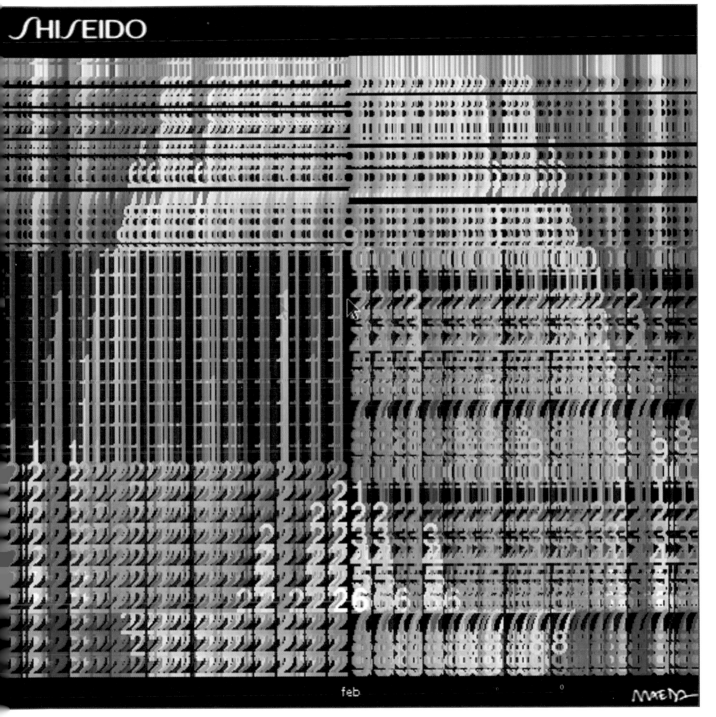

The memory of an escape to Cape Cod. →

Winter remembered as an origami-like snowflake. Depending on the direction in which the mouse is spun around the center, the crystal increases or decreases in complexity. →

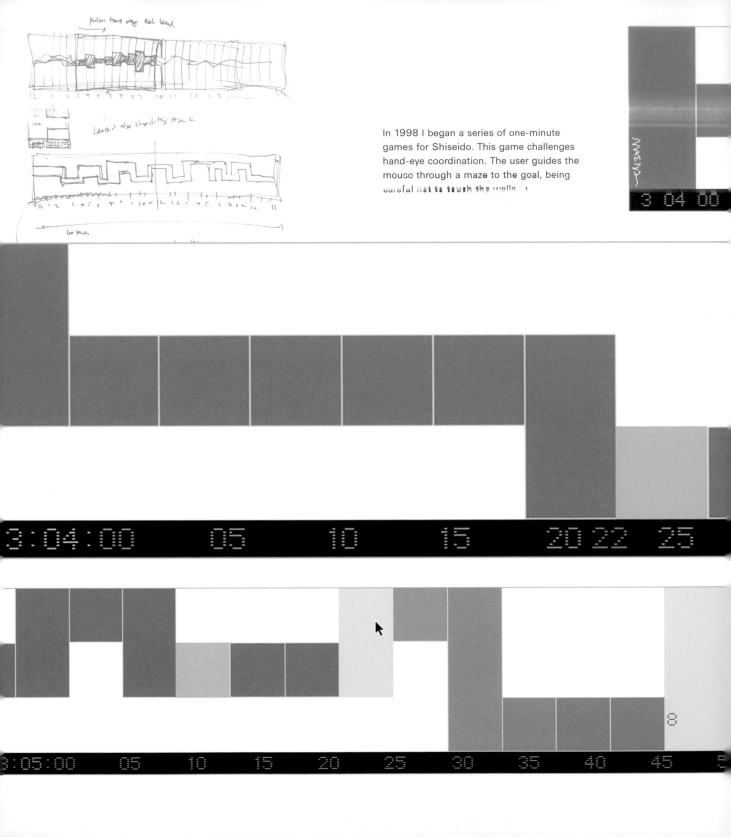

In 1998 I began a series of one-minute games for Shiseido. This game challenges hand-eye coordination. The user guides the mouse through a maze to the goal, being careful not to touch the walls.

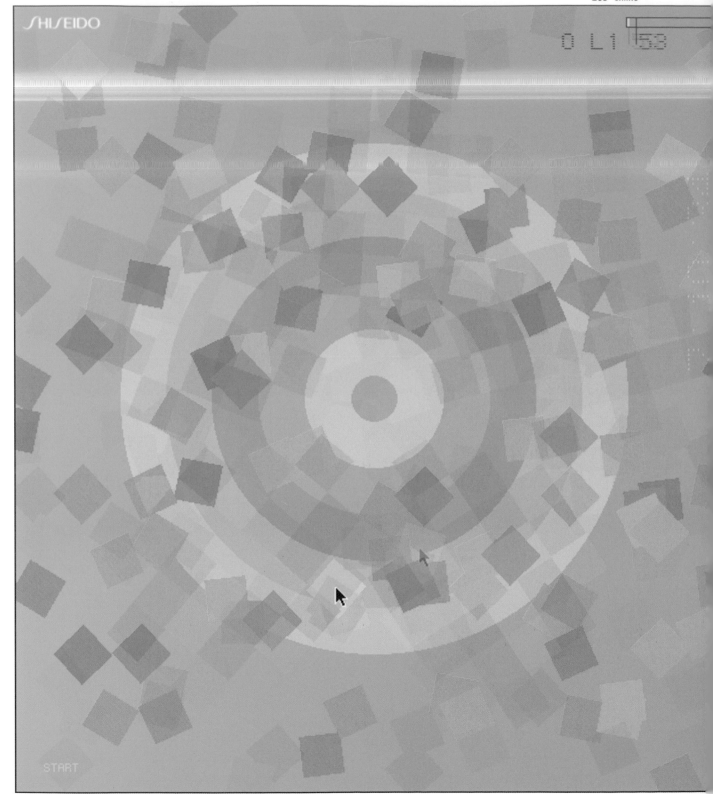

/HI/EIDO

0 L1 53

START

The computer is useful for managing a large set of similarly behaving elements. It is when the elements are dissimilar in size, shape, attitude, and behavior that most methods of programming fail. A completely new paradigm and kind of mind will be required to navigate the construction of future systems that scale infinitely.

Catch as many cherry blossom petals as you can in one minute. →

Racing through a winding maze of twists and turns in one minute. →

In a game of strategy and vertigo, the player starts from the spinning center and attempts to navigate a path to the outermost layer in a variably rotating set of circles.

When a path traveled through interactive space is not in a planned horizontal or vertical motion, there can be a sense of thrill similar to riding a rollercoaster. For some it is an unwanted ride, in which case they should just get off; for others, it is a welcome moment of dizziness in an otherwise routine day.

Unsolicited proposal for a denim pattern simulator for a jeans manufacturer.

If a business proposal does not make immediate sense to a potential client, do not bother to desperately express the originality of your ideas. Exit gracefully, and trust that fate will guide you to a believer.

ABCDEFGHIJKLMNOPQRSTUVUXYZ
abcdefghijklmnopqrstuvuxyz

Tangram typeface designed in 1993, dynamically reinterpreted in 1998 to celebrate the launch of the InterMedia Design Association in Japan. All seven geometric parts of a tangram are continually conserved across all letters, thus each letter freely morphs into another as subpart transformations.

The reinterpretation of a static piece as a dynamic form is usually a bad idea unless the original static form has either been developed with some degree of variability or is an unfinished work. An unfinished work represents a non-terminating point, which is precisely the rationale for any purely motivated dynamic form.

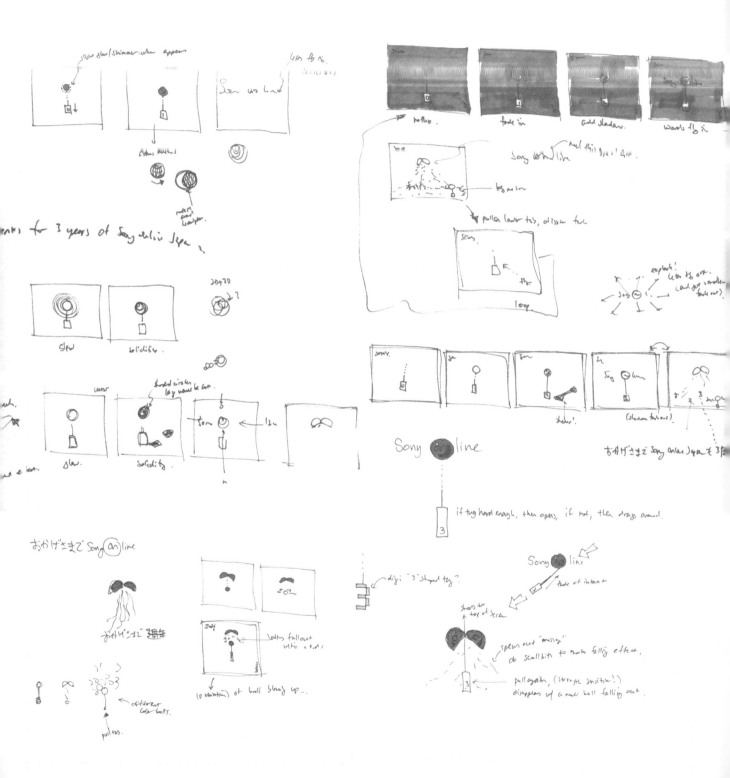

3rd Year Anniversary graphic for Sony Online

The majority of kinetic constructions I make today are limited to no more than three hours of total construction time. My reasons for doing so are a mixture of damaged hands, enforcing a small program footprint, and a desire to keep the program as simple as possible.

Ginza Graphic Gallery (GGG) Time graphics for three galleries managed by Dai-Nippon Printing Company.

Because of their implicit use of mathematical structures, geometrically derived forms are perfect candidates for kinetic reinterpretation in the computational domain.

Center for Contemporary Graphic Art (CCGA)

Dai-Nippon Duo Dojima Gallery (DDD)

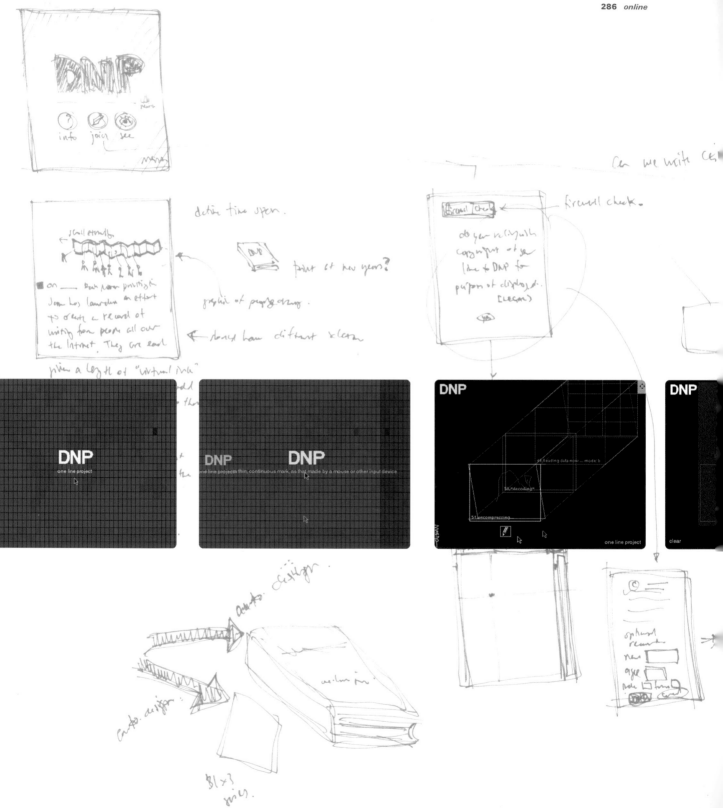

DNP
one line project

DNP
one line project thin, continuous mark, as that made by a mouse or other input device

DNP
one line project

DNP
clear

It is doubtful that there will be great web designers in the manner that there were great print designers, such as Paul Rand, Saul Bass, Josef Müller-Brockman, and Yusaku Kamekura, for the simple reason that designing for the web exacts a curse with each project. Once printed, a print piece is finished; only in the rarest cases does it come back. A web piece is never finished, even after it is officially delivered and launched. Making sure that it works with every new browser release and operating system is alone a full-time job, which despite perhaps being a profitable support business, is another set of creative shackles that prevents your mind from running free.

 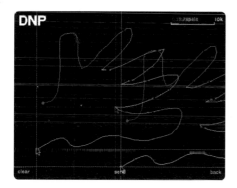

The One Line Project was conceived for Dai-Nippon Printing as a long-term web-based art project with the goal of spanning the circumference of the earth with a single connected digital line. Participants from around the world enter a stroke that is connected endpoint to endpoint with all the other strokes collected by the server.

An online digital Japanese typeface composed in four hours by eighty workshop participants in March 1997.

9 *noise* According to basic information theory as formalized by Claude Shannon in 1948, information can be mathematically modeled as a stream of variable amounts of noise. In essence, the noisier the stream, the more "information" there is. As a result, by application of a simple equation it is possible to show that an expressionist painting by Jackson Pollock has infinitely more "information" than a suprematist painting by Kasimir Malevich. Though this is an unsurprising result from an immediate perceptual perspective, it is inaccurate when considered from the perspectives of content and context. Meanwhile, the computer forces our society to think within the metrics of information— its continually reported size in kilobytes acts as a constant reminder. We are implicitly guided by the belief that more is better, and as a result expect extreme chaos or any other mode of lavish detail to signify success in the digital medium. The shortest path to the destruction of order is to introduce massive irregularities induced by random noise—a process often glorified as intentional homage to the spirit of dada. Noise should neither be seen as noble nor as a necessary improvisational aid; it is a numerical color that can be quickly overused.

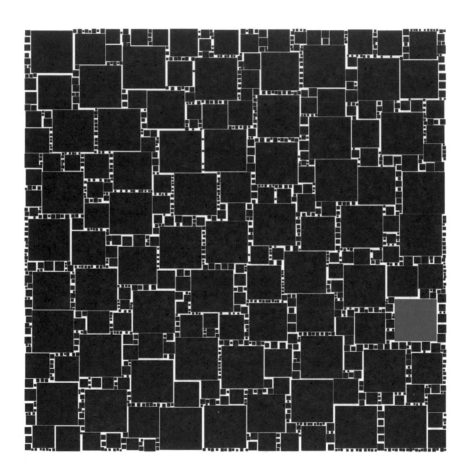

10 *now* After beginning my first reactive graphic experiments, I sent an e-mail from Japan to Muriel Cooper: "I figured it out!" She was notorious for never answering but replied, "Good. Show me." I was greatly saddened when I learned she had passed away just a week later, and I would be unable to show her what I had begun to uncover. A few years later, the head of the department, Whitman Richards, led a search to return the spirit of design to M.I.T.'s Media Lab. Considered a candidate, I was asked to give a job talk at M.I.T. The day before my talk I had met Paul Rand at his house in Connecticut and was in such high spirits that I cared little about the position. This must have been a useful attitude as I was subsequently offered the job. With my new teaching commitments, I worried that I wouldn't be able to continue designing, but the head of the lab, Nicholas Negroponte, reassured me that the job was to spend four days a week at the institute and the "other three days" to pursue my design career. "How nice," I thought. With the time left over from managing my research group, I continue to experiment in reactive, static, and online media. I hope to carry on.

Essay for *IDEA* magazine, Tokyo 1997.

As a graduate student at M.I.T. I stumbled upon a thin, nondescript book called *Thoughts on Design* by Paul Rand. At the time I was trying to build a reputation for myself as a graphical user interface designer. But as I flipped through Rand's book, I was humbled by the power with which he manipulated space and the clarity of his prose. I was immediately inspired to pursue the field of graphic design, not necessarily pertaining to the computer.

It was fitting that eight years later, I would return to M.I.T. as a professor of design, and that I would host a lecture by Paul Rand at M.I.T. The time for the lecture was set at ten in the morning. An early lecture in American universities is rare because students usually study late into the night and are less apt to attend early events. But Rand insisted that he speak in the morning. He said, "If someone isn't willing to wake up to hear me to speak, I don't want to speak to them!"

The auditorium was packed beyond capacity with people from all over New England, some waking up as early as five in the morning to arrive in time for the lecture. The Director of the Media Lab, Nicholas Negroponte, later remarked that during his career at M.I.T. he had never seen such an overwhelming audience for a morning lecture. Although the lecture hall was crowded, complete silence reigned as everyone's attention was completely focused on Rand.

The night before the lecture we had dinner together. Afterwards he asked me, "So, what are we going to talk about tomorrow?" My immediate reply was, "We?" He said, "Yes, it's boring if I just get up there and talk. So let's have a conversation first." Following Rand's request, I began with some very basic questions.

PR: I've waited eighty-two years to come to this place. I knew Gyorgy Kepes and Muriel Cooper, but they never invited me. I'm wondering why Mr. Maeda invited me at this late date, but I'll do my best.

JM: What is design?

PR: Design is the method of putting form and content together. Design, just as art, has multiple definitions, there is no single definition. Design can be art. Design can be aesthetics. Design is so simple, that's why it is so complicated.

JM: What is the difference between a designer and an artist?

PR: There is no difference between a designer and an artist. They both work with form and content. I try to create art, whether I make it or not is not up to me, it's up to God.

JM: What is the difference between *good* design and *bad* design?

PR: A bad design is irrelevant. It is superficial, pretentious … basically like all the stuff you see out there today.

JM: What are the fundamental skills of a designer?

PR: The fundamental skill is talent. Talent is a rare commodity. It's all intuition. And you can't teach intuition.

JM: Most of your designs have lasted for several decades. What would you say is your secret?

PR: Keeping it simple. Being honest, I mean, completely objective about your work. Working very hard at it.

JM: How did you get started as a young designer?

PR: (raising his eyebrows) I think you should ask instead, "How did I get started as a baby?"

After his lecture, Rand offered to autograph copies of his books and there was a line that did not clear up until an hour later. I tried to shuttle him off to a private reception but he refused to leave until all the people in line were signed and served.

His lecture was so well received at M.I.T. that Dean William Mitchell and Negroponte suggested that Rand join the faculty at the Media Lab and we immediately began the process of appointing him. Negroponte wanted me to confirm Rand's interest in joining the Lab, after which we faxed Rand explaining the situation. He replied, "Of course I accept the position." A few days later he passed away.

*Graphic design
which fulfills aesthetic needs,
complies with the laws
of form and the exigencies
of two-dimensional space;
which speaks in
semiotics, sans-serifs, and
geometrics; which abstracts,
transforms, translates,
rotates, dilates, repeats,
mirrors, groups, and regroups
is not good design if it is
irrelevant.*

*Graphic design
which evokes the symmetria
of Vitruvius, the dynamic
symmetry of Hambidge, the
asymmetry of Mondrian;
which is a good gestalt,
generated by intuition or by
computer, by invention
or by a system of coordinates
is not good design
if it does not communicate.*

Paul Rand

Yale University Professor Emeritus
Designer of many of the canonical identities of corporate
America including ABC, IBM, Westinghouse, UPS, and NeXT.

Poster announcing lecture by Paul Rand at the M.I.T. Media Lab

*Paul Rand
at the MIT
Media Laboratory*

*November 14, 1996
10 am to 11:30 am*

*Bartos Theater
MIT Wiesner Building*

Open to the public and admission is free.
For information call (617) 253-0356, or visit http://acg.media.mit.edu/rand.

たて組 50 ヨコ組

TATE GUMI YOKOGUMI
MORISAWA QUARTERLY 1997

Cover artwork for *Tategumi Yokogumi* magazine

たて組 ヨコ組

50

TATEGUMI YOKOGUMI
MORISAWA QUARTERLY 1997

ISSN: 0913-9923

GILBER

BE GREAT

Gilbert Paper promotion (produced by Rick Valicenti)

REALM™ IMAGINE THE POSSIBILITIES

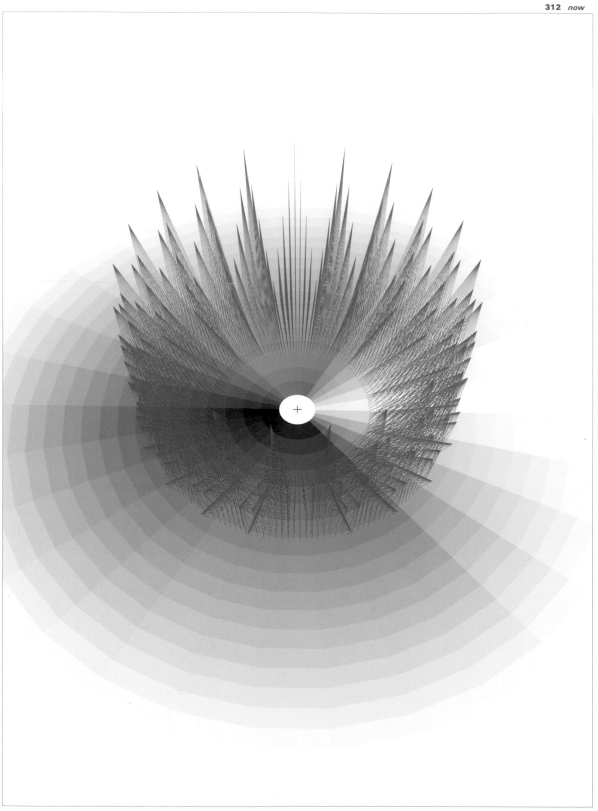

Gilbert Realm promotional book, page 3

Gilbert Realm promotional book, page 25

Gilbert Realm promotional book, pages 15 to 18 (gatefold spread)

EATPRINT™

REALM OFFERS A SMOOTH FINISH WITH **GREATPRINT** SURFACE ENHANCEMENT FOR EXCELLENT PRINTABILITY AND SUPERIOR INK HOLDOUT

Gilbert Realm promotional book, page 10

REALM EXCEEDS ALL EXPECTATIONS OF REALITY

Gilbert Realm promotional book, page 13

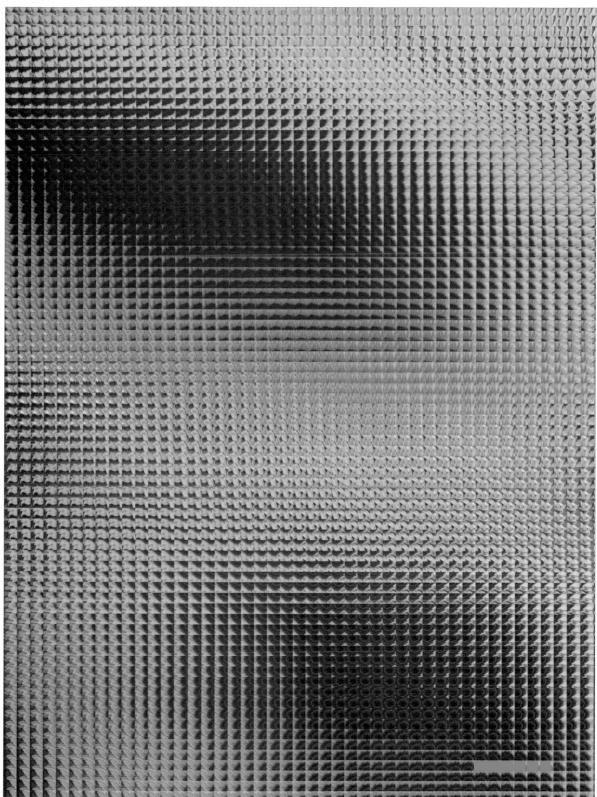

Gilbert Realm promotional book, page 31

Based on the electric typewriter as an homage to my mother's incredible typing skill, the fourth Reactive Book was entitled *TAP, TYPE, WRITE.* →

Sound as an effect, versus a necessity, is a difficult distinction to make. We expect most of our actions to result in reactions that are not only visual but aural. Without sound, one is distanced in reality from the reaction, making it more abstract. Once a sound is made, however, your body receives confirmation that the event is not imagined, but real.



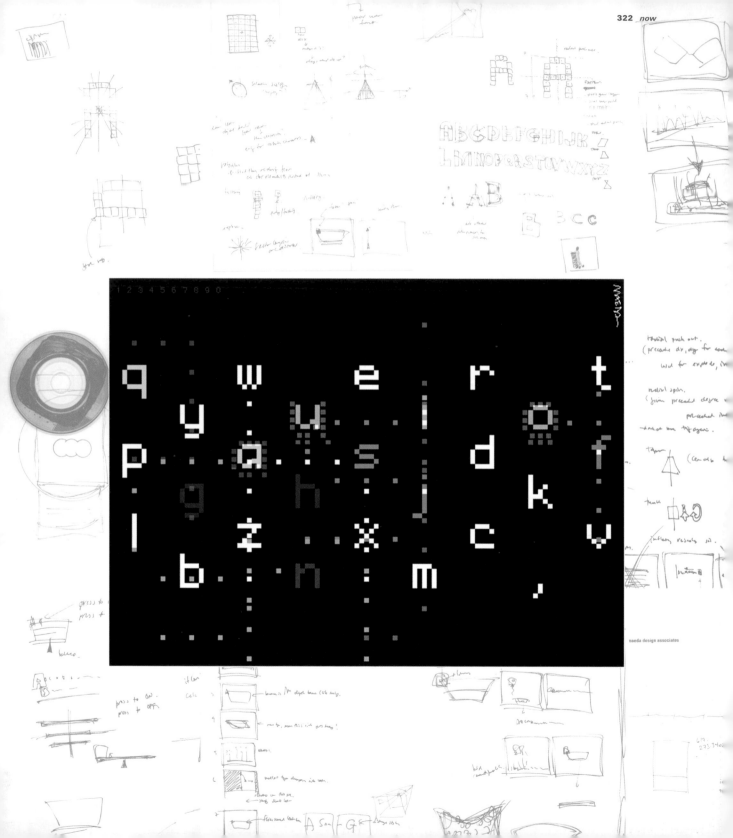

naeda design associates

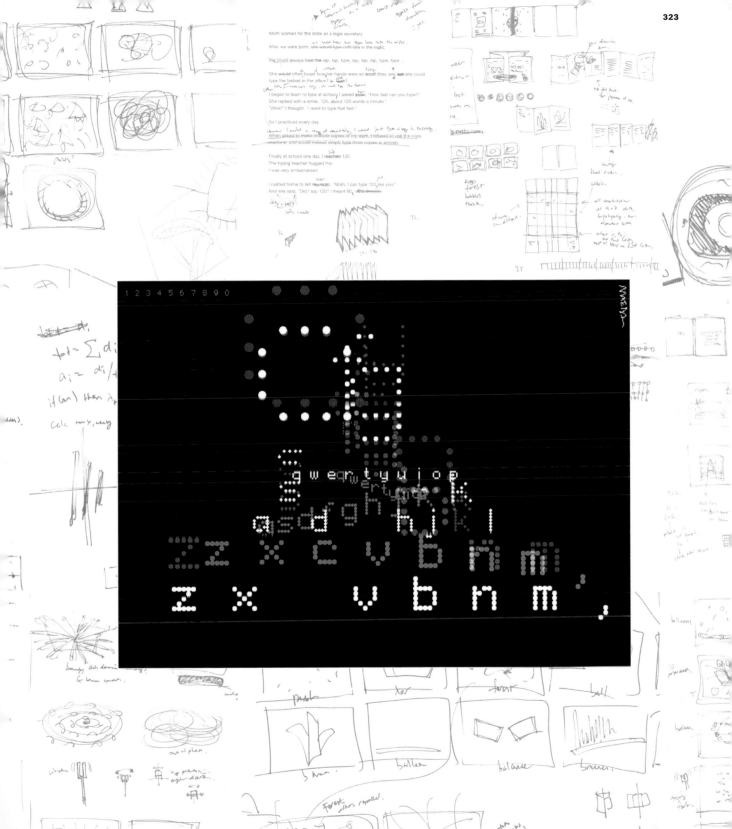

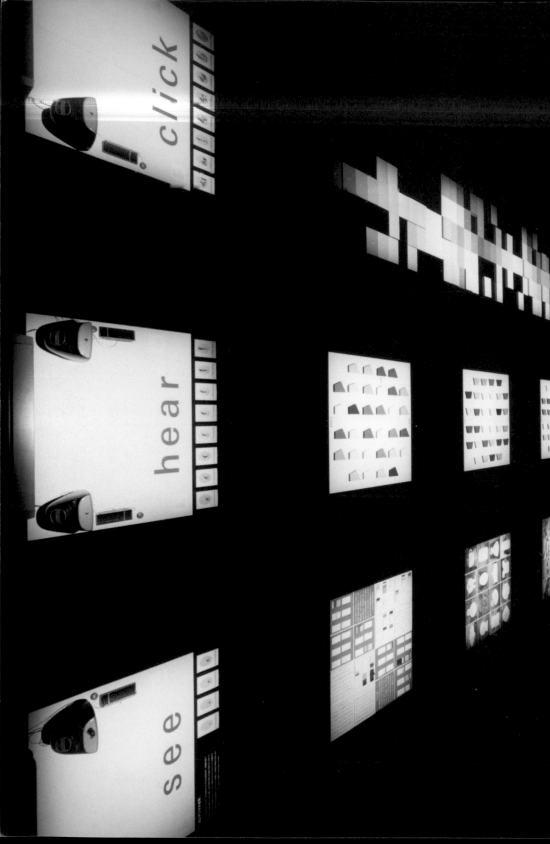

Cutting-edge content is most easily created under situations where great physical distances separate the client and artist. If the option to move farther geographically from the client is not possible, then achieving stature in one's field also appears to be a key factor. However, the latter approach is much less reliable, and often less meaningful than a healthy move.

Project for the Japanese paper company Takeo using three computers that respond to sound, mouse, and video input *(see, hear, click),* each of which generates related print-outs.

Perhaps the most powerful impetus for self-improvement is to be flatly told that your work stinks.

Proposal for a new launch page for the Media Lab. It was turned down because "it doesn't do anything."

The New York Times Magazine

OCTOBER 10, 1999 / SECTION 6

THE NEW NEW NEW NEW NEW NEW NEW NEW NEW NEW NEW NEW NEW
NEW NEW NEW NEW NEW NEW NEW NEW NEW NEW NEW NEW NEW NEW NEW NEW NEW
NEW NEW NEW NEW NEW NEW NEW NEW NEW NEW NEW NEW NEW NEW NEW NEW NEW NEW NEW
NEW NEW NEW NEW NEW NEW NEW NEW NEW NEW NEW NEW NEW NEW NEW
NEW NEW NEW NEW NEW NEW NEW NEW NEW NEW NEW NEW NEW NEW NEW
NEW NEW NEW NEW NEW NEW NEW NEW NEW NEW NEW NEW NEW NEW

THE NEW NEW THING

NEW NEW NEW NEW NEW NEW NEW NEW NEW

NEW NEW NEW NEW NEW NEW NEW NEW NEW NEW NEW

NEW NEW

NEW THING

How Jim Clark taught America what the techno-economy was all about. By Michael Lewis

Plus: Why Matthew Barney Matters, by Michael Kimmelman

A core challenge of digital art is to establish the relevance of a physical place in relation to virtual space. Drawing on the inherent similarities between the two spaces is a tiring theme that reveals nothing more than what is presented. Within their respective contexts, each space presents the differences as honest facts versus forced fiction.

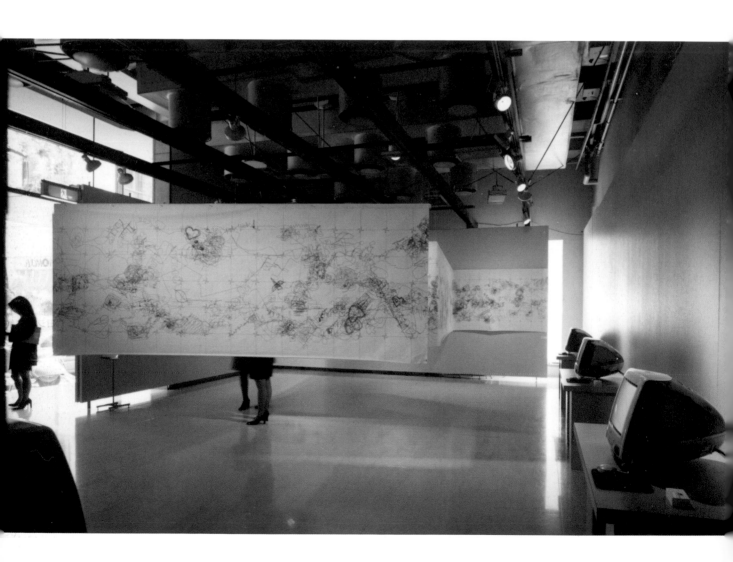

In August 1999 the status of the One Line Project was presented at the Ginza Graphic Gallery. An 80-meter-long print-out was displayed together with ten computers showing digital interpretations of the One Line Project data. →

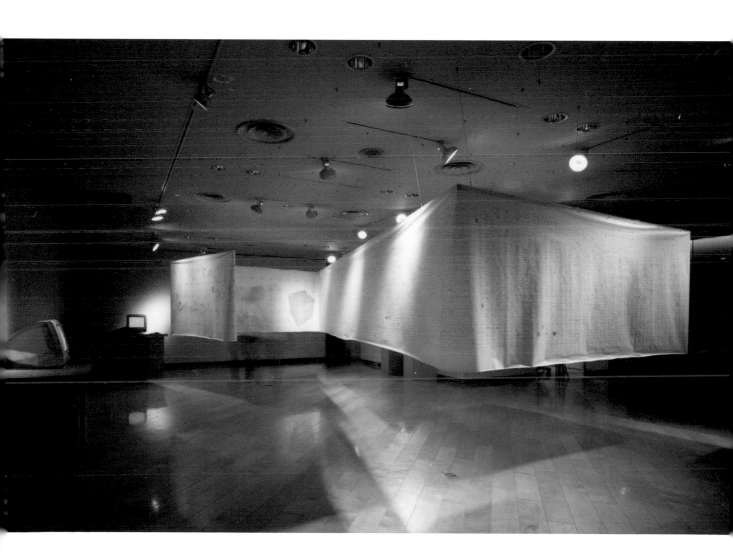

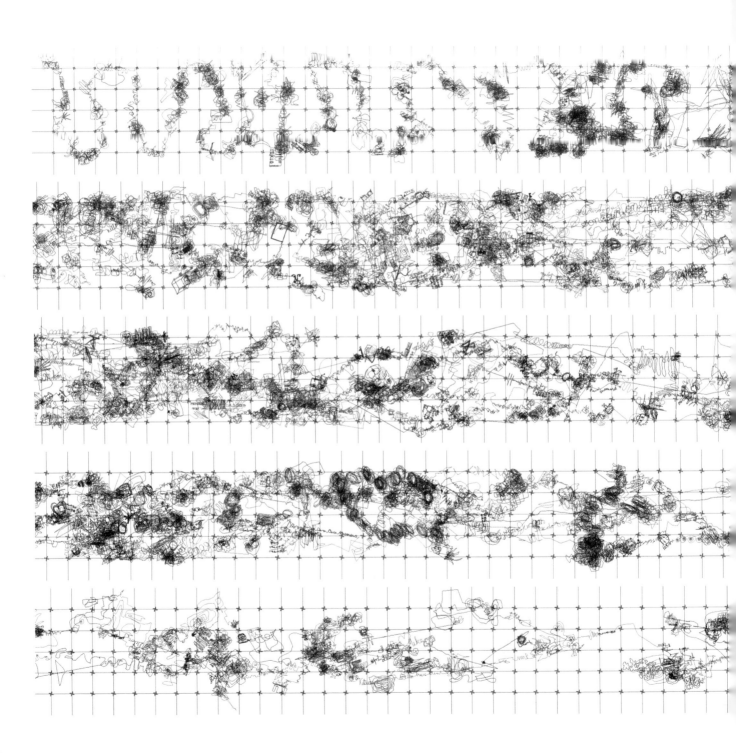

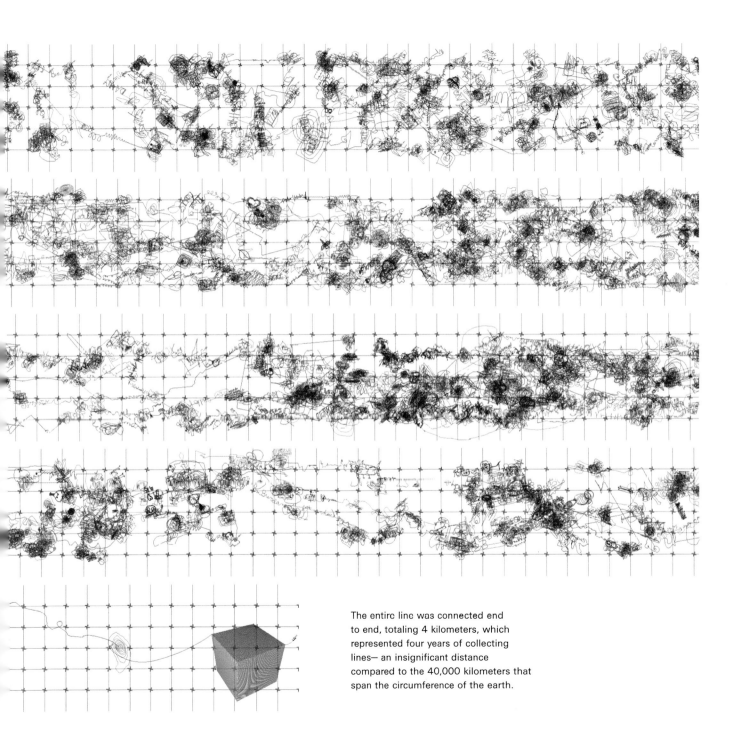

The entire line was connected end
to end, totaling 4 kilometers, which
represented four years of collecting
lines— an insignificant distance
compared to the 40,000 kilometers that
span the circumference of the earth.

Sketches and final artwork (opposite)
for an Absolut Vodka advertisement.

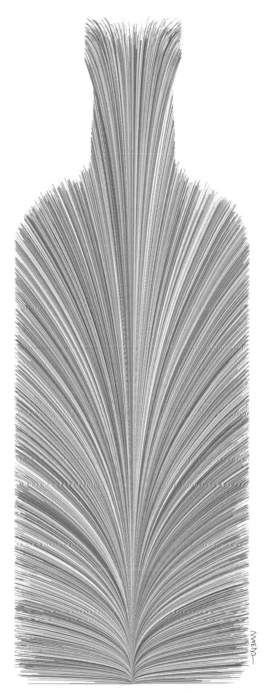

ABSOLUT MAEDA.

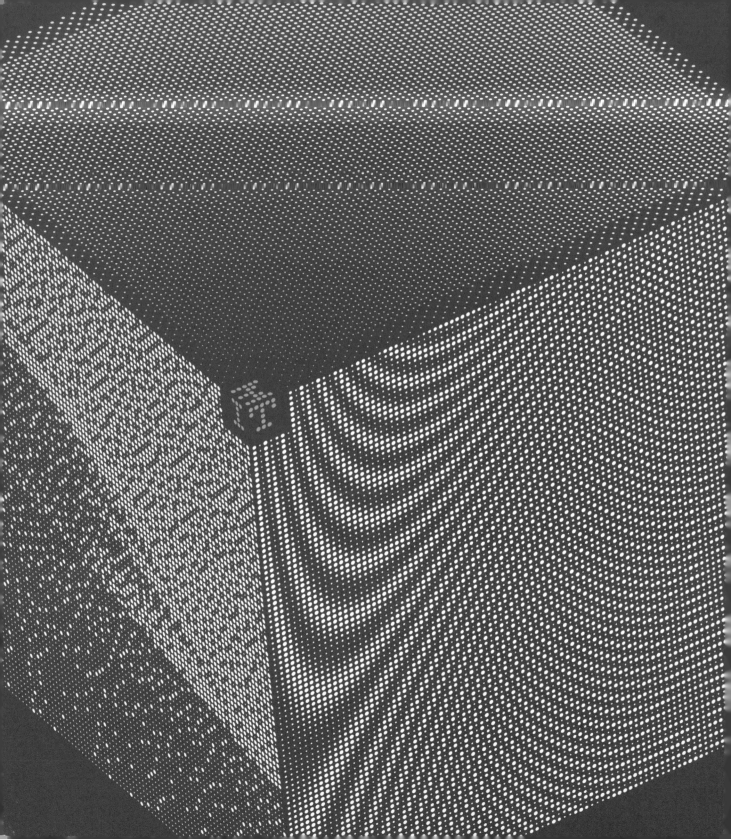

M.I.T. shirt created in reaction to the substandard generic collegiate T-shirts that prevail everywhere today.

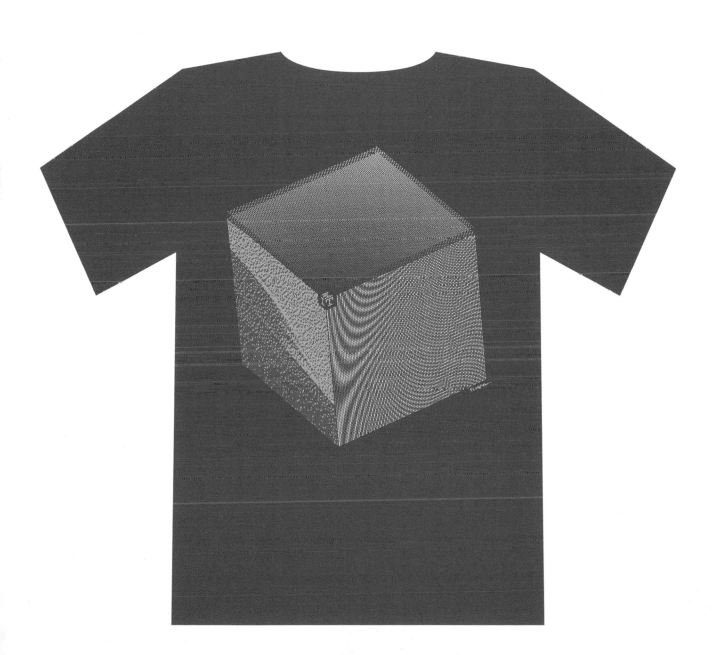

Poster for Ginza Graphic Gallery, Graphic Message for Ecology Exhibition

11 *space* In the religion of book design there are many interpretations of the truth, many faiths, many sects that silently clash in regard to proper margins, proportions, and, most importantly, the holy science of typography. For a time I was blissfully brainwashed to follow the absolute laws of the Swiss layout mantra—the Grid. Whenever I committed a sin such as the lackadaisical place-ment of a text block without exactitude, I was prepared to be struck down by lightning. Heaven forbid that I should rely solely on my intuition! Over time I realized that with consistency the lightning never came, and I further discerned that my .01-point precision wasn't worth anything unless I was willing to print and trim every single page of paper by hand. Perfection is an exciting goal, but the imperfect nature of the mechanical production process suggests that you seek more realistic thrills than perfection. Such excitement always lies beyond what is known to be creatable; it exists in the conscious *expansion* of creativity itself. Look deeply into a set of tools and materials and coerce them to reveal their hidden potential. Discover their core abstract properties by ignoring the constraints dictated by uncreative conventions.

start here ————

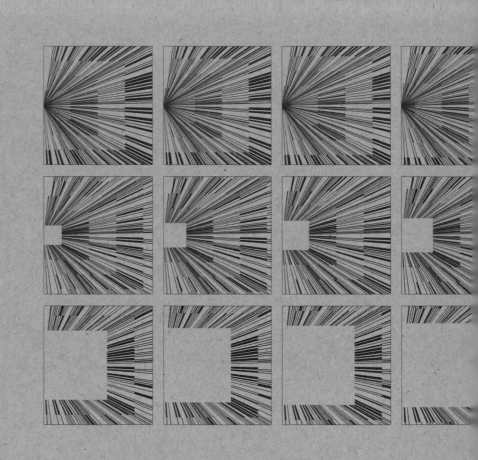

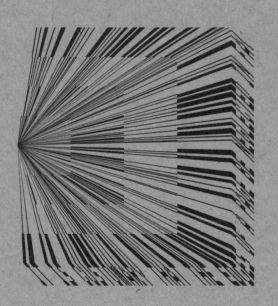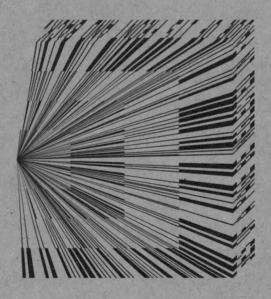

12 *computer* In Japan a *miyadaiku* is a carpenter trained in the ancient art of Japanese temple carpentry who attains special status from the emperor if the temple he builds stands for more than a thousand years. "Such temples," said one of the last *miyadaiku,* the late Tsunekazu Nishioka, "stand not because of the magnificence of their design, but because the *miyadaiku* goes to the mountain, and selects trees from the south face of the mountain to be used for the south face of the temple, trees from the west face of the mountain for the west face of the temple, and so on for the other two sides." Because building materials are carefully selected to respect the laws of nature, the temple coexists in harmony with nature. Both the extrinsic and intrinsic qualities of the temple radiate its overall strength and beauty. Meanwhile, in the field of digital art, an entire generation of creators shop at the equivalent of home improvement megastores, eagerly acquiring all kinds of prefabricated components and add-ons. Blissfully unaware of—or even worse, uninterested in—the basic nature of the technologies they are using as tools, the creative élite oversee the assembly of substandard digital objects and experiences.

I was inspired to creatively explore software in 1988 by the work of the incomparable animator-hacker Bob Sabiston. The result was a year-long immersion in an animation system motivated by ideas in sketching toward finished animated work. →

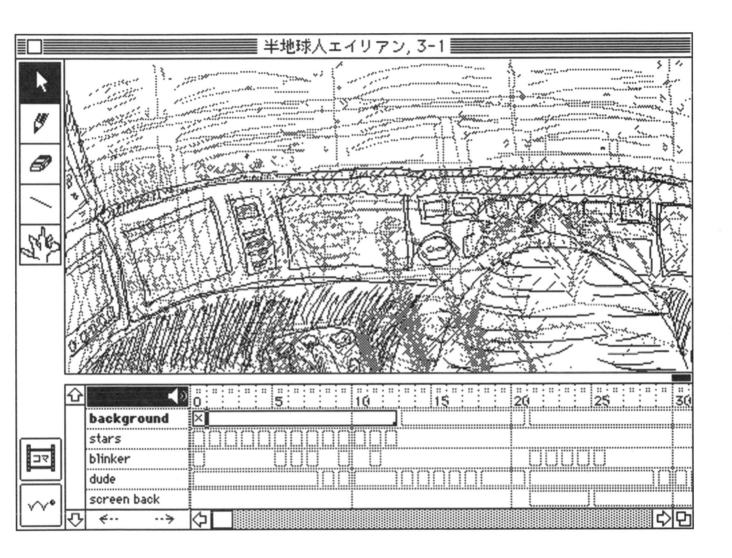

The dilemma for a person who builds tools for others is that she rarely learns how to use it for herself. As a selfless virtue, creating new tools for others is a commendable public service that has its own set of rewards, sometimes monetary, in which case the virtue value lowers proportionately. One can argue that the design and implementation of a software tool is by itself an extremely creative, artistic activity. History shows, however, that it is the artist who first effectively uses a new tool, not the person that makes the new tool, who is remembered.

The intent of devising a tool for animation was to create images I had in mind. But by the time I had completed the tool, I had lost interest in making an animated feature altogether.

The process of programming is to unerringly describe the structure of a machine as a sequence of textual codes, which when brought to life in the mind of the computer performs a specific processing task. A major flaw in programming methods is the vast chasm that separates the program's cryptic codes and its graphic output. There is no greater need for visual design than rethinking and redesigning programming itself.

Inspired by early computer artist A. Michael Noll's programmatic adaptation of an artwork by Bridget Riley, I further interpreted it as a small program in the PostScript language.

```
/nollcurve {
  /stepamp exch def /numsteps exch def /cycles exch def
  /xscale exch def /amp exch def 0 amp moveto /curx 0 def
    1 1 cycles {
      /i exch def /radbase 180 i 1 sub mul 90 add def
      /numincrs numsteps stepamp i mul mul def
      /dx 180 numincrs div def /x radbase def
      1 1 numincrs {
        pop curx amp x sin mul lineto /x x dx add def
        /curx curx xscale add def
      } for } for stroke  } def
/noll90 {
  .7 setlinewidth 0 setgray
  1 1 90 {
    gsave 3.4 mul 20 add 0 exch translate
    15 1 9 8 1.25 nollcurve grestore
  } for } def
noll90
```

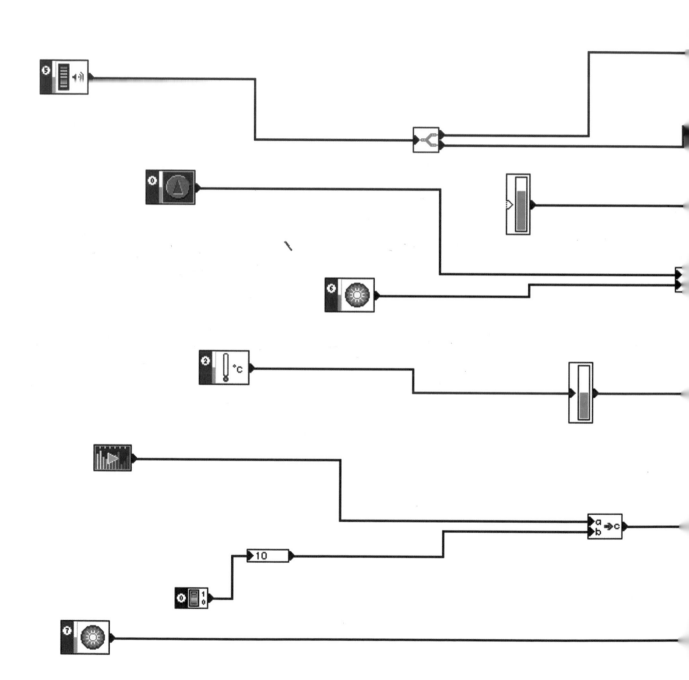

An early attempt in designing a visual
programming system for quickly
prototyping robotic-control systems.

A-Paint, or "Alive"-Paint, suggested a
way to program an illustration based on
the properties of pen strokes, and how
these different strokes might interact
both temporally and interactively.

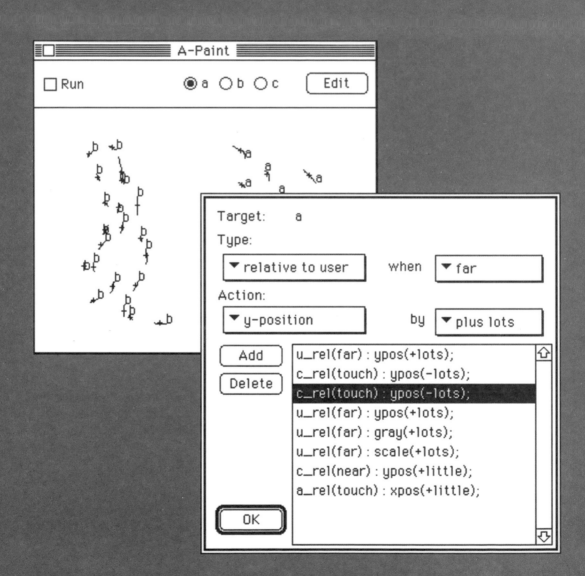

When investigating new architectures for expression, a key source of discouragement comes from one's subconscious denial of the illogic presented before her. It is important not to forget that your conscious actions represent the courageous act of reaching deep into the chaotic mist of possibilities and extracting a small, discernable volume of hope.

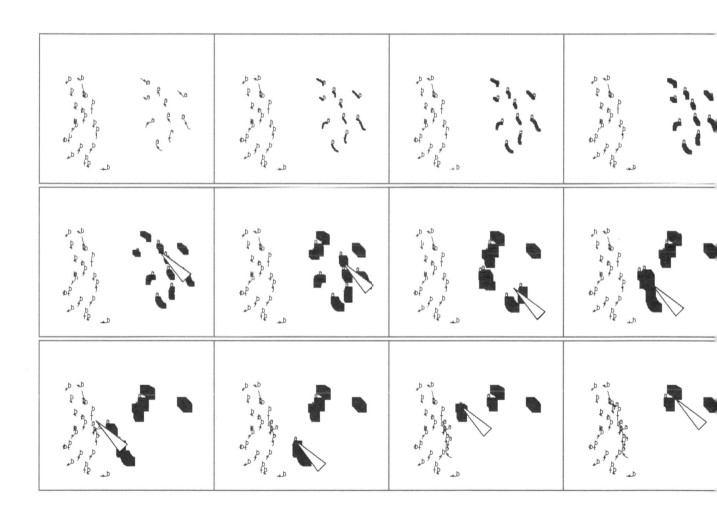

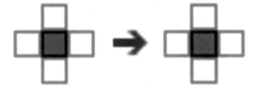

Computer languages are unique
examples of the maxim in which
"form follows function" is only
indirectly applicable. There is indeed
the form of the computer program,
which is translated into other
programs that map better to the
computer's way of thought. It is only
at the bottom level of translation—
machine code—that a software form
reveals its true functions.

Thirty-two patterns of before-after behaviors. The first statement is read, "If a black cell is surrounded by black cells, then in the next cycle the cell stays black." The second statement is read, "If a white cell is surrounded by black cells, then in the next cycle the cell turns black." →

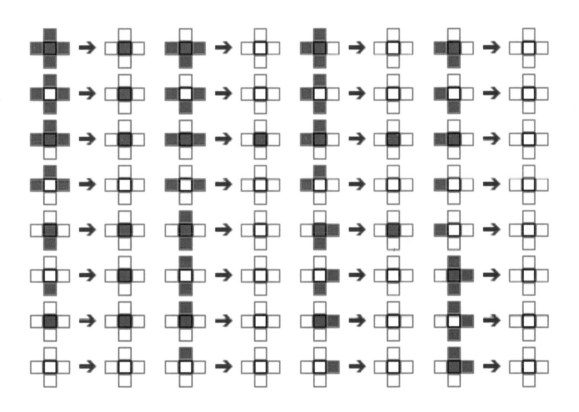

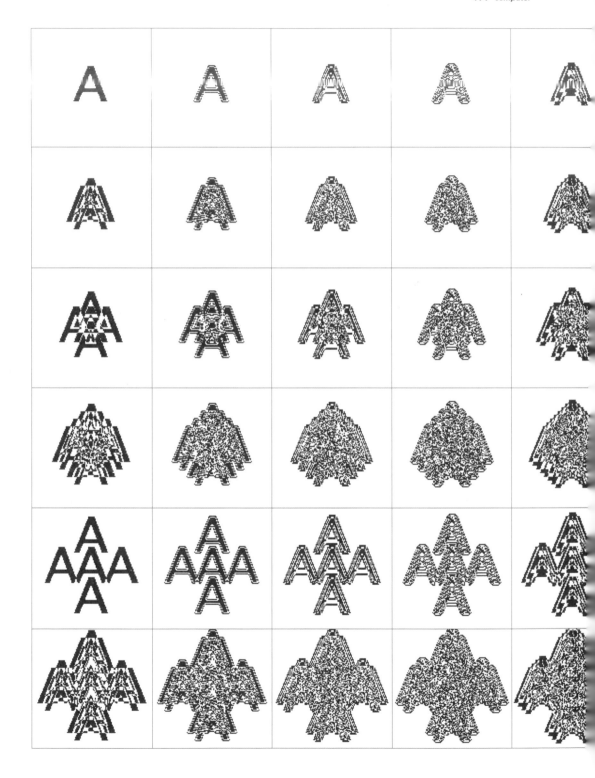

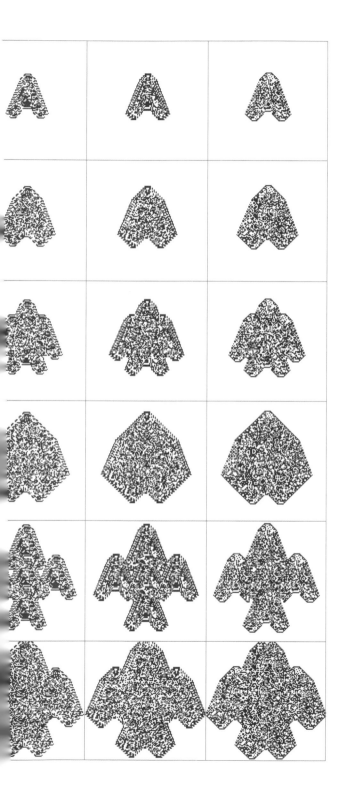

The thirty-two-patterned program is applied to a cell grid containing the uppercase letter "A." The resulting transformation is completely defined by the simple before-after patterns. →

Succesive transformations on a single theme have an entertaining quality that decays as the monotonies of the process are identified. The entirely deterministic style of conventional programming is at fault, but this should not suggest the alternative of randomizing the process in any way as the sole method for escape.

Drawing on the cellular automata experiments, a semiproduction version capable of generating Photoshop plug-in filters was created and later discarded. →

When a tool is fully developed and then immediately discarded, it assures the artist's freedom to continue to explore rather than be stuck in a trap of her own making.

Finding a method to broaden one's thinking processes to acquire the expansive shape of the computer's processing envelope requires the ability to pipeline, scale, and visualize every subprocess that might be active in the past, present, and future all at the same time.

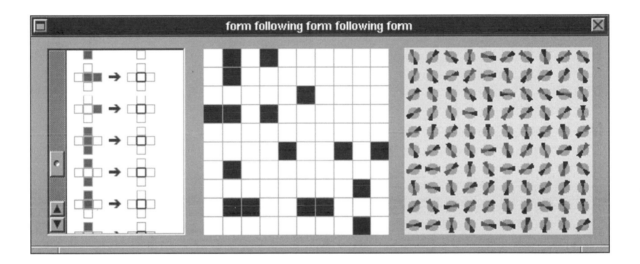

Continuation of cellular automata experiments as a visual form system that synthesizes one form that in turn drives another.

The human-powered computer, as earlier presented in this book (page 54), represented a return to the basic principles of computer programming. →

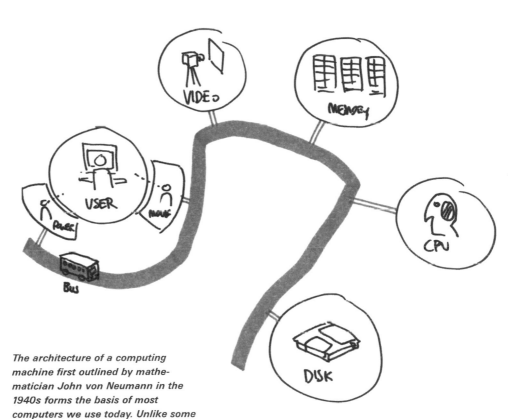

The architecture of a computing machine first outlined by mathematician John von Neumann in the 1940s forms the basis of most computers we use today. Unlike some core scientific theorems of absolute physical fact, von Neumann-style computers do not necessarily represent the *fundamental means for computing. It is akin to our society's reliance on the gasoline-driven combustion engine as the primary means to propel our cars: Even when there are superior means to accomplish a task available, we tend to take comfort in a method that already works, no matter how inefficient or limiting it may ultimately be.*

A handwritten program inscribed on a cardboard floppy disk guides the execution of smaller programs distributed among the various subsystems such as disk drive, power, video, memory, mouse, etc.

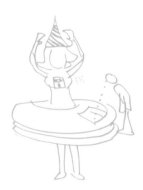

When activated, a human-powered computer is like a playground of colorfully clad human machinery. Although each actor plays an integral part in the system's operation, there is no one more busy than the bus, whose job is to transport information around the computer. After a few hours of operation, the central role of the bus becomes most clear as she begins to move more slowly and the performance of the computer drops significantly. A special moment of fine humanity occurs as the other parts of the computer offer to take up the work of the bus so that she can get a rest. From this elaborate contraption, the most important lesson is the importance of team work.

DISK の 内容

1. DO "MOUSE" (SEND TO MOUSE)

2. WAIT "DONE"

3. SET REG A → VIDEO 0

4. WRITE O TO # [REG A]

5. ~~LEAVE~~ INCREMENT REG A BY 1

6. IF REG A == [~16 VIDEO] ~~GOTO 8~~ SET P.C. TO 8

7. ~~GOTO~~ SET P.C. TO 4 } CLEAR SCREEN

8. READ #[MOUSE X] TO REG. A

9. READ #[MONEY] TO REG. B

10. MULTIPLY REG A AND REG B → PUT INTO REG A

11. DECREMENT REG A BY 1

12. ~~PUT~~ RE WRITE ~~REG A~~ 1 TO #[REG A] } MOUSE PLOT

13. DO "SCREEN" (SEND TO SCREEN)

14. WAIT "DONE"

15. SET P.C. 1

POWER MANAGER

*** WHEN ON**

Ⓐ TURN ON LIGHTS
Ⓑ TURN ON MONITOR

① TURN EVERYTHING ON

② READ DISK

②③ [TELL DISK READ #0 ← [#0 → #?]
WAIT FOR DATA
TELL MEMORY TO WRITE DATA
WAIT FOR OK DONE]

③ WRITE TO MEMORY

④ TELL CPU TO START

⑤ WAIT FOR "OK"

VIDEO MGR
*TURN ON → WAIT

Ⓐ ~~TURN ON MONITOR~~

◎ WAIT FOR "UPDATE SCREEN"

Ⓐ SET S.C. TO 0 S.C.
Ⓑ SEND READ # VIDEO # TO MEMORY
Ⓒ WAIT REPLY
Ⓓ WRITE DATA (0 # 1)
Ⓔ INCREMENT S.C.
Ⓕ IF S.C. FINISH? SEND DONE
Ⓖ GO TO Ⓑ

① READ VALUES FROM MEMORY

SCREEN COUNTER <3<2

② PLOT SCREEN

③ SEND "DONE" TO CPU

*** TURN OFF** Ⓐ ~~TURN OFF MONITOR~~

Creating a tangible example of a concept from the virtual domain instills the illusion of comprehensibility borne of the ability to literally grasp a concept. As concepts become more abstract, physical metaphors reveal their brittleness as their distance to the reality of the abstract makes them significantly unreal.

DYNAMIC FORM

We introduce solid programming by beginning with a block that accepts a single input and a single output. There is a female <u>connector</u> at the input end, and a male <u>connector</u> at the output end, where input and output stream in a left to right, x-direction. In the vertical direction there is another set of <u>connectors</u> that allow streaming in the vertical, y-direction. And finally there is a set of oriented <u>connectors</u> that allow stacking of the blocks in the z-direction. In addition there is a <u>slot</u> near the input end and a <u>slot</u> near the output end which can fit a small, physical tag in a comfortable, visible manner.

DYNAMIC FORM AND DESIGN

Next, consider a set of tags that fit these slots at the input and output ends that have words written on them like *hot, cold, warm, heavy, tiny, blah,* etc.

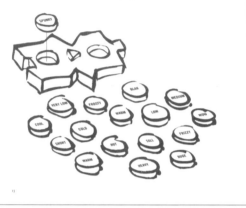

To realize a more complex rule, like "IF *sensor1 is cold* AND *sensor2 is heavy* THEN *motor1 is high*", we simply take another block, attach *heavy* to the input, snap it in the y-direction parallel to the previous block, and connect the input to *sensor2*.

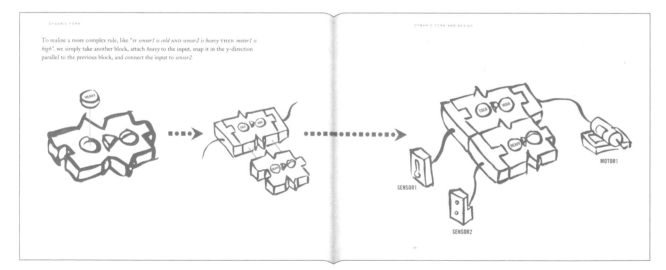

A computer language based upon the handling of actual blocks replaces many cumbersome interactions with mouse and keyboard.

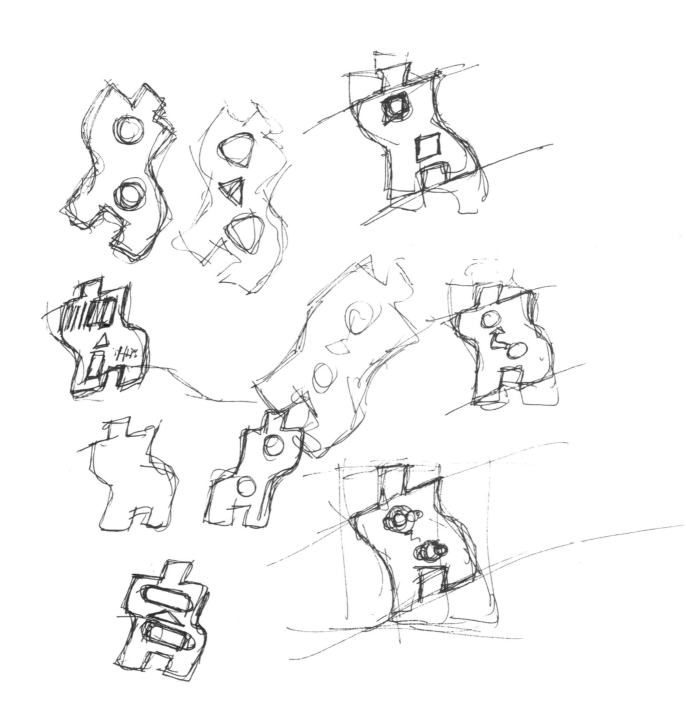

*Much rhetoric and a lot of money
are spent on realizing the classroom
of the future. Surely, they say,
there is a computer for both the
lecturer and individual students, and
it could not be built without having
a high-speed network that ties the
classroom together, and in turn
connects it with the world. Although
my research team at M.I.T. and I
develop technologies to aid the
education of artists and designers,
we keep a backup perspective of
what to do in the event of a power
blackout or dropped network.
This way of thinking might seem
obvious at once, in which case you
understand that we are all at the
mercy of systems that have nothing
to do with our abilities to think,
create, and relate, and everything to
do with a new mischievous god of
the earth who stands next to fire,
wind, and water—technology.*

Experiment in the instruction of
concepts in computer programming
without using any actual computers. →

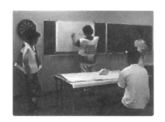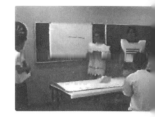

A student sits down and asks the blue pen to draw from the right side to the center. Whoops, he meant the exact center.

More careful this time, he asks the green pen to draw from the exact upper right-hand corner to the exact lower left-hand corner.

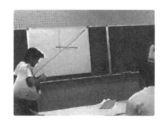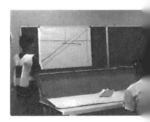

Successive pens are asked to draw in relation to the intersection of line points, and exact offsets from the corners and edges.

The exercise of drawing without one's hands requires concise communication skills in relation to the human pens. The creative problem of how best to grip the entirety of the space through solely vocal commands presents a unique challenge. →

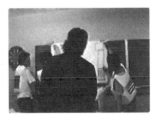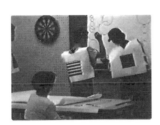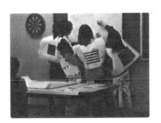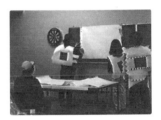

A variety of methods to speak to the paper are devised, the potentially most exciting is the suggestion to create a grid.

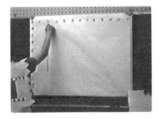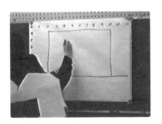

Yet although positioning of marks becomes significantly easier, the result is early-computer-style house graphic.

Subsequent homework is administered in the form of two sheets of paper, one with a written description of a figure, the other with the rendered figure.
In class students exchange instructions and hand-render each other's program. The results are compared with the intended figures to reveal the lack of skill on both the programmer's and computer's part. →

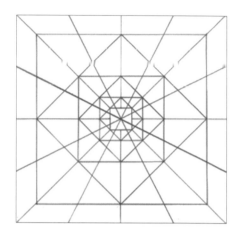

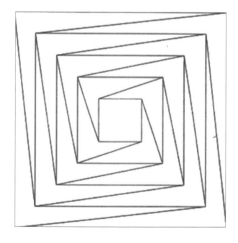

G language

① ⊛と⊛をむすぶ。

② ⊛から□ひく。

☆

1. 画面の中心
2. 左上の角
3. 左下の角
4. 右上の角
5. 右下の角
6. ペン
7. ①と③の交点
8. ①の始点
9. ①の終点
10. ①の中点

↑
⇄
answ

□
1. 上に（　）cm
2. 右ななめ上に〜cm
3. 右に〜cm
4. 右ななめ下に〜cm
5. 下に〜cm
6. 左ななめ下に〜cm
7. 左に〜cm
8. 左ななめ上に〜cm

screen is always a square

box = 〜

PROGRAM
(1) Ｏと⊛
(2)
(3)
(4)

MEZASU MEDCONNAR

Writing programs to create illustrations
never makes much sense to students
because they can be drawn much more
easily by hand. However, as interactions
are introduced, the differences between
~~paper and computer become clear to~~
students of any level.

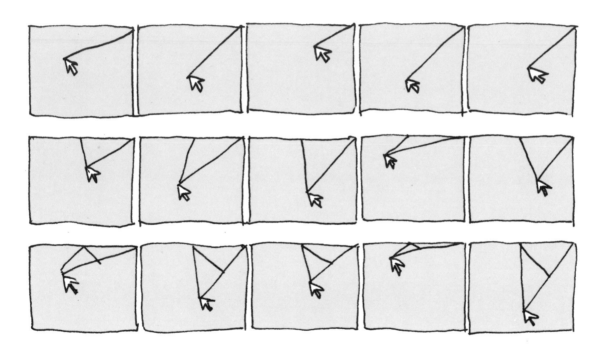

*The task of rendering quality static
illustrations, no matter how complex,
is best done by hand, when time
permits. Creating a program to create
a static drawing is in many senses
overkill because it is like drawing a
million similar illustrations just to
achieve one.*

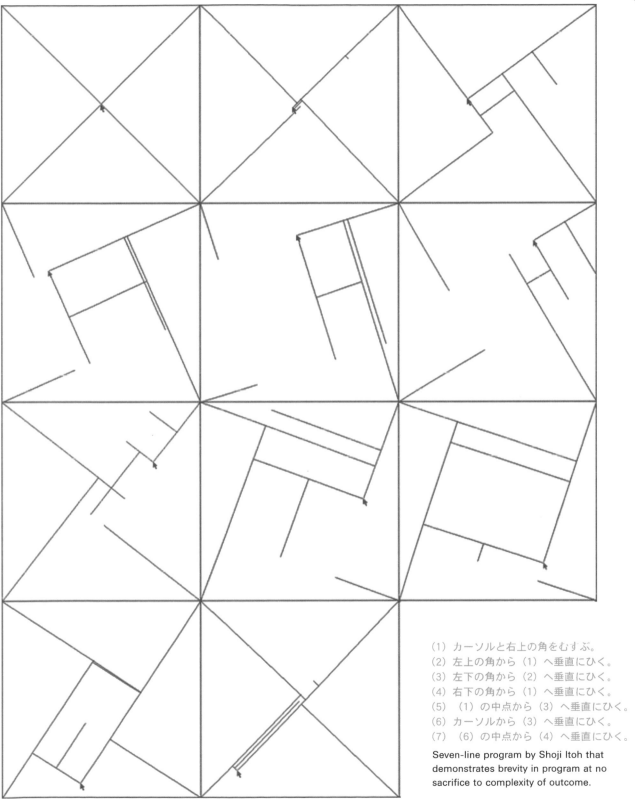

(1) カーソルと右上の角をむすぶ。
(2) 左上の角から（1）へ垂直にひく。
(3) 左下の角から（2）へ垂直にひく。
(4) 右下の角から（1）へ垂直にひく。
(5) （1）の中点から（3）へ垂直にひく。
(6) カーソルから（3）へ垂直にひく。
(7) （6）の中点から（4）へ垂直にひく。

Seven-line program by Shoji Itoh that demonstrates brevity in program at no sacrifice to complexity of outcome.

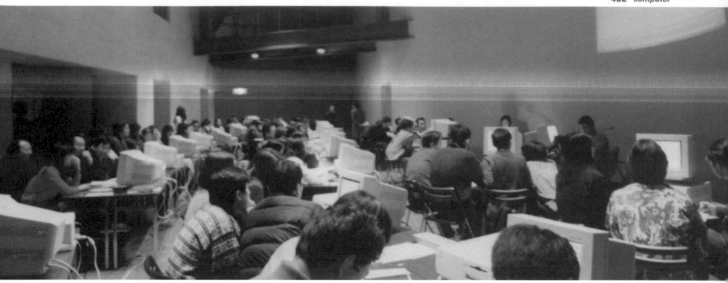

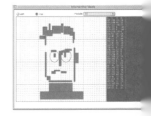

A good mentor is someone who patiently tolerates you when you are blatantly wrong, knowing with minimal smugness that in two to three years you will eventually see it their way. A good mentor is someone who leaves a legacy of possibilities that do not constrain younger people's lives, but instead gives them the tools by which they can surpass their mentor.

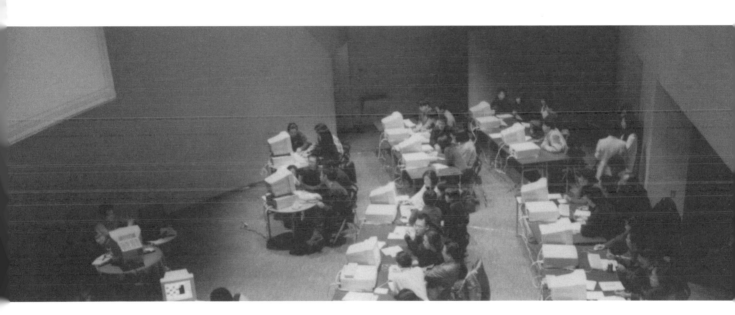

Workshop at Tokyo Design Center using five series of java-based systems created to investigate visual aspects of computational constructs.

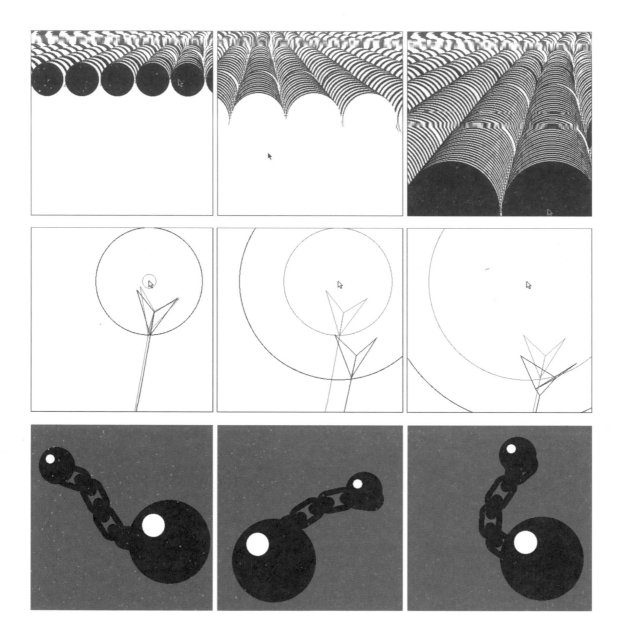

Exercises in computational form by Peter Cho (top), Reed Kram (middle), Matthew Grenby (lower), and Tom White (opposite).

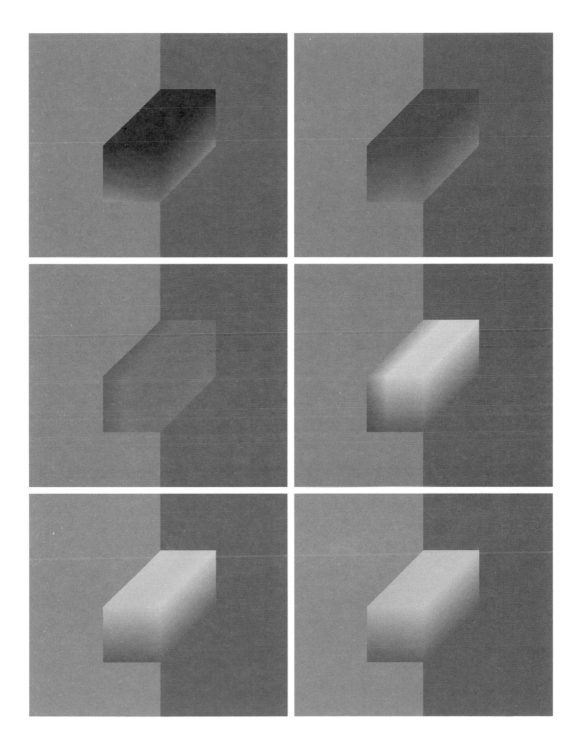

```
The quick brown fox
jumped over the lazy dog.

Typography at its best
is a visual form of language
linking timelessness and time.|
```

```
The quick brown fox The quick brown fox
jumped over the lazy dog.jumped over the lazy dog.

Typography at its best Typography at its best
is a visual form of language is a visual form of language
linking timelessness and time.linking timelessness and time.
```

```
The quick Tbhreo wqnu ifcokx  brown fox
jumped over jtuhmep elda zoyv edro gt.he lazy dog.

Typography Taytp oigtrsa pbheys ta t its best
is a visual foirsm  ao fv ilsaunaglu afgoer m of language
linking timeleslsinneksisn ga ntdi mteilmees.sness and time.
```

```
ThTeh eq uqiucikc kb rborwonw nf ofxo x
jujmupmepde do voevre rt hteh el alzayz yd odgo.g.

TyTpyopgorgarpahpyh ya ta ti tist sb ebsets t
isi sa  av ivsiusaula lf ofromr mo fo fl alnagnugaugaeg e
linlkiinnkgi ntgi mteilmeeslsensessnse sasn da ntdi mtei.me.
```

Classroom exploration in the visual possibilities of the computer mediated through existing tools results in a predictable set of elements and constructions that reveal the unfamiliar personalities of the students through the familiar personalities of the tools. When the constraints of expression are relaxed and students start from absolutely no known digital assumptions, the outcomes are surprisingly varied and witty in ways that more effectively communicate the spirit of the students, rather than of the computer.

Exercises in computational typography by Peter Cho (opposite, above and below) and Tom White (below).

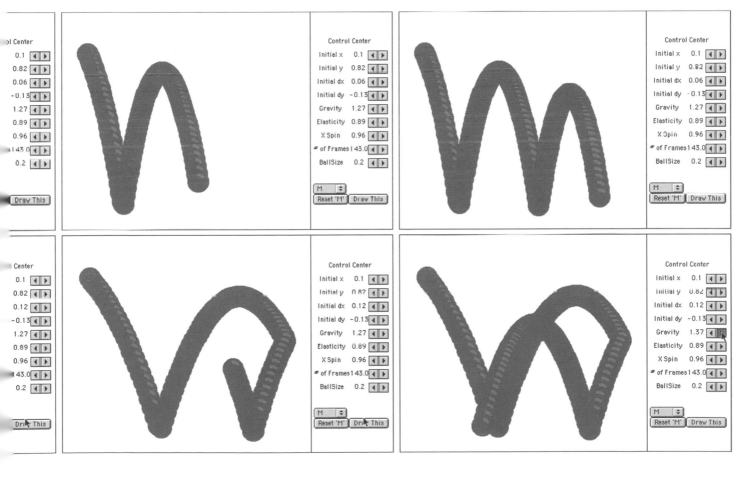

Exercises in numerical photography by Elise Co (top), Golan Levin (above), and Benjamin Fry (opposite).

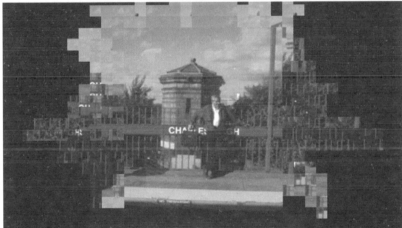

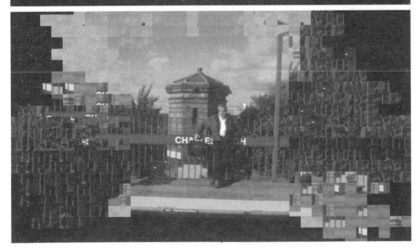

In the hands of students who treat the computer as a truly plastic medium, the creations are as varied as you might expect when metal, plastic, and plywood were introduced into the artistic realm. Fostering people's creativity in this manner can clash with society's unfortunate push to manufacture two distinct types of thinkers: one who is technically adept and humanistically inept, the other who is humanistically adept and technically inept. It seems unproductive that such boundaries should exist when now more than ever we need people who can lead humanity toward technologies that improve society rather than technologies that simply show improvement over technology itself. When asked what kind of students I create, I say they are a new type of person: "humanist-technologists."

A new undergraduate course was
developed together with Tom White and
Jared Schiffman to introduce students
simultaneously to concepts of compu-
tation and traditional visual art.

When the output of a visually oriented program is a single animation, its true multidimensional nature is hidden from the viewer because of the perceived limitations of the display screen. With a slight change in visual language, a programmatic form can be read closer to its native set of dimensions. In which case you stare at what unravels before you and scream, because you realize it is not your eyes that limit your thinking, but your mind.

mas110—fundamentals of computational media design

Given two parameters, 'mx' and 'my' both ranging from 0 to 100, create an animation that lasts exactly 2.5 seconds valued in UNITY and FRAGMENTATION.

mx+y ☑ Run speed = 1.0

jocelyn_ps4_p4

Exercise in temporal form by Jocelyn Lin unfolded in a five-dimensional display.

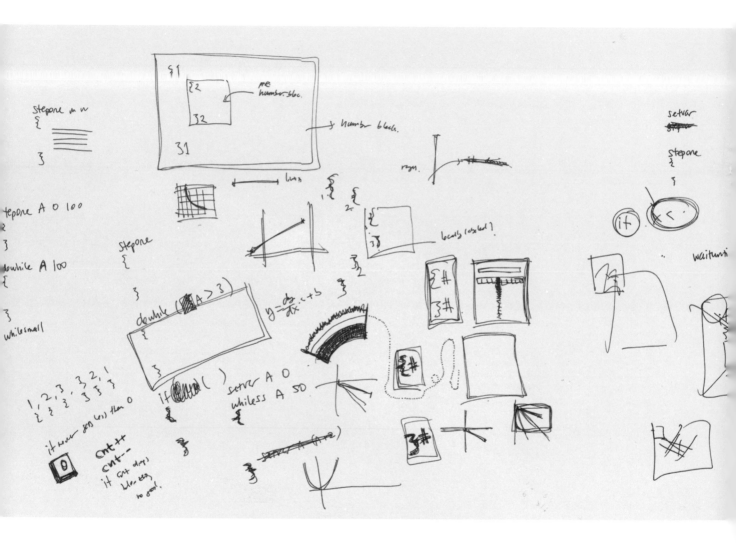

A comprehensive system was developed
with sufficient limitations and subtle
extensibilities to enable a wide range
of digital expressions for the beginning
computational art student. The result
was the Design By Numbers system. →

- drawline
- setvar
- stepone
- [xy] ——→ drawline
- { } block
- nested

- setvar (set) (set)
- drawline (line) (line) (loop)
- stepone (step)
- (*+-/)
- [x y]
- stepone [x y] [drawline]
- { image / pattern }
- using gray ... bits ... using animation (clear) bits, then lines or just bits
- using input ... lines
- using non-visual (compiler computation).
- using ... [introduce polar coordinates?]
 rotate / scale / translate

(transform SC_x SC_y θ t_x t_y)

rotate
scale
(translate)

drawline ⟨x x⟩

drawline (20@30) (10@30)

drawline ___ ___ ___

setvar (A) 3

stepone A 3 10 [x y].
 { lie closing
 ───── filled areas.
 ───── circles.
 ───── image.
 } { { nested } }

repeat

[)

setvar [x y] 275

pixel under?

(5@20) (10@20)
 rotate scale

drawline

drawline x₁ y₁ x₂ y₂

drawnotline

within a block
rotate 30

rotate 30
3

[rotate?]
scale?

Distilling a basic vocabulary of computational visual art requires years of experience in practice and instruction of basic principles. Considering that I only have some twenty years of experience in working with this material and that it is relatively recently that they have become conceptually clearer to me, I hesitated before undertaking the definition of a basic programming language for art and design education. However, having seen java and c++ (languages that would easily discourage the most ardent of young futurists) take hold as the de facto method for students to acquire computation skills, I chose to prescribe a minimal degree of knowledge in the ongoing Design By Numbers project. →

Draw a Line You can now write a three-line program, which is your first major graphics program if only a single black line on white paper. (Note: all drawings are rendered at half their original scale for enhanced page balance.)

```
Paper 0
Pen 100
Line 40 20 80 60
```

The line is 40 over and 20 up, to 80 over and 60 up — not a particularly exciting line, aside from the similar lack of smoothness in the opening example. The reasons for this jaggy characteristic will be discussed in Chapter 8, but for now understand that the paper we draw upon (not to be confused with the actual paper used in this book) is coarse in a virtual sense. Therefore, any mark left on the paper will have a rough, textural flavor, the classic signature of digital artwork. In some cases, the texture will not be apparent, such as in a perfectly horizontal or vertical line. In these cases, the lines are smooth because they essentially fit into the perfect horizontal and vertical grooves in the texture of the page. But in general, the lines will be coarse.

You can now draw a variety of lines on different

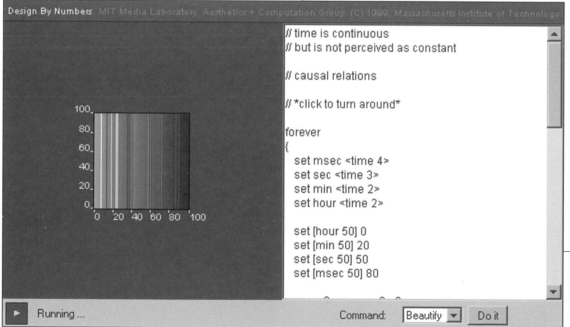

Exercise in temporal form by Casey Reas.

56 27

10 11

30 4

90 90

75 80

0 84

24 8

Where Is the Line? There are some cases where you draw a line and do not see the intended result. For instance, imagine what happens when you draw outside the paper?

```
Paper 0
Pen 100
Line 20 30 200 300
```

The line starts from 20 left and 30 up to 200 left and 300 up, but you never see the line as it leaves the 101-point square. Any portion of a line drawn outside the space will be ignored and clipped to the edges in this fashion.

Also, what happens when you draw in the same shade as the paper?

```
Paper 66
Pen 66
Line 0 0 100 100
```

Since the digital medium is exact, drawing a diagonal line in the same shade as the underlying paper appears to produce nothing, even though you might expect to see some faint impression of the line as is common in a double hit of ink.

Another surprise occurs when you draw a line and then request a new sheet of paper.

```
Line 0 50 100 50
Paper 50
Pen 0
```

In this case, the intent is to draw a white horizontal line across the center of a gray sheet of paper, but the new sheet of paper is placed on top of the line. Thus the line is not visible.

Finally, there is the case where the Pen is not explicitly set and a Line is drawn.

```
Paper 100
Line 3 33 97 66
```

When the Pen is not set, the default setting is 100 percent black. As an additional convention, when the Paper is not set explicitly, the default setting is 0 percent black, meaning white.

With the exception of the first example, nothing appears to happen in the visual output. But be aware that something has indeed happened from the viewpoint of the computer. The computer has labored to create a line, just as if the line were visible. The computer does not know when it has done something completely useless, such as drawing a black line on black paper. Only you do.

Summary The process of drawing requires a means to establish where the pen is to be placed on the paper. Otherwise, the computer cannot know where to draw. Your hands usually serve as the means to locate points in space; however, in the computational model of drawing, the only purpose your hands serve is to type commands. The constraint of measuring horizontal and vertical dimensions from the lower-left corner was introduced as a way to make dimensions consistent. Dimensions are always in units of points.

The Line command is followed by two points, where each point is a pair of numbers, always horizontal then vertical, and separated by spaces.

33

The *Design By Numbers* book (1999) describes personal perceptions of the relationship between computation and digital form with working examples in a freely available language called DBN.

"Programming is the process of abstracting a graphic form into its fundamental geometric components."

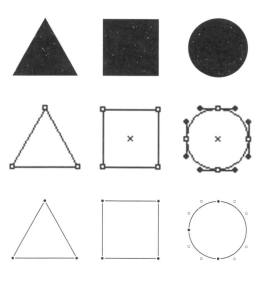

```
newpath
  68.45 297.33 moveto
  92.83 339.85 lineto
 117.21 297.33 lineto
closepath
fill
```

```
newpath
 136.77 339.85 moveto
 179.29 339.85 lineto
 179.29 297.33 lineto
 136.77 297.33 lineto
closepath
fill
```

```
newpath
 223.22 297.33 moveto
 235.54 297.33 244.48 306.27 244.48 318.59 curveto
 244.48 330.91 235.54 339.85 223.22 339.85 curveto
 210.90 339.85 201.96 330.91 201.96 318.59 curveto
 201.96 306.27 210.90 223.22 223.22 297.33 curveto
closepath
fill
```

I wrote these words in 1995 and drew this diagram, believing at the time that programming was simply a form of visual math, a skill of seeing the world and decomposing what you see into mathematical primitives. I later understood that it is no different from drawing a picture, except that no picture is actually drawn. The essence of what exists—i.e., the entire set of possibilities generated from a core idea—is rendered into reality as computational structures. Having established this basic fact, my next thought was, "So what?" →

A moment of clarity presented itself five years later. I created a simple painting tool in the image of one of my first inspirations, the software system originally bundled with the Macintosh computer called MacPaint, credited to Bill Atkinson. I wondered, "What if in 1984 MacPaint were designed in such a way that it was incomplete—much like a piece of unfinished furniture or a pen-making kit."

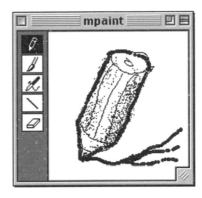

By cracking the icon for a tool open, you would reveal the programming code that realized that specific function. By changing the code, the user could change the way the pencil behaved at will, much in the same way a real pencil might be customized. I believe that such approaches are the basis for fine artistic control over a system. We must have the ability to dig into the tools and materials, whether they be pencil, paper, metal, oil paints—whatever—to reshape, manipulate, and recast them into something either new or at least relevant to our individual styles of thought.

The responsibility to make the computer a better space for visual thinkers is currently in the hands of large software companies with limited imaginations. As a result there are few real choices in operating systems and their related software—I count three or four. In contrast, if you had to select a cup or other object of daily use, there would be hundreds, perhaps even thousands, of diverse items from which to choose. Some of the artifacts would be unsuitable, of course, some would be acceptable, and if you were lucky there might be something truly exquisite. Through quantity emerges quality, and for quality to emerge there must be more visual thinkers who seize control of the computer's future by contributing their personal visions. Not as mere written words or editorial complaints but as working artifacts and architectures that can inspire the development of computing spaces painted through and through in the joyous colors of humanism.

acknowledgments

I had just completed the writing, design, and production of *Design By Numbers* when a curiously enthusiastic gentleman from London proposed the absurd undertaking of a new book. Perhaps it was my weakened state and associated stupor that gave in to the seemingly infinite energy of Lucas Dietrich of Thames & Hudson. Whatever it was, this book somehow now exists, and I am grateful for Lucas's infinite patience, fastidious attention to detail, and sincere concern for high artistic values.

I was deeply honored that Professor Nicholas Negroponte agreed to write the foreword to this book. His intensity, coupled with a unique sense of style, was evident the first time I leafed through his influential book *The Architecture Machine.* The notion that the spirit of architecture, technology, art, and design could combine in a single person has been exemplified by Professor Negroponte from the very beginning.

By creating this book I am now properly able to thank the many people, companies, organizations, and institutions that have fundamentally affected my thought patterns in a direct way.

First I must thank Tadashi Morisaki for his early influential mentorship, for teaching me how to see and create in a way that is most natural, yet not out of touch with the comedy of everyday life. After his tutelage, my work would have never reached the public without the help of three unique risk-takers: Michio Iwaki, Naomi Enami, and Taiji Watanabe. Michio Iwaki, of Shiseido, gave me great leeway in creating a variety of constructions that were beyond the scope of conventional commercial design; Naomi Enami produced and published a series of my books that to this day have not made a profit; and Taiji Watanabe permitted me to explore a number of printing concepts without concern for cost and only concerned with quality.

I have been fortunate to have a series of direct encounters with exceptional educators that have provided not only myself but all those with whom they come in contact with profound inspiration that will last a lifetime. Paul and Marion Rand and Ikko Tanaka showed me a pure way of existence that embraced a sincere dedication to form and the happy, beautiful moments of life. Katsumi Asaba and Takenobu Igarashi represent the complex two sides of the Japanese psyche. Muriel Cooper inspired me to leave M.I.T. to run away from technology. Whitman Richards cursed me by bringing me back to M.I.T. William J. Mitchell made me feel it was okay to be back at M.I.T. Bill Verplank kept track of me from the very beginning and led me all the way. Gillian Crampton-Smith set the world straight with true attention to the finer details of design and technology. Daniel Boyarski made me feel it was okay to be a professor. Wolfgang Weingart showed me that even with a glass of wine or stein of beer you could still be completely coherent and inspiring. Donald Knuth and Gilbert Strang make mathematics and computer science look truly extraordinary and graceful, from any perspective. Chris Pullman was a voice of reason in the Boston area. Matthew Carter on his perch only a few miles from M.I.T. made me act responsibly in a typographic sense. Although we spoke together at a conference, I did not know Scott Makela, but through his many students I hear his voice. Richard Farson scared me with email regarding the weight of fame. Like my father, Masami Shigeta, upholds the unyielding, quintes-sential spirit of a poorer, yet proud, Japan. Finally, my teachers at Tsukuba, Kiyoshi Nishikawa showed faith in my early ideas in the face of constant debate, and my dear advisor Akira Harada was a strong voice for innovation in *all* things.

A cluster of old-timer professors at U.C.L.A., Mitz Kataoka, John Neuhart, Vasa, and Jim Bassler, encouraged me to return to the United States. Their unique perspectives, especially the Japanese-American juggernaut Mitz, taught me about the fine line that separates design and art, which is a thicker line than I expected.

When I moved back to the East Coast of the United States, I did not know any designers besides Paul Rand, who had just passed away. I was fortunate to meet Tibor and Maira Kalman when they visited M.I.T. Tibor kindly introduced me to the New York design community. Katherine Nelson and Peter Hall subsequently published an article in *Print* on my activities in Japan, which greatly helped to generated interest in the U.S. on the issues that I represent.

Paola Antonelli, Chee Pearlman, Myrna Davis, Aaron Betsky, and Ric Grefé have been key supporters in my attempts to destabilize common notions of segregation in design and technology. Their compassion and criticism have led to a much clearer navigation of concepts that I have struggled to understand. Ellen Lupton, Christopher Mount, Janet Abrams, Rick Valicenti, Kathy Merckx, Claudia Dreifus, Janet Froelich, Liz Faber, Karrie Jacobs, Takako Terunuma, Kaoru Matsuzaki, Fumi Iwane, Kikuo Morisawa, Takeshi Morisawa, Nobuo Tomita, Tomitsugu Tachibana, Yutaka Itoh, Yoshio Hirayama, Hiroko Sakomura, and Maria Grazia Mattei presented unique opportunities to convey the themes that I (and now my students) attempt to reconcile.

A small group of people in the Cambridge-Boston area make the place a relevant community of design excellence: Al Gowan, Jan Kubasiewicz, Yasuyo Iguchi, Ori Kometani, Robert Prior, and the staff at the M.I.T. Press Bookstore, led by Mo and John.

I am grateful to the many designers and artists that have given me encouragement, discouragement, and embarassment: Mitsuo Katsui, Yoichiro Kawaguchi, Toshio Iwai, Gento Matsumoto, Kenya Hara, Katsuhiko Hibino, Minoru Niijima, Norio Nakamura, Noriyuki Tanaka, Masaki Hagino, Shuichi Ono, Masaki Kimura, Yayoi Kanbayashi, Keizo Matsui, Ken Miki, Shinnoske Sugisaki, Giorgio Camuffo, Yumie Sonoda, Paul Davis, Alexander Gelman, Just van Rossum, Erik van Blokland, Peter Girardi, Erik Adigard, Stefan Sagmeister, Gong Szeto, and Lisa Strausfeld.

At M.I.T. a special clan of similarly aged thinkers have deeply inspired me from the start: Bob Sabiston, Suguru Ishizaki, David Small, Mike McKenna, John Underkoffler, and Kevin McGee. I am also indebted to the guidance of two professors that remind me of the intense themes that we should uphold: Hiroshi Ishii and Krzysztof Wodiczko. My daily life at M.I.T. is deeply augmented by the help of Connie Van Rheenen. Her clear-mindedness continues to give me inspiration. Linda Peterson, Deborah Cohen, and Ellen Hoffman provide me with sanity (in their own insane way) at crucial moments.

Intel Corporation has aided me at many times. In particular, the help of super-hacker John David Miller and his boss, Dr. Carmen Egido, has been always greatly appreciated.

While a student in Japan, for four years Tamon Hosoya and I would have lunch regularly to debate issues in art, design, and technology. Those intense conversations made us both stronger. Kazuo Ohno, of the International Media Research Foundation, kept the momentum going at a rate that continued to surprise me, despite his insistence that his life was "finished at 40."

The indirect and direct support of Yoshiharu Fukuhara, Ryuichi Sakamoto, and Nobuyuki Idei have been pivotal.

I thank the many institutions and organizations that have supported various facets of my activitites: Misawa Homes, Shiseido, Sony, Yamaha, Digitalogue, .Too, Dai-Nippon Printing, Grapac Japan, Morisawa, Seibu, Tokushuu Seishi, Tokyo Type Director's Club, Art Director's Club, Gilbert Paper, Takeo, Seagrams, The American Institute of Graphic Arts, San Francisco Museum of Modern Art, MdN, Axis, IDEA, Nikkei Design, Print, I.D., Technology Review, Creative Review, Eye, ArtByte, and The New York Times.

My very first students, Rie Komuro, Akira Yamanaka, and Yoshihisa Sawada, introduced me to the complexities of research management. Those early experiences suggested that it might not be such a bad full-time job. My research group at M.I.T. has evolved in positive directions over the years thanks to Tom White, Peter Cho, Ben Fry, Elise Co, Golan Levin, Jared Schiffman, Casey Reas, Axel Kilian, Bill Keays, Reed Kram, Matt Grenby, Chloe Chao, and Doug Soo who have all contributed to the concept development of the Aesthetics and Computation Group at the Media Lab. I look forward to their many ground-breaking contributions in the future.

In my on-the-way-home conversations with Brian Smith I have learned a great deal on subjects that would not be appropriate to espouse in this book. His many insights give me courage where I would have none.

My informal extended family of Mitsue, Nobuyuki, Nobuki, and Mitsuki Ueda have always been enthusiastic supporters in innumerable ways.

My parents, Yoji and Elinor Maeda and Matthew and Elizabeth Sheahan have given me more love than any son could deserve.

Most importantly, my daughters, Mika, Rie, Saaya, and my wife, Kris, have given me the greatest gift of all—the inspiration to make the world a better, happier place.

How this Book was Produced When it was suggested that a new book could be created within a year, my immediate reaction was that I needed to design software to enable the automatic layout of the entire book. Since I had imagined that this would be possible, I envisioned a book of at least five hundred pages. Considering that designing for the computer screen entails conceiving thirty frames per second, I reasoned that five hundred pages was equivalent to around 17 seconds of animation, which didn't seem so difficult. I thus spent about seven months developing a special system in java and python to enable the rapid design and prototyping of pages. As the deadline neared, it began to dawn on me that it would be impossible to realize such a mythical layout. So I turned to the conventional old-fashioned solution of "just doing it."

Sifting through all the material, it became clear that I would have to re-create a majority of the artwork to be printable in a smaller form than the sizes for which they had been originally made. Furthermore, many of the time-based pieces had to be condensed into a cogent static form. With a huge mass of work before me, I spent at least three weeks thinking that it would be impossible to reformat everything within a reasonable amount of time. Fear led to depression, until a glimmer of hope appeared when I gradually was taken by the idea of never having to talk about this work again in public. Presenting my work was getting so laborious that each moment of reliving the past weighed down my thinking and kept me stuck in the past. I needed to be renewed.

This epiphany brought about a surge of strength. I spent late nights and early mornings scanning, rendering, tweaking,

until it all began to finally materialize as something semi-worthy of printing.

The issue of the book's layout was approached by writing on the back of the large press sheets from my first book, which I had kept as souvenirs to sleep upon. Once the map was built, the layout gradually took shape, and I allowed space for the fictional "new" material between signature, hoping that it might magically take form during the layout process. At first, the sections began to fill in very slowly, but near the end they came at a much more rapid pace and everything began to cohere. I don't have the luxury of a production assistant, so any infelicities in this books are Impardonably mine. Sigh.

My process for creating the new artwork in this book differs from work in the past with respect to speed. I used to think of everything in the C language, which was necessary because the computers I used were very slow and I required the maximum speed possible. This time I used primarily high-level languages to create the new images, but at times there were things I simply could not do, in which case I created special codes in C to break free.

Many people continually ask, "What programming language do you use?" I have never been fond of this question. It is like asking someone, "What kind of paper do you use?"—indeed a question that people do ask. A good idea can be rendered as a digital construction in any available computer language, as an illustration in any ink on any paper, or as a mammoth skyscraper of any metallic alloy or building compounds. It must be realized with the utmost quality and care—a poorly constructed object usually gives away a poorly constructed idea, regardless of the materials used.

(12) Sand bar: active ornamentation [interactive].

audio.

(13) pocket of data. Eg

john's vase of data.
trashcan

(14) the humble scrollbar. (the evolution. T] explorer → etc
velocity trigger.

(15) life on the desktop. / anthropomorphism.
butterfly 🦋

EX FRAMES.

① creative flood fill

② pattern generation

③ connect 4 pts.

④ network core point

⑤ live data feed → virtual heart beat

⑥ type manipulation of ascii codes.

⑦ design for 5 minutes. (amount.

⑧ dynamic ligatures.

⑨ flying our data.

⑩ gradation studies

⑪ spatial change in intensity

(E) traditionals:
sound.
figure

(F) move away from input, for back to input.
windowing of information.
access to many grids.

(G) context of display
wave of X ware
display on ceiling

(H) compactly & dynamic
HPCW
illustrator.

(I) motion on screen.
raster.
A + B
line

(J) interactive of intersection
graphic transition
mode.
standalone object.

⑥ DISCRETE MULTIPLE VIEWS (STAGING)
different views displayed
to different domains but
w/ corresponding references

⑦ DICTIONARY OF FORM

の サイズ だ...

250 mm → square-ish.

12"

3 130 mm

4
200mm
250mm

6"

8"

small, reserved, elegant.

either big cut beautiful
→ this is best direction perhaps.

MAEDA @ MEDIA

- we foldouts as planned as caused too
 much paper crumpling at boundary.

- 6 color in signatures. will plan
 around this. Combination of 2,4,6 is fine.

CONCLUSION:

① 12" x 250mm book size. 250mm / 12"

 Stacked 3 high = 1 yard
 side-by-side 4 wide = 1 m.

② paper is Matte (preferably Mohawk superfine)

③ no special paper gymnastics (mentioned double gate folds before but as is too difficult perhaps)

④ combination of 2, 4, and 6 color pages. Can design around a given spec.

⑤ jacket : prefer to use translucent material / yupo with silkscreened texture.

⑥ length : approx. 200 to 300 pages

⑦ Content breakdown : Ⓐ PAST COMMERCIAL WORK → COMMENTARY + IMAGES (30%)
 Ⓑ NEW WORK, NEW DIRECTIONS → WRITINGS + IMAGES (60%)
 Ⓒ EDUCATIONAL WORK AT MIT → COMMENTARY + IMAGES (10%)

⑧ TITLES (UIE: "MAEDA @ MEDIA", "THINKPAINT", "THOUGHTPAINT"

MAEDA @
MEDIA

a continue of paper
a libration screen.
a monitors

paper on unique backgrounds.

paper has expanded beyond. the imprint of light

illusion of the

the last example is the soul of the paper
itself fostered into sculptures though
a strip of folds

acquires a visible
soul.

we continue for

is two year away

were such a fear made possible
through the miracle of science, the result
would be tired of the attempt to emulate that

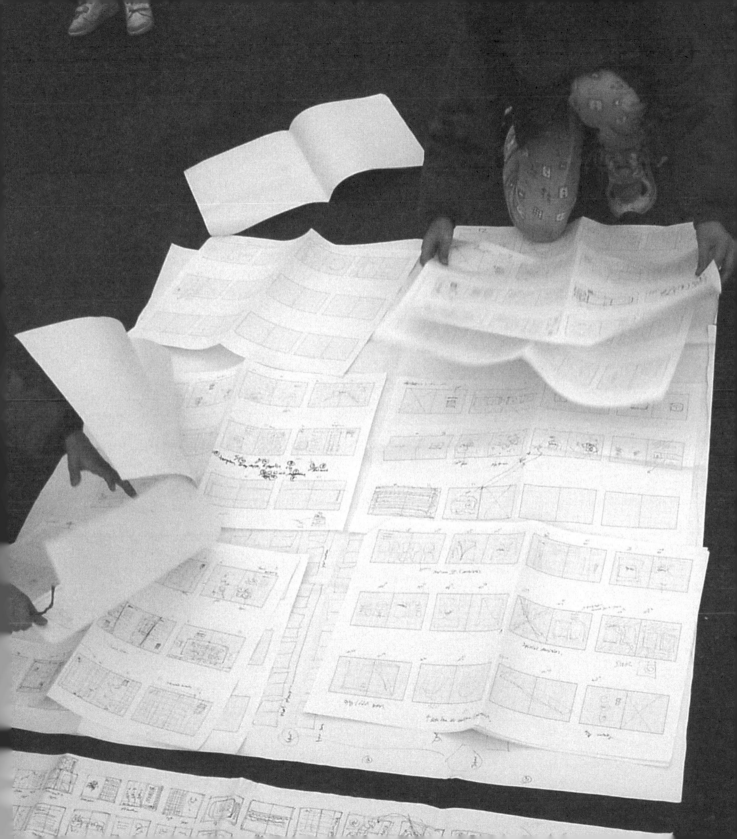

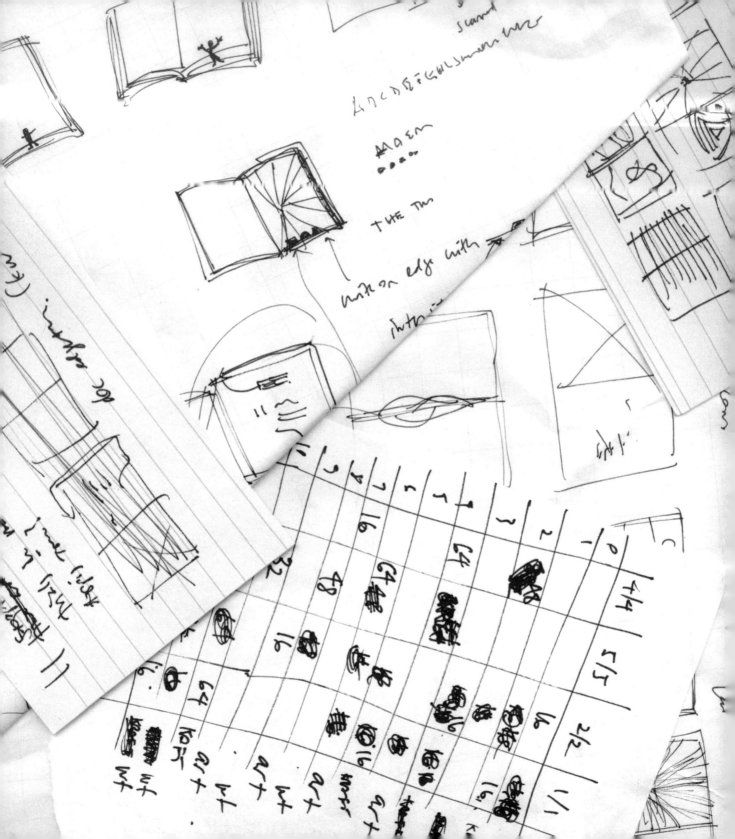

She new show quite plump. And happy (quin)
on the blob. ~~but~~ ~~no~~ wherever he went

at a much faster rate
the pink ~~changed to a bright green~~
the same red that the pixel always
~~the last it always did the pixel to herself.~~
~~it all was so longer what the ?~~
~~That ~~And there~~ But was forever gone with~~
~~the mamt~~ how dear life really was to her,
~~to retain her identity~~ the pixel wished
her might that she might exist. And
a funny this happened. ~~The wish came~~
~~it to sky edge forces blue square.~~
~~became~~
reincarnated as

~~after she~~
~~wanting to painted they the ??~~
very changing also.

~~I dropped ?? one dy out answered that~~
~~note ice~~
~~other ?? She had~~ She noticed that
was never the same blue square.

she didn't exist. And sometimes was barely
(tel + ??)

~~② "I am here.~~
the familiar number "
continued. The plump
?? as her ??
barren white had now pr

~~②③ in pixel ?? it cute
until she suddenly realise
herself was not the pixel ??
but pixel~~
~~②③ Just before~~
~~the ?? when the~~

⑭ Reincarnated as a less
blue square with a a
began her new life again it
great texture and centros
change. ~~to~~
~~?? that her life ??~~
~~fully illusory~~

⑮ The blob often ?? k (frequently)
again
never asked the blobs
significant that the fr
she knew just as well
their reality was fragile
~~that their pixel blob, c~~

elements of nature... wind, water, etc.

harvesting / tool

tool.

1D is like using a roller coaster (train / elevator, up/down / sound louder/volume, etc.

2D is like driving freely / sailing

3D is being submarine or airplane or blimp (slow)

encount.
water, wind, etc.
the natural world

Compost in [light] tone.
go from pinks,
to colors.

1st person / 3rd prs

overall map.

local m

view angles

amoebal / liquid like.

speed.

slow

discrete steps turn

size

to sophisticate the design & ...
establish the releases of
computational ...

• tool is not self-describable
• language is able to be itself

TOOL

LANG

highly
indivisible

HEAD-MOUNTED
CITIES

references

Ammeraal, Leen, *Computer Graphics for Java Programmers* (John Wiley & Sons, 1997)

Antoniades, Anthony C., *Poetics of Architecture: Theory of Design* (Van Nostrand Reinhold, 1992)

Arnheim, Rudolf, *Visual Thinking* (University of California Press, 1989)

Banham, Reyner, *Theory and Design in the First Machine Age* (MIT Press, 1981)

Burnham, Jack, *Beyond Modern Sculpture* (George Brazelier, 1968)

Conrads, Ulrich, *Programs and Manifestoes on 20th Century Architecture* (MIT Press, 1971)

Dondis, Donis A. and P. A. Dondis, *A Primer of Visual Literacy* (MIT Press, 1973)

Foley, James D. and A. Van Dam, *Fundamentals of Interactive Computer Graphics* (Addison-Wesley, 1982)

Forty, Adrian, *Objects of Desire* (Cameron Books/Thames & Hudson, 1986)

Garratt, James, *Design and Technology* (Cambridge University Press, 1991)

Gerstner, Karl, *Kompendium für Alphabeten* (Arthur Niggli, 1990)

Gill, Eric, *An Essay on Typography* (David R. Godine, 1988)

Gombrich, E. H., *Art and Illusion* (Princeton University Press, 1969)

Gropius, Arthur and A. Wensinger, *The Theater of the Bauhaus* (Johns Hopkins University Press, 1996)

Henderson, Linda D., *The Fourth Dimension and Non-Euclidean Geometry in Modern Art* (Princeton University Press, 1983)

Lucky, Robert, *Silicon Dreams: Information, Man, and Machine* (St. Martin's Press, 1991)

Krauss, Rosalind E., *Passages in Modern Sculpture* (MIT Press, 1981)

Knuth, Donald E., *Surreal Numbers* (Addison-Wesley, 1974)

Laurel, Brenda, *Computers as Theatre* (Addison-Wesley, 1991)

Levy, David, *Computer Gamesmanship* (Simon & Schuster, 1983)

Lutz, Mark and D. Ascher, *Learning Python* (O'Reilly & Associates, 1999)

Maeda, John and K. McGee, *Dynamic Form* (International Media Research Foundation, 1994; http://www.imrf.or.jp)

Maeda, John, *Design Machines* (International Media Research Foundation, 1994; http://www.imrf.or.jp)

Maeda, John, *Design By Numbers* (MIT Press, 1999)

McCloud, Scott, *Understanding Comics* (Kitchen Sink Press, 1994)

McCorduck, Paula, *Aaron's Code* (Freeman, 1990)

Meggs, Phillip B., *A History of Graphic Design* (Van Nostrand Reinhold, 1991)

Müller, Lars, *Josef Müller-Brockmann: Pioneer of Swiss Graphic Design* (Lars Müller Publishers, 1995)

Myerson, Jeremy, D. Gibbs, R. Poynor, *Beware Wet Paint: Designs by Alan Fletcher* (Phaidon Press, 1996)

Nicolaides, Kimon, *The Natural Way to Draw* (Houghton Mifflin, 1941)

Norman, Donald, *The Design of Everyday Things* (Basic Books, 1990)

Rand, Paul, *From Lascaux to Brooklyn* (Yale University Press, 1996)

Schodek, Daniel, *Structure in Sculpture* (MIT Press, 1993)

Shannon, Claude E. and W. Weaver, *The Mathematial Theory of Communication* (Illinois University Press, 1963)

Sharff, Stefan, *The Elements of Cinema* (Columbia University Press, 1982)

Simon, Herbert A., *The Sciences of the Artificial* (MIT Press, 1981)

Snyder, Gertrude and A. Peckolick, *Herb Lubalin: Art Director, Graphic Designer, and Typographer* (American Showcase, 1985)

Strang, Gilbert, *Linear Algebra and Its Applications* (Academic Press, 1980)

Tanchis, Aldo, *Bruno Munari: Design as Art*

Toffoli, Tommaso and N. Margolus, *Cellular Automata Machines* (MIT Press, 1987)

Tomura, Hiroshi, *Jikuu No Tsumiki* (Nihon Hyoron-sha, 1992)

von Moos, Stanislaus, *Le Corbusier: Elements of a Synthesis* (MIT Press, 1979)

Wall, Larry, T. Christiansen, R. Schwartz, *Programming Perl* (O'Reilly & Associates, 1996)

Wichmann, Hans, *Armin Hoffman: His Work, Quest, and Philosophy* (Birkhaüser, 1989)

Willberg, Hans Peter and F. Forssman, *Lesetypographie* (Verlag Hermann Schmidt, 1997)

Williams, Robert, *The Geometrical Foundation of Natural Structure* (Dover Publications, 1979)

① PERFECTING SPACE
(Jenny) NEW

② NARRATIVE SPACE
(Japan) NEW

③ EXPANDING SPACE
(NEW STUFF) NEW

④ SIMULATED SPACE
(simulate)